QUALITY IN PHOTOGRAPHY

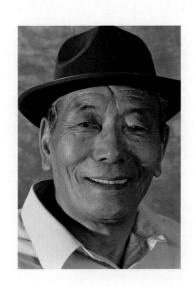

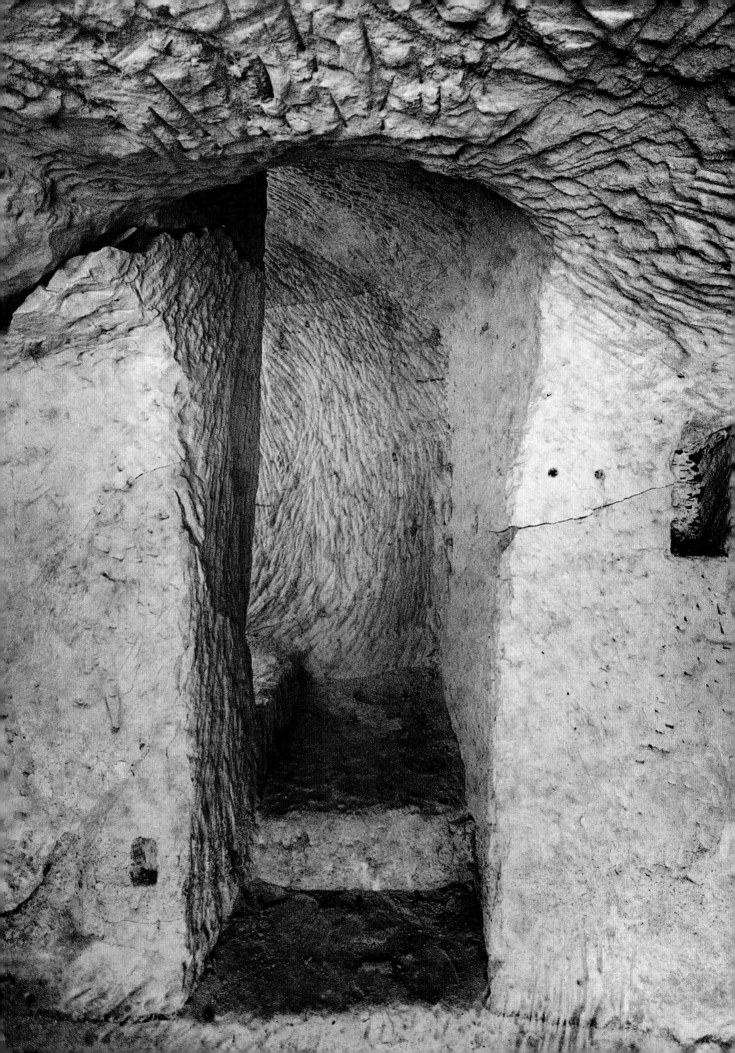

QUALITY IN PHOTOGRAPHY

HOW TO TAKE, PROCESS AND PRINT EXCELLENT PHOTOGRAPHS

ROGER HICKS AND FRANCES SCHULTZ

AMPHOTO BOOKS
An imprint of Watson-Guptill Publications/New York

FOR COLIN GLANFIELD 1934–1999
THANK YOU

First published in the United States in 2000 by Amphoto Books,
an imprint of Watson-Guptill Publications, a division of BPI Communications, Inc.,
1515 Broadway, New York, NY 10036

First published in the UK in 2000 by David & Charles

Library of Congress Catalog Card Number: 99-69359

ISBN 0-8174-5634-1

Designed by Bruce Low
and printed in Singapore by C S Graphics Pte

1 2 3 4 5 6 7 8 9 10 / 09 08 07 06 05 04 03 02 01 00

FRONTISPIECE
ABANDONED TROGLODYTE HOUSE, GOZO
*Quite honestly, we could have taken this picture — which is one of our favourites of all time —
with almost any camera we own, provided we used a tripod and metered carefully to get
adequate shadow detail. The key to quality, ultimately, is passion: after that, all you need is a
reasonable grasp of technique, and reasonable care in execution.*
TECHNICAL INFORMATION CAN BE FOUND ON PAGE 125. (FES)

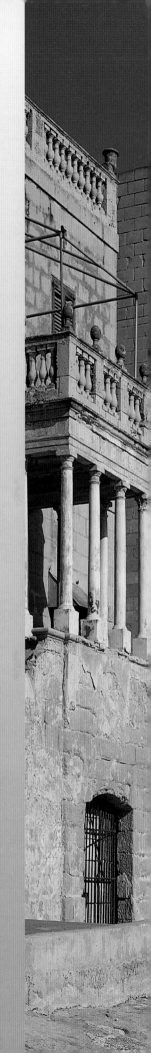

CONTENTS

∎ ∎ ∎

INTRODUCTION AND ACKNOWLEDGEMENTS

Colin Glanfield was Roger's first serious mentor in photography, and his 'gaffer' when he was an assistant in a London advertising studio in the early 1970s. Among his many words of wisdom in the years between then and his death in 1999, one of his most memorable was, 'When you stop learning, you're dead.'

The individual aspects of what needs to be learned, at least in photography, are seldom very demanding. Anyone of ordinary intelligence and diligence can soon achieve an adequate mastery of exposure, say, or film processing, or printing. The aesthetic side – composition and content – is principally a matter of practice, except for those rare individuals who seem to be born with a good 'eye'. And while theory may seem dry in isolation, once you see how a better understanding brings better results, even the densest text is worth the effort of reading.

But because there are so many aspects to photography, the most difficult thing, for many people, lies in choosing – or even in recognizing – which improvements need to be made. How best can we direct our time, our energies, our money, in order to improve our pictures?

The only answer is to look at the chain that links the original subject, and the picture that is made of it. At any one time, there will be one link that is weakest, and that is the link which demands attention, *at that time*. Once it has been strengthened, it is time to move on.

Today, for example, the problem may be empty shadows; the answers will lie in exposure technique, or in printing. But once that problem is remedied, we may find ourselves confronted with technically good pictures that lack passion. Now is the time for different questions: why choose that subject, why portray it that way? When (and if) these are answered, the next areas to examine might be tonality and film development, or composition.

Whatever a particular photographer's needs may be, the trick is to keep moving. There is no sense in endlessly refining the solutions to problems we solved half a decade ago, when what is really holding our photography back today is something quite different. This is why this book is different from what we would have written ten years back, and different from what we might write in ten years' time; but there is enough in it, we believe, to help anyone to understand their own photography better, and therefore improve it, regardless of their current level of skill.

We have already acknowledged Colin's contribution to our understanding. Another teacher (and fellow student), without peer, is Mike Gristwood at Ilford. Marie Muscat King, whose pictures appear in a number of our books, is someone else with whom we regularly exchange knowledge. On a technical level, one of the delights of achieving some small fame is that manufacturers are willing to lend equipment. A surprising number of the pictures in this book were taken with cameras which were relatively recently acquired, but which were so easy to use, and delivered such superb results, that they acted as a spur to our photography: namely Contax and Alpa.

To acknowledge everyone who has helped us to form the ideas in this book would require another book. Not only would it include countless photographers whom we have met in the flesh, but also countless others whose work we have seen, whose books and articles we have read, and with whom we have corresponded over the years. But before this turns into an Academy Awards acceptance speech – we would, of course, like to thank our parents, our postman and the cat next door – one last vote of thanks: to you, the reader, who shares our desire to learn about photography.

RWH
FES
Minnis Bay 1999

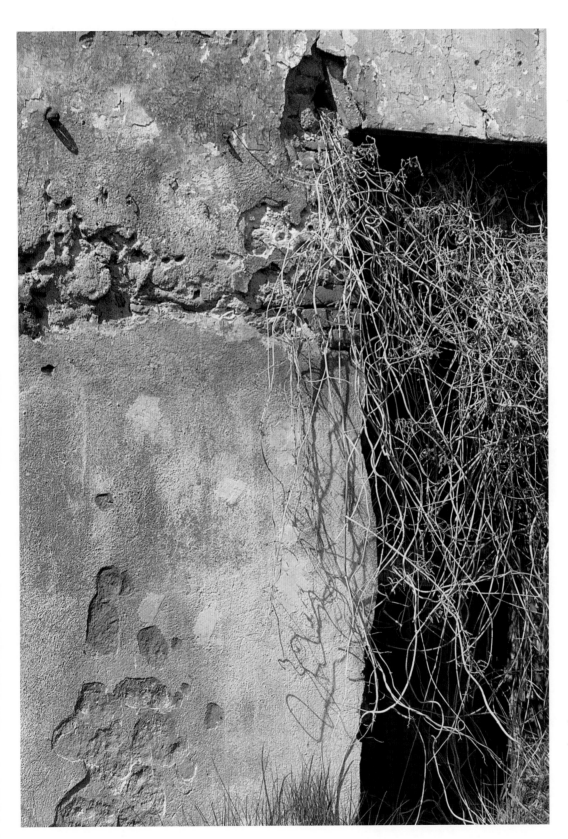

RUIN, AOSTE
*'Quality' can mean many
things, but this is one of
Roger's favourite pictures,
just as the Frontispiece is
one of Frances's. Why? He
just likes the colours and
the shapes: the composi-
tion, in other words. But
without reasonable
sharpness and precise
exposure, it is nothing.*
NIKON F, 70-210/2.8 SIGMA,
FUJI PROVIA.

CHAPTER ONE

UNDERSTANDING QUALITY

Quality is not an absolute. A picture may be adequate (or even superb) for one purpose, but quite inadequate for another. A picture which reproduces beautifully may well be disappointing as an exhibition print; a magnificent exhibition print is often equally disappointing in reproduction. A picture which is truly magical at postcard size may 'fall apart' when it is enlarged; but another picture, unremarkable as a postcard, may be very striking indeed at poster size.

Also, quality is easier to recognize than to analyse. We all know photographers whose prints are technically superb, but curiously lifeless and formulaic. We know others who have a superb 'eye', but who are lazy or incompetent when it comes to technique. And most of us have seen prints which fairly exuded quality, without our understanding quite how or why.

Perhaps the first point is that quality must be appropriate. It is most appropriate when it is least apparent; in other words, a picture must succeed as a whole, without technical quality taking precedence over content, composition, and all the other things which go to make up a picture. If it evokes the reaction, 'Great picture, shame about the technique,' then clearly the photographer has not fully succeeded; but if the reaction is, 'Technically superb, but...' then the photographer has equally fallen short.

As a general rule, for obvious reasons, it is better to have too much technical quality, rather than too little: a picture that is technically better than needed is clearly preferable to one that is technically inadequate. This is where the concept of the 'quality threshold' comes in.

This is the level below which, by any reasonable standard, quality is inadequate. Obviously, it varies. If you only ever shoot postcard-sized prints for the family album, you are placing fewer demands on your camera, lens, film and technique than if you habitually produce 16x20in (40x50cm)

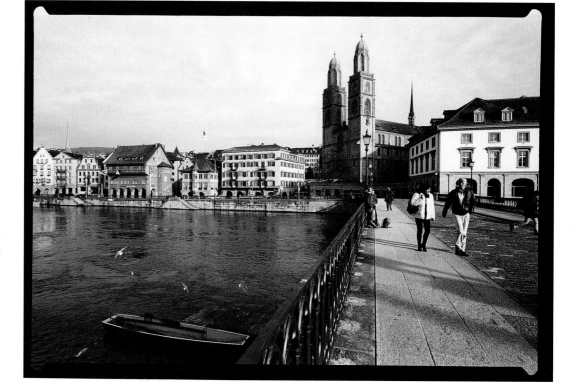

BRIDGE, ZUERICH
Most decent cameras are above the 'quality threshold', though few are as far above as the Alpa 12 WA with which this was taken. Most materials and chemistry, likewise, will deliver excellent quality. All you normally have to do is to follow the manufacturers' instructions: this was Ilford HP5 Plus, developed in Paterson FX39 and printed on Ilford MG Warmtone, then partially toned in Paterson sepia. The main things are holding the camera level and pressing the shutter release at the right time.
CAMERA HAND-HELD, 38/4.5 BIOGON, 44X66MM. (RWH)

exhibition prints. The quality threshold can therefore be correspondingly lower. Also, it is undeniably true that almost any technical shortcoming can be turned into an asset, in the right picture.

Even for exhibition prints, though, the quality threshold can be reached surprisingly affordably. For example, we have a brace of Pentax SV cameras from the 1960s, with contemporary lenses. Modern 35mm cameras may (or may not) be easier to use, but very few will deliver better quality. Many will not even be as good. And one of the finest photographers we have met is a retired submarine commander, living in Moscow, whose ancient Mamiya roll-film cameras might well be relegated to the junk shelf in most camera stores.

The same photographer – Rustam – produced stunning prints on paper so old that he had to add generous quantities of benzotriazole to the developer to stop it fogging. This led to very long exposure and development times, but the prints were (and are) still superb. Equipment and materials should not, then, prove a barrier: technical and artistic skill are what matter. So how can they be cultivated?

THE VALUE OF PRACTICE

To a very large extent, both technical and artistic skill depend on practice. If you have a few hundred pounds, dollars or euros which you can

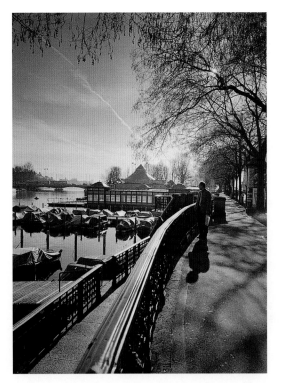

BACKLIGHTING, ZUERICH
This is, believe it or not, a snapshot with a guessed exposure. The exposure was guessed because Roger had not realized we were going to be loaned the Alpas that day, and had not brought even an exposure meter, let alone a tripod. But with medium-format colour negative film, there are no great penalties for over-exposure. It is a snapshot because he had to shoot fast before the man on the right moved. Frances is in shot on the staircase to the left of him.
ALPA 12 WA, 58/5.6 SUPER ANGULON ON 6X8CM, KODAK VERICOLOR.

afford to spend on photography, you will almost invariably do better to spend it on film, and on going somewhere to take pictures, than on 'upgrading' cameras and lenses.

While it is (of course) true that some cameras and lenses are better than others, and while Chapters 3 and 4 deal with these very questions, it is equally true that the vast majority of

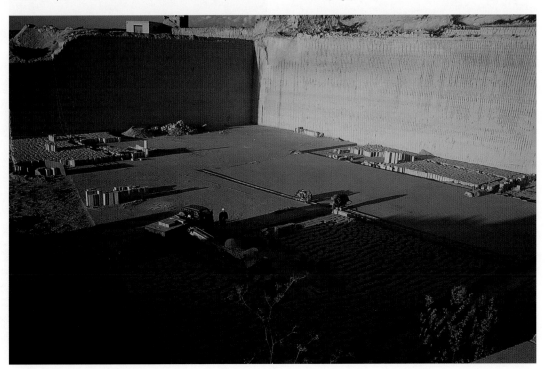

QUARRY, GOZO
Never be afraid to 'waste' a few frames on a subject which might not work out. You may get lucky, and even if you don't, you will have learned something about how your camera, lens and film perform in a given set of circumstances. It is always worth making an effort to finish the last few frames of a film on experimental subjects, rather than letting it sit in the camera.
HAND-HELD LEICA M2, 35/1.4 SUMMILUX, FUJI ASTIA (RWH)

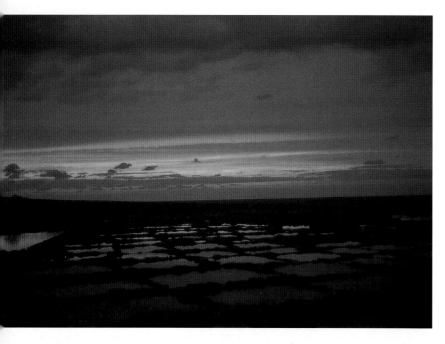

SUNSET AND SALT PANS, GOZO
A 'kickself' picture. The light was gorgeous; the reflections in the salt pans were fascinating. Roger mistakenly believed there would not be time to get out a tripod. As a result, there is some camera shake, and depth of field is inadequate. A light, fast-acting tripod is an essential accessory for many pictures, and desirable for almost all.
LEICA M2, 35/1.4 SUMMILUX, FUJI RA. (RWH)

SETTING SUN, MALTA ▶
The classic advice for getting good press pictures was 'A sixtieth at f/8 and be there.' Well, this was more like ⅕ at f/8 but the advice to be there was just as important: we hung around on the hill for almost an hour as the sun set, watching, and shooting, the changing light.
LEICA M2 ON TRIPOD, 35/1.4 SUMMILUX, FUJI RA. (RWH)

photographers never push their equipment to its limits. Until you genuinely know that you are being limited by your equipment, and understand why, there is absolutely no point in 'upgrading'; unless, of course, you feel that sheer pride of ownership might make you try harder. This should not be neglected: trying to 'live up' to a Contax or an Alpa or a Gandolfi can be quite a spur to improvement.

The great thing about practice is that you can improve the aesthetic side of things – your 'hit rate' of successful images goes up steadily – while at the same time constantly refining your technique. If a roll of film lasts you ten days, then the things that you did right and wrong, the way you shot a particular picture, cannot be as fresh in your mind as they would be if you finished the roll and processed the film immediately. And if you shoot five rolls in a week (or a month), then you should learn more, and faster, than if you shoot just one.

TIME AND MONEY

It is never easy to fit a serious commitment to photography around a busy life in which you have to earn a living, run a household and maybe raise children as well; but equally, you might be surprised, if you stopped to think about it, at how little extra it will cost you, in either time or money, to take your photography a bit further.

In particular, instead of letting the last few

frames sit in the camera, shoot them off. Try new techniques: very long time exposures, double exposures, heavy filtration. Shoot the same subject hand-held, and with the camera on a tripod, and see what difference it makes to sharpness. Look for deliberately 'off the wall' subjects: semi-abstracts, ultra close-ups. Zoom during exposures. Shoot brick walls, to test resolution and distortion. The possibilities are endless, and not only will you learn more about things you had not previously tried; you will also have things fresh in your mind when you see the pictures.

Of course, if you like the results you get, you can end up spending a lot more time and money on your photography. We ended up earning our living from it. But even if you never see a penny back in financial terms, you can still get a tremendous return on your investment, little be it or much, in sheer enjoyment.

LEARNING ABOUT QUALITY

Practice alone can teach you an enormous amount about quality, but you can learn faster and better if you combine practice with two other

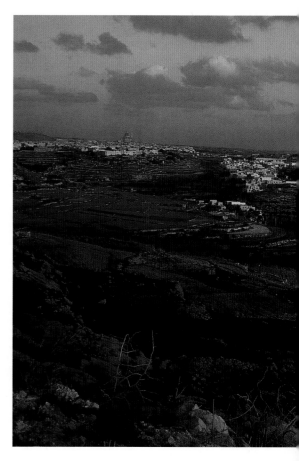

approaches. One is trying to understand the theory behind what you are doing, and the other is looking at as many original prints as you can.

Theory is dry and irrelevant on its own, but it really comes to life when you see its relevance in your own pictures, and in others' pictures. To a very large extent, this is a book of theory; but it is, we hope, a book in which theory and practice are intertwined to an extent that will make you want to understand both better.

PICTURES AT AN EXHIBITION

The important thing about original prints is that they can show you interpretations of quality that you will never get from reproductions. An original print can hold a far wider range of tones, far more subtly, than even the best photomechanical reproduction; until you have studied a wide range of original prints, you will never understand what quality can really mean.

The prints need not be by great photographers, though equally, if they are, the pleasure is greater; but even a local camera club exhibition can turn up prints which fairly take your breath away

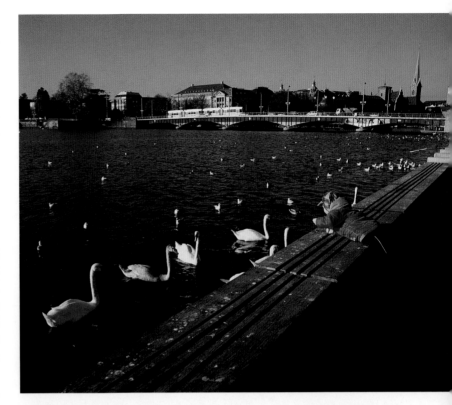

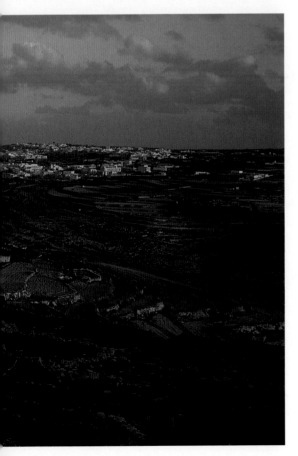

technically, whether or not they are aesthetically remarkable. The same exhibition may also provide ghastly examples of techniques to avoid, or of techniques improperly realized, which can be another useful lesson.

You may however be surprised if you see original prints by 'Great Photographers', which hitherto you had seen only in reproduction. Some will have a lambent quality which was barely hinted at in the reproductions, while others may be surprisingly poor. Even the great Ansel Adams is not immune from this criticism: some of his Hasselblad pictures were, without doubt, over-enlarged for exhibition, and look a lot better on the printed page.

Another important point about seeing original prints is that they are the only way in which you can appreciate so-called 'alternative' processes. These can have a charm that is all their own, but if you only ever see them in reproduction, they normally look like inferior versions of conventional silver gelatine prints.

CHILD AND SWANS
*Can you have too much quality? Arguably, yes. This is a charming snapshot, but thanks to the equipment and film used (hand-held Alpa 12WA, 58/5.6 Super Angulon on 6x8cm, Kodak EPL) it is arguably too slick, too 'chocolate boxy'. A 35mm compact with colour negative film might have removed the temptation to make an exhibition print from it.
(RHW)*

THE PAINTED WORD

Looking at pictures is one thing, but reading about them is quite another. Photography is a visual medium, and must stand as such. If a photograph

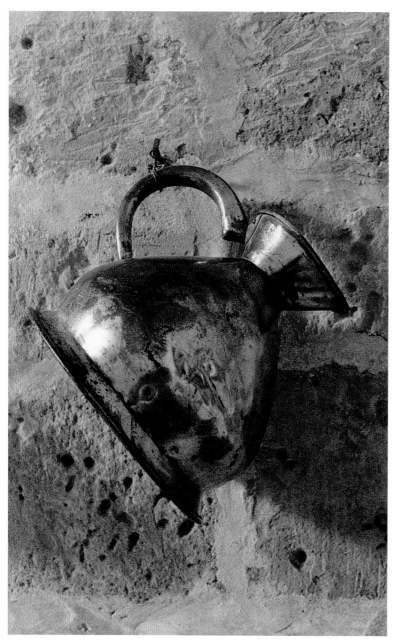

often rather different. A well-made monochrome print has a wonderful, and very extended, range of tones which range from a clear, paper-base white to a deep, rich black. The actual brightness range of the print may exceed 200:1, a density range of 2.3 or about 7½ stops.

In colour, while it is possible to capture an equally wide tonal range, pleasing colours can only be represented across a brightness range of at most 32:1, a density range of 1.5 (5 stops). Very light tones tend to turn into shades of yellow, and very dark tones into browns, so unless the lighting is under the photographer's control, there may well be significantly larger areas of blocked-up shadow detail than there would be in a monochrome print of the same subject. It is often impossible to favour the shadows any more, because this would lead to unpleasantly large areas of burned-out highlights.

A great deal of the appeal in a colour photograph therefore tends to reside in the use of colour, and of broad areas of light and dark. In monochrome, the length and subtlety of the tonal range is often the most noticeable aspect of quality, and sharpness and detail may also be more relevant than they are in colour. There is also more scope for dramatic lighting in black and white. But heresy though it may be to say it, there are two things which can be more important than any of this. They are content and composition.

COPPER JUG
Grain does not automatically preclude quality. When Kodak TMZ P3200 was the only ultra-fast film available, we loved it. Then Ilford Delta 3200 came along, with ⅓ stop more speed and vastly better tonality.

The true specular highlights on this polished copper are going to 'blow' no matter what you do, but otherwise, the tonal range is extraordinary.
CONTAX RX ON TRIPOD, 100/2.8 MAKRO-PLANAR, PRINTED ON ILFORD MG IV SEQUENTIALLY TONED IN SEPIA AND GOLD. (FES)

requires endless explanation, analysis and criticism, you have to ask yourself why. The answer, all too often, is that it has nothing to say on its own, or in other words, that it is not much good as a photograph. Tom Wolfe's *The Painted Word* is a trenchant commentary on art criticism; many of his observations are equally applicable to photography.

MONOCHROME AND COLOUR

One more point is worth making, while we are talking about learning to recognize quality. It is that the criteria for colour and monochrome are

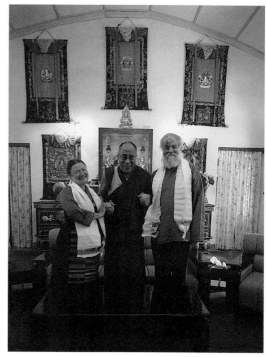

CONTENT

The vast majority of pictures are valued, above all, for their content. This is true whether you are a grandparent looking at photographs of your new grandchild, an armchair traveller looking at pictures of some remote destination, or a news editor looking at a picture of a princess kissing a playboy. The news example is deliberately left until last because, in the real world, it has the least

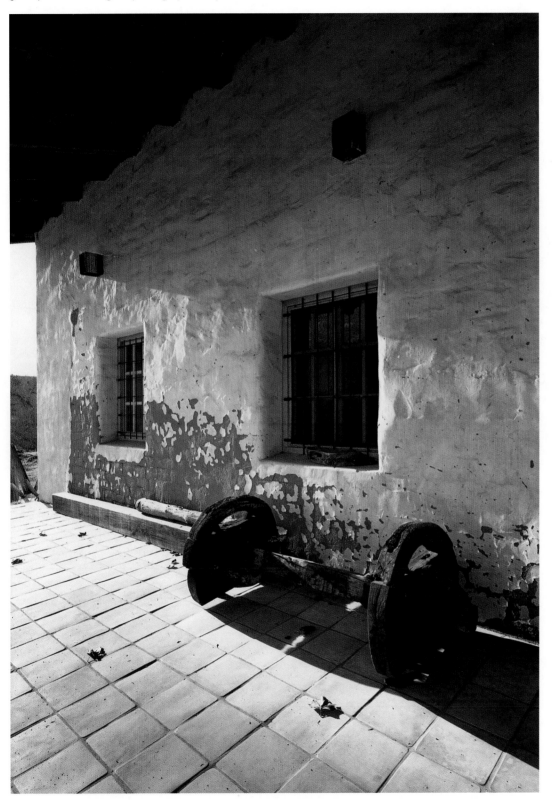

MISION SAN ANTONIO, CALIFORNIA
In monochrome, the single most important factor is exposure. Here, the aim was to hold detail in the roof beams and on the side of the wheel: limited-area readings made sure that they did not block up into feature-less black, though the detail may not be visible in reproduction. After that, the important point was not to overdevelop and 'blow' the highlights; there is even a tiny bit of tone in the sky on the left.
ALPA 12 WA HAND-HELD, 38/4.5 BIOGON ON 44X66MM, ILFORD 100 DELTA PRO PRINTED ON ILFORD MG WARMTONE TONED WITH SELENIUM. (RWH)

◄ **HH DALAI LAMA**
This is not the sharpest picture in the world, but it is very precious to us: His Holiness was much amused by Roger's monocle, and insisted that he put it in for the picture. Ultimately, content must always take precedence over technical quality. The picture is also a classic example of stupidity on our part: we should have thrown away the unexposed roll of Ilford HP5 Plus in the camera and replaced it with Delta 3200, for extra depth of field and a higher shutter speed.
ALPA 12 WA HAND-HELD, 38/4.5 BIOGON ON 44X66MM. TENZING GEYCHE

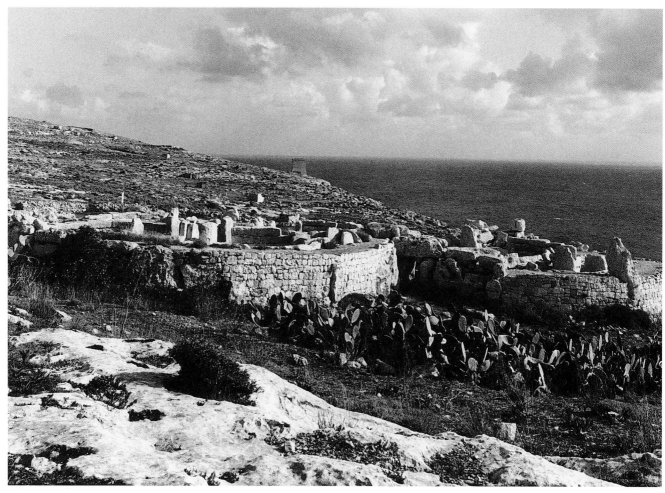

MNAJDRA, MALTA
We both have a great weakness for historical subjects, and love to explore the textures and shapes of ancient buildings. These temples at Mnajdra are about as old as they come – they are roughly contemporaneous with the Pyramids of Gizeh – and Frances shot them on Ilford SFX using an infra-red filter.
CONTAX RX ON TRIPOD, 100/2.8 MAKRO-PLANAR.

enduring importance: it will be thrown away with the day's paper, while the family pictures will be kept forever, or as close to forever as human lives and family histories permit, and even the travelogue may well be read again and again.

In all of the above cases, and in many others, quality takes second place to content. As long as the subject is reasonably recognizable (and reasonably interesting), no one is too fussed about grain and tonality or many of the other things which photographers normally worry about. This is a sobering and salutary reminder.

On the other hand, concern for content by no means precludes quality. If the news photographer could duplicate the pose of Rodin's *The Kiss*, while still ensuring that at least the princess (and preferably the playboy) remained recognizable, it would be a better picture than a blurry, grainy picture taken with an ultra-telephoto lens.

If, however, the people or places involved are not inherently interesting, or for that matter if the subject matter is overly familiar, then technical quality can be very important. A good

photograph reveals its subject as if for the first time, and technique can be a key to this. But so can passion.

PASSION

A point widely ignored by writers on photography, despite its fundamental importance, is that few people take good pictures – that is, pictures which succeed as pictures, rather than as record shots – unless they have some interest in the subject. It is not enough to try sports photography unless you like sports, or portraiture unless you really want to photograph people. 'Passion' may be an exaggeration, but equally, the best pictures are often taken by people who are passionate about their subjects.

It is true that you can come to be fascinated by a subject as a result of trying to photograph it, but it is also true that you can quite easily confuse your feelings about a subject with your feelings about photographs of it. You can then waste a lot of time in trying to emulate photographers whose

work you admire, without realizing that you have no real sympathy with what they photograph.

We did exactly this with landscapes. There are countless superb photographers in the United States who take as their text the unspoiled wilderness, or something that looks like it. We both wasted a good deal of time in trying to emulate them, before we accepted that both intellectually and aesthetically, we are more inclined to the eighteenth-century view that man shapes and gives meaning to the landscape. We are therefore happier photographing ancient buildings, terraced fields, prehistoric ruins, handsome cityscapes, mediaeval villages, and even workshops and factories; and we get better pictures this way.

The view – again common in America – that man can only despoil and ruin the planet is very much a product of a particular place and (still more) of a particular time. There always have been, and still are, those who can harmonize the natural and the man-made. We prefer to celebrate them, rather than to ignore them or to deny their existence.

COMPOSITION

Like content, composition can transcend technical quality. Some people can arrange shapes, tones or colours in a way which is so inherently attractive that sharpness and grain and the like take a very subordinate place.

Even so, technical quality is often important. A picture that is well composed and potentially attractive, but lacks technical quality, can be a painful reminder of what might have been. Initially, the lack of technical quality may not seem to matter, but sooner or later it will start to annoy. This is especially true of one's own work.

We have written more about composition in Chapter 7, where we have described it as a non-photographic skill, which it is: the overall techniques of composition, of handling shapes and colour and light and shade, are as applicable to drawing or painting as they are to photography. With this in mind, it is time to begin to look at the technical side of quality, and in particular at sharpness and resolution, tonality and colour.

BARRELS, FORT SCOTT, KANSAS
We shot this in about 1991 for a book – which came to nothing – on the American Civil War, a sequel to our Battlefields of the Civil War *(1989). It shows how wide-angles have to be used with care and discretion, if one is to avoid give-away distortions: this, like everything else in the photographic process, is a link in the chain of quality.*
NIKON F ON TRIPOD, 14/3.5 SIGMA. (FES)

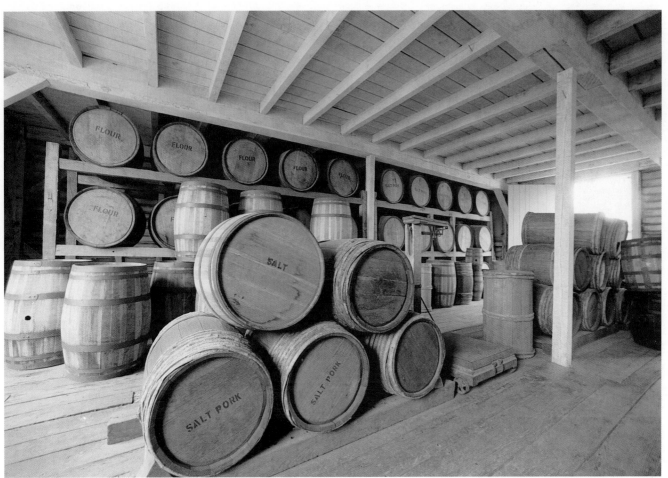

CHAPTER TWO

TECHNICAL QUALITY

MONK WITH PRAYER WHEEL, BIR

Biting sharpness in the skin and beard textures is an essential part of this picture: Frances used a 100/2.8 Makro-Planar on a Contax RX to ensure it. Ilford XP2 Super allowed a reasonably short hand-held exposure, at the expense of a slight loss of depth of field (look at his right hand). He is looking at a Polaroid of himself that we have just given him.

Sharpness and resolution are an obvious starting point for any consideration of quality, before we go on to look at tonality and colour. Although they are intimately related, sharpness and resolution are not the same thing; and both are equally intimately intertwined with the question of film grain, which is covered in Chapter 6.

We are concerned here with what looks sharp, and there are a distressing number of variables. Visual acuity varies from person to person, even with corrected vision (if necessary). Viewing distance is critical: a picture that looks sharp at arm's length may not look so sharp when it is examined close up. It is quite possible to have a lens of high sharpness and a film of modest sharpness, or vice versa: it is of course desirable that both should be as sharp as possible. And the sharpest films do not always have the most pleasing tonality.

The traditional argument about viewing distances is that bigger pictures are normally viewed from further away. This would make the problem self-solving, but to a very considerable extent, it is simply untrue. A really good photograph is a 'magic window': it invites the viewer into its own miniature world, like Alice through the looking glass. People may start off looking at it from a distance, but they are drawn closer and closer, until they end up with their noses a mere hand-span from the print.

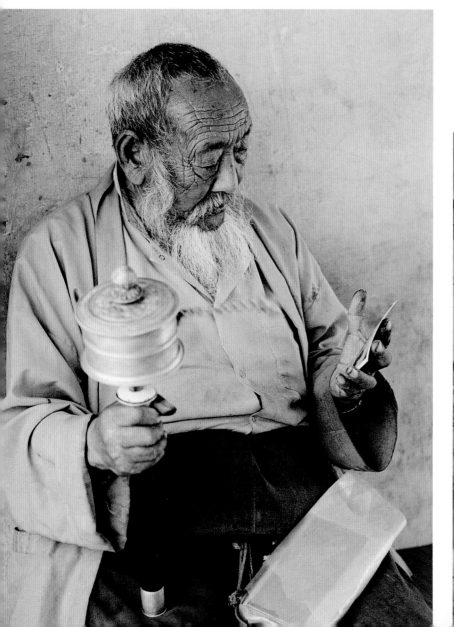

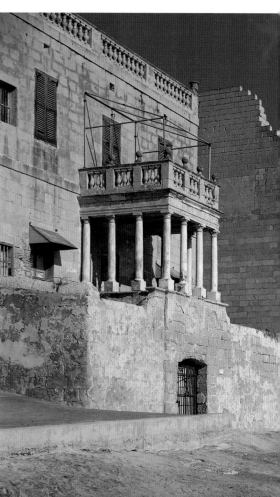

SHARPNESS

Sharpness is a measure of the transition between a light area and a dark area. The clearest example is the 'knife edge' test. Where the emulsion is covered by the knife, it should be clear, because no light has reached it. Where the emulsion is uncovered, it should darken. With a perfectly sharp emulsion, the gradient between the two would be a sudden cut-off, a right-angled step.

In the real world, there is an S-shaped gradation between the two areas. This is caused by the scattering of light within the emulsion, which is one reason why thin emulsions are generally preferable to thick ones. If the gradation is too gradual, then fine detail will lose contrast and may even disappear altogether: the centre of a sufficiently thin line may simply fail to reach an adequate density to differentiate it from the surroundings, and the edges will diffuse into the background. This micro-contrast or edge-contrast is commonly known as 'acutance', a term coined by Higgins and Jones of the Kodak research laboratories in the 1940s.

There are a number of ways to improve sharpness. Obviously, a sharp lens helps. So does a

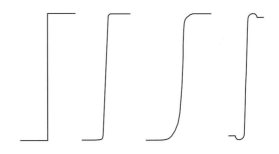

sharp, thin-emulsion film. Acutance developers are discussed at greater length in Chapter 9. A very simple route, though, is to use a bigger image. If a bar that is 10mm (0.4in) wide is projected on to the film as a line that is 0.5mm (1/50in) wide, then it is unlikely to disappear; but if it is only 0.05mm (1/500in) wide, it may well disappear as a result of low acutance, high grain, or poor film resolution – or, for that matter, because of poor lens resolution and flare (see Chapter 4).

SHARPNESS
The drawing on the left represents 'perfect' sharpness: a clean, sharp transition from light to dark. The two centre drawings show what happens in the real world: a slight 'bleeding' of the boundaries, so that the transition is S-shaped rather than square. The left centre film exhibits higher acutance than the right centre. Finally, the drawing on the right shows the use of edge effects (via developer exhaustion) to accentuate acutance. This is a useful trick, but taken to extremes, it can look unnatural.

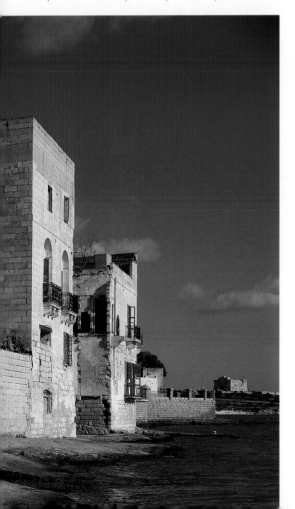

◄ **NEAR MARSAXLOKK, MALTA**
This was a deliberate experiment with Fuji Velvia, a very saturated, contrasty film, in bright sunlight. A half stop less exposure blocked up the shadows hopelessly; a half stop more 'blew' the high-lights to a featureless white. The picture is very dramatic – but a more forgiving film would have made life a lot easier, and it is generally a good idea to learn on the easiest materials available, rather than the most difficult. 'BABY' LINHOF TECHNIKA IV ON TRIPOD, 100/5.6 APO-SYMMAR ON 6X7CM. (RWH)

lengths, for example, means that we can apply a 50 per cent correction factor and the maximum resolution we can see goes up to 120 lp/mm.

There are two important things to remember about any resolution chart. The first is that there is always a degree of subjectivity: the point at which you can, or cannot, resolve a given target is always disputable. The second is that a great deal depends on the contrast of the target itself. A very high contrast target, such as could be made by laser-cutting slots in a thin sheet of metal and placing the whole thing on a light box, will give much higher resolving power than a printed target of the type we use: contrast ranges could easily be 1000:1 with the former, but will rarely exceed about 20:1 with the latter.

The relationship between resolution and sharpness is not hard to understand. Visually, high resolution with low sharpness may well appear less sharp than somewhat lower resolution coupled with higher sharpness.

RESOLUTION

The easiest way to understand resolution is with an old-fashioned lens testing chart. Most are designed to give a direct read-out in line pairs per millimetre (lp/mm) at a particular distance. The long-obsolete Paterson chart which we use is designed to give direct readings at up to 80 lp/mm at 26x the focal length of the lens in use. With a 50mm lens, therefore, you would shoot at 26x50 = 1300mm; 1.3m is about 51.2in. Where we suspect that we will get better than 80 lp/mm, we increase the shooting distance: working at 39 focal

SHARPNESS AND THE HUMAN EYE

A good rule of thumb is that the human eye can resolve about one minute of arc at normal (daylight) brightness levels. This equates roughly to seeing a black hair on a sheet of white paper at 3m (10ft), or a human figure at a distance of around 5km (3 miles). Obviously, many people are going to need eyesight correction of some kind to

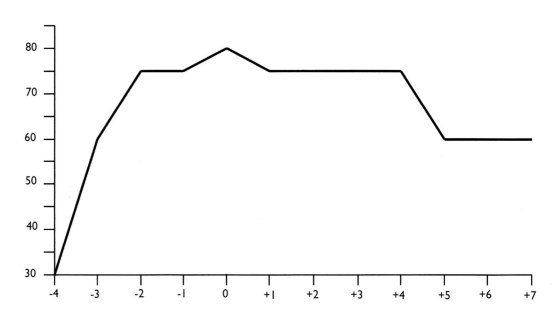

DEREK
In portraiture, by convention, sharpness seems to be pretty much optional. Shallow depth of field and soft-focus lenses (or diffusion disks) are commonplace, and provided the eyes are reasonably sharp, as they are here, more depends on pose and lighting than anything else. Frances shot this with a 90/2.5 Vivitar Series 1 on a Nikkormat, using Kodak PJ400 negative film; hand-holding the camera has taken the edge off sharpness.

achieve this, but it is the sort of resolution which is available to most people without telescopes or binoculars.

For a print viewed at 25cm (10in), this would translate to a requirement for on-the-print resolution of around 8 lp/mm. You can then obtain a good idea of the minimum necessary resolution on the film by multiplying 8 lp/mm by the degree of magnification which is required to make the print.

Thus, for example, an 8x10in borderless print is a bit under an 8.5x enlargement off 35mm:

MARKET STALL, DHARAMSALA
Many subjects call for a film with a long recording range. The important part of this subject is the stall and traders, but the picture would be a failure if the top of the awning were any more burned out, and inky shadows would also detract from the image. Recommendations to use only high-saturation, high-contrast films should be treated with caution.
LEICA M4-P HAND-HELD, 90/2 SUMMICRON, FUJI ASTIA. (RWH)

8.5x8 = 68 lp/mm, which should not be too difficult with any reasonably good camera and lens, used carefully with many films up to ISO 400 or so. Go up to 12x16in (30x40cm), however, and you need a 12.5x enlargement or 100 lp/mm on the film.

Although 100 lp/mm is just about achievable with the best available cameras and lenses, on slow film, you would need a perfect enlarging lens to see 8 lp/mm on the print at 12.5x, and perfect enlarging lenses do not exist. You might get 6 or 7 lp/mm on the print if you were lucky, but this would increase the minimum viewing distance in

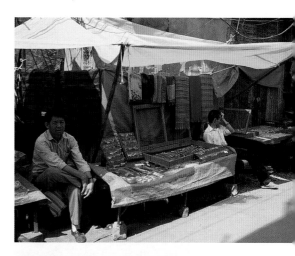

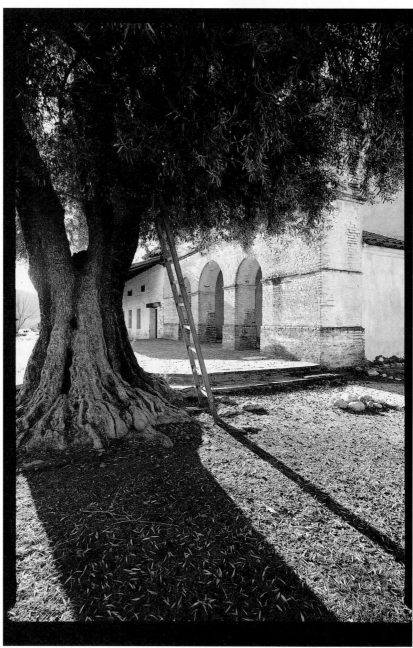

TREE AND LADDER
Without the texture in the tree, this would lose much of its appeal. In order to ensure adequate shadow detail, Roger took a limited-area reading from the darkest shadows on the side of the tree, and gave 2 stops less exposure.
ALPA 12WA, HAND-HELD, 38/4.5 BIOGON ON 44X66MM, ILFORD 100 DELTA PRO.

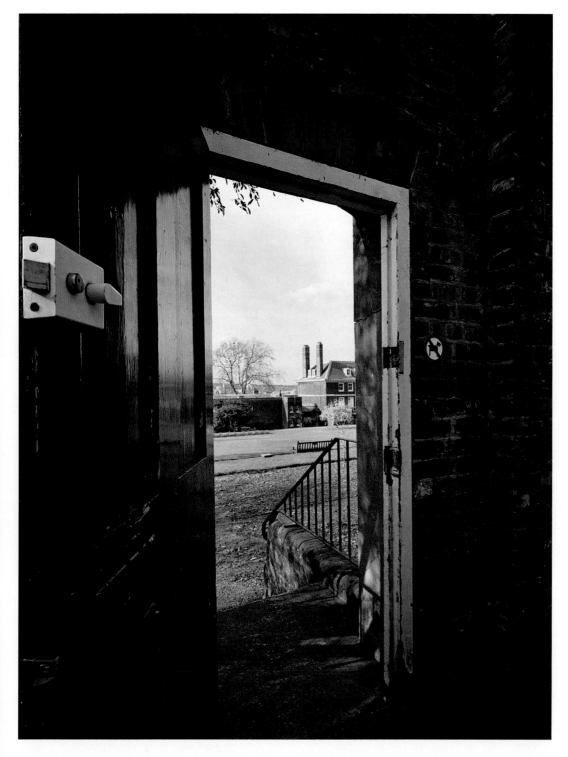

DOOR, CHATHAM
The easiest way to hold a long tonal range is to expose for the shadows – Frances took limited-area readings – and then to dodge and burn as necessary in order to get what you want on the print. This is almost invariably more successful than curtailing development to any great extent, an approach which commonly leads to flat, muddy pictures.
ALPA 12 SWA ON TRIPOD, 35/4.5 APO-GRANDAGON ON 6X9CM, ILFORD HP5 PLUS.

direct proportion to the loss in resolution: at 6 lp/mm, the minimum viewing distance as specified above would be 33cm (13in).

What is more, some people are going to examine any print, regardless of its size, from 15cm (6in) away; in which case, you need 13 lp/mm on the print. This equates to 110 lp/mm even for the 8x10in print off 35mm, assuming

(once again) a perfect enlarger lens. Move up to a 4x5in camera, however, and even a 12x16in (30x40cm) print is only just over a 3x enlargement. Even if you look at it from 15cm (6in), where you need 13 lp/mm on the print, you still only need about 3x13 = 40 lp/mm on the negative – which should be achieved by most lenses.

BARLEY
This is actually quite a sharp, grainless shot – but it would have worked equally well with significantly more grain and less sharpness, because the texture of the cut barley conceals the grain, and our brains fill in the sharpness from memories of similar scenes.
LEICA M4-P HAND-HELD, 35/1.4 SUMMILUX, ILFORD XP2. (RWH)

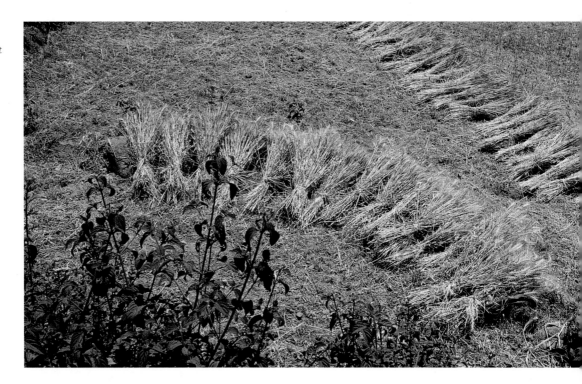

Ctein, a leading theoretician, has advanced the argument that in order to achieve sharpness which is comparable with a contact print, you need some 30 lp/mm on the print. We have to confess that we do not fully understand his thesis, nor yet are we fully convinced (from the evidence of our own eyes) that he is entirely correct; but we would agree that the criteria advanced above are pretty flexible, and that for ultimate quality, they should be regarded as the minimum requirements.

TONALITY

Most people prefer the tonality of a print made from a negative which has received more than the minimum exposure. Even if they do not, there is without doubt more 'meat' on a generously exposed negative, so you can dig out more shadow detail if you want it. In practice, tonality is often more of a limit to enlargement than resolution. This is partly because of the necessity for minimum exposure with 35mm; partly because of edge sharpness or acutance, as described above; and partly because of the half-tone effect.

MINIMUM EXPOSURE

When you are shooting 35mm film, both sharpness and grain are of paramount importance, so you want to keep exposure to a minimum: more exposure always means less sharpness, and with conventional monochrome films, it also means bigger grain. The larger the format, the smaller the penalties for over-exposure.

ACUTANCE AND TONALITY

Clearly, the more a film is enlarged, the more the unsharp boundary between light and dark areas is enlarged, and the clearer (and more disturbing) this boundary becomes. Sooner or later, there is a degree of enlargement where the whole image has a 'glassy' look, and the edges are not quite sharp. This is easier to recognize than to describe, but without question, it is readily recognizable.

THE HALF-TONE EFFECT

Before grain becomes obvious throughout the print, it affects the apparent tonality of an image. This is especially clear with fine black and white prints, where the 'liquid' tonality of a contact print or a small enlargement is lost at greater enlargement sizes.

This is called the 'half-tone' effect by analogy with photomechanical reproductions or 'half tones', which are made up of dots of different sizes (and, in modern stochastic printing processes, of dots which are closer together or further apart).

THE HALF-TONE EFFECT
The picture on the left was made in the usual way, with the paper stationary. For the picture on the right, the paper was rotated during the exposure, so that there is no pattern of dark grain and light paper. The difference should be apparent, though the tonal values will inevitably have been distorted again by the photomechanical printing process used in this book, which (after all) relies on half-tone dot screens to create greys, unlike the photographic process which is grainless and truly continuous at small degrees of enlargement.

The effect is clearer in some tones than others: with a conventional monochrome film, areas of the negative which have received more exposure (the subject highlights) will be grainier than those which have received less (the shadows). This is why chromogenic films like Ilford's XP2 and Kodak's T400CN look even finer-grained than expected: not only is the grain finer for a given film speed (see page 72), but it is finest in (for example) the sky, where it would normally be most obvious.

The classic demonstration of the half-tone effect is to make a pair of enlargements of a negative of uniform tone, so that the print is a light mid-tone. The degree of enlargement that is necessary will depend on the film, and the degree of exposure it has received, and the development regime, but the half-tone effect is likely to become apparent at around 5x or 6x. It is unlikely to be visible at less than 4x, and it will almost always be apparent by around 7x or 8x.

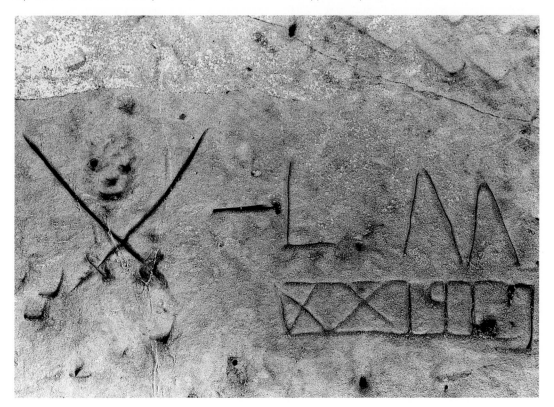

GRAFFITI
Traditionally, the way to get good contrast in a subject like these graffiti in a troglodyte house in Gozo is to over-develop the film. In practice, a hard grade of paper is more than adequate, and allows a mixed range of other subjects to be accommodated on the same roll of 35mm film.
CONTAX RX ON TRIPOD, 100/2.8 MAKRO-PLANAR, ILFORD XP2 SUPER. (FES)

For one enlargement, you leave the paper stationary, in the usual manner. For the other, you move it during the exposure. The best (though not necessarily the easiest) way to do this is on a turntable. The first picture will show the familiar speckling of grain. The second will (of course) be of a uniform tone – and will look significantly different from the first.

The effect of the half-tone effect is twofold. First, it distorts tonal relationships, and second, it makes the tonality seem harsher and cruder than it should be. Either way, tones which are identical when measured with a densitometer can look different to the human eye.

Obviously, 35mm is at a disadvantage because it is normally enlarged more than the larger formats. Our own view is that for optimum quality, enlargement ratios must either be very small, typically 5x or less, or quite large, maybe 10x or bigger. In the former case, there is no half-tone effect and prints have a characteristic 'creaminess', and in the latter, they are big enough that the grain is visible everywhere and the half-tone effect is greatly reduced.

We shall return to the relevance of format to both sharpness and tonality at the end of the chapter, but before then, we should take a quick look at the difference between what can be recorded in monochrome, and what it is desirable to record, before going on to colour.

TONAL RANGE

A black and white film can record an enormous subject brightness range: as much as 10 stops, 1000:1, is quite easy, and still greater ranges are possible.

The maximum possible brightness range of a print, from pure paper-base white through to absolute maximum black, is much smaller: about 8 stops, or around 250:1. Most papers are more likely to offer about 7½ stops or 200:1. The maximum dynamic range, from the brightest area with detectable texture through to the darkest area with detectable texture, is smaller still: most people would regard 6½ stops, 100:1, as excellent.

If the subject brightness range is in fact greater than the chosen paper can represent, and if it is nevertheless required to be represented in full, then inevitably, the print brightness cannot be in one-to-one correspondence with the subject brightness.

Historically, a popular view was that print brightness and subject brightness should match precisely, so that if one area in the original subject was 3 stops brighter than another (a ratio of 8:1), then the corresponding areas in the print should also have the brightness ratio of 8:1.

This is entirely feasible as long as the film and the printing paper can both record different brightnesses more or less linearly, and as long as the brightness range of the subject is 100:1 or less. In practice, film is normally developed to rather less than the contrast which a 1:1 relationship would imply, and paper of a rather higher contrast is used, in order to bring the contrast back up to 1:1.

In any case, two things militate against this old view. One is that at low exposure levels, the relationship between exposure and density is not 1:1, even if it is 1:1 at higher levels. This is explained in the panel, 'The D/Log E Curve'. The other is that a subject brightness range of (say) 1000:1, log range 3.0, on to a print with a brightness range of (say) 100:1, log range 2.0, necessarily precludes a 1:1 relationship.

Our own view is that mild compressions do not matter much, because they do not look too unnatural. The same is true of expansions, for that matter, where the subject brightness range is less than the print brightness range. Outside a very mild degree of compression or expansion, however, we find that the results can look unpleasant and awkward: compressions are often flat and dull, and expansions can look more like drawings than photographs, though they are often in fact more successful than are compressions.

If the subject brightness range is very much greater than can be captured one-for-one on the print, we therefore believe that it is generally better to let the shadows go dark, or to recover shadow detail by dodging and burning on the print, rather than to try to compress the whole range linearly.

We shall have a good deal more to say about this when we come to techniques of exposure, developing and printing, but it is worth emphasizing that there is no need to capture an enormous tonal range, just because it is possible. Nor, for that matter, is there any need to preserve

THE D/LOG E CURVE

The D/log E curve plots density (D) against the log-arithm of the exposure (log E) required to achieve that density; as already mentioned, density is nor-mally measured logarithmically anyway. As can be seen, it consists of a long, substantially straight portion (called, logically enough, the straight-line portion), and two portions where the curve is shallower, the toe and the shoulder.

While it is entirely possible for the slope (gamma) of the straight-line portion to be 1.0, so that an increase in log exposure of 0.30 gives an increase in density of 0.30, the slope of a real-world D/log E curve is typically between 0.55 and 0.70, or about 30 to 35 degrees: in other words, an increase in log exposure of 0.30 gives an increase in density of 0.165 to 0.210. Also, in a real-world D/log E curve, the 'straight-line' portion is not necessarily all that straight. Typically, it is a gentle S-shape, though modern mixed and multi-layer emulsions also mean that it may have bumps and hollows superimposed on the basic shape.

The density range which is needed to make a good print is much shorter than the overall density range of the negative, and it is possible to select a printable density range from just about anywhere on the curve. There is more about density ranges for printing in Chapters 12 and 13.

In general, the minimum possible exposure is desirable because it allows smaller apertures or faster shutter speeds, or both, and because less exposure means higher sharpness and (with conventional mono films) finer grain.

With 35mm, in particular, it is therefore normal to use a part of the toe of the curve, even though the tonal relationships between the subject and the negative are not the same here as they are on the straight-line portion.

With large formats, where grain and sharpness do not matter very much and where the camera is tripod-mounted anyway, it is entirely feasible to take the printable density range from further up the curve, ignoring the toe. Many people prefer the tonality which this allows.

Only very rarely is the shoulder of the curve of any relevance, because the densities here are much greater than the range normally used for printing. Normally, the only time that the shoulder is important is when you use a compensating developer, as described on page 112.

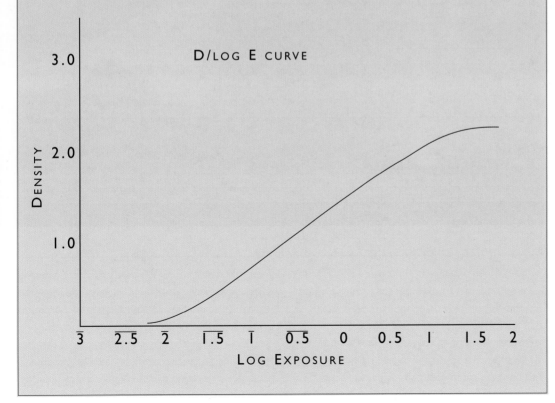

a 1:1 relationship between subject brightness and print tones. Photography as an art is a matter of interpretation, not of precise correspondences; and interpretation is a very important aspect of quality.

COLOUR

The most important thing to remember about the colours in a photograph is that they are not the true colours of the original subject: they are a re-creation. Indeed, they are not even a full re-creation: they merely look pretty much the same to the human eye. Most of us have had unpleasant experiences when trying to record two different colours on the same photograph: there

closer and closer to that of the human eye, but the two are unlikely ever to match perfectly.

All that one can hope for, therefore, is pleasing colour; the term 'accurate' colour is either so vague as to be all but meaningless, or so precise as to be unattainable. Even then, there is little or no agreement about what is 'pleasing', except perhaps that most people will prefer a picture which is warm or golden in tone to one which is cool or blue. When it comes to colour saturation, there is little doubt that the popular view is that more is better; but then, many people watch television with the colour turned up to a level which looks garish and poster-like to the eye of the photographer, who is more used to judging subtleties in colour photographs.

TUNNEL, FORT ST ANGELO, MALTA
Roger chose one of the most forgiving slide films on the market, Fuji Astia, to record this very long tonal range – but even then, the lower edge of the rock on the right merges with the shadows, and the edge of the side-tunnel could not take any more exposure. Colour negative film makes shots like this much easier.
'BABY' LINHOF TECHNIKA IV ON TRIPOD, 100/5.6 APO-SYMMAR ON 6X7CM.

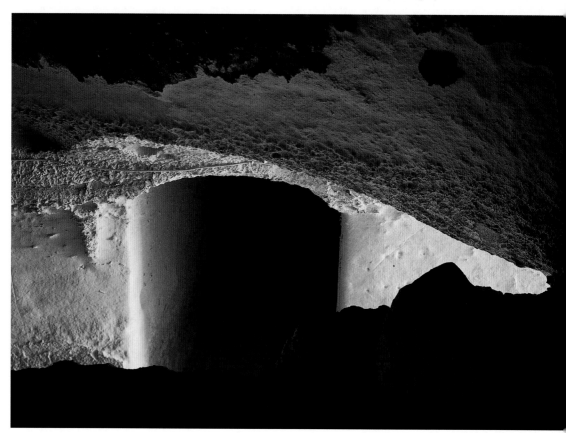

can be irremovable discrepancies when the print is directly compared with the original.

For that matter, photographs of pale blue flowers often have a tinge of pink in them. Attempting to filter out this pink, with a very weak cyan filter, simply does not work: colours go all over the place. This is a result of differences in response between the human eye and the film. Manufacturers bring the response of their films

There are clearly some subjects, or at least some interpretations of those subjects, which cry out for the brightest colours and deepest saturation possible. Other subjects and interpretations may demand desaturation and subtlety. The only thing that is possible, in the search for quality, is to try to match colour renditions both to the subject, and to a vision of the final picture.

QUALITY AND FORMAT

From what has gone before, there is little doubt that quality and format are intimately interrelated; but equally, a great deal depends on the form in which the final pictures are to appear. For photomechanical reproduction, except on the very finest glossy paper, or for pictures enlarged to half-page and above, there is little or no advantage in going larger than 35mm.

If every picture in this book had been shot on 35mm, it would not make much difference to the final quality, because the paper and the reproduction quality are a great leveller. The differences would certainly be apparent in double-page spreads, and they would probably be clear in single-page pictures; but at half-page and below, you would only be able to tell 35mm shots from roll film or even large format if the 35mm pictures had been shot on very fast film such as Ilford's Delta 3200, or from internal evidence such as the sort of perspective associated with very long lenses, which are not available for medium and large formats.

WATERFALL, CALIFORNIA
An extreme wide-angle lens – a 35/4.5 Apo-Grandagon on 6x9cm, about equivalent to a 15mm shift lens on 35mm – meant that Frances was so close to this little waterfall that her feet got wet. The big format, over five times the area of 35mm, allowed plenty of detail and excellent tonality. Note the slight loss of definition in the upper corners, a result of shifting the lens to its limit.
ALPA 12 SWA, ON TRIPOD, ILFORD HP5 PLUS.

Also, although years of practice mean that we are pretty good at shooting and printing for reproduction, there are still times when a print or transparency which we think will reproduce well, won't; and only very rarely is it feasible to re-make a picture so that it will reproduce better. When comparing original exhibition prints, the differences between enlargements from the various formats, and contact prints from the larger formats, are generally obvious; but you cannot do this in a book, where all you have is the printed page.

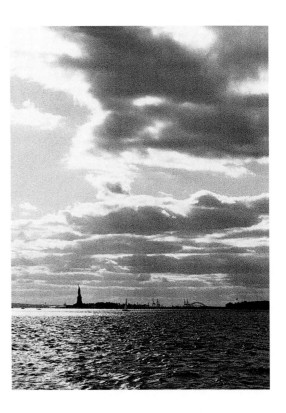

QUALITY AND IMAGE SIZE

Another very important point is that if you could see our exhibition prints, you would find that they vary quite widely in size, and that many of them are surprisingly small.

The size is partly a matter of practicality. We rarely print even 12x16in (30x40cm) for exhibition, because (like everyone else) we find it difficult to handle very large prints, and because the paper is expensive.

At least an equally important consideration, though, is that we prefer small prints. Even with roll-film, we seldom go larger than 11x14in because, at that size, we find it easy to preserve the kind of creamy tonality which we like in monochrome.

From 35mm, we may well make enlargements as small as 5x7in. An enlargement of this size from 35mm cannot have the tonality of a contact print from 5x7in, but it can still be remarkably good if we use slow films such as Paterson Acupan 200, Ilford Delta 100, or Maco Ort 25.

Almost paradoxically, we are more inclined to make bigger prints from faster films, where the grain structure is much clearer: we quite often make 11x14in prints from Ilford Delta 3200, and from Ilford SFX extended-red film. That way, we make a feature of the grain, rather than trying to conceal it (which we cannot).

For publication, we habitually print on 8x10in paper with a wide border, and by the time the pictures appear in the book, they have been sized by the designer so that even the smallest prints are rarely as large in reproduction as they would be in an exhibition. Occasionally they surprise us, and run a picture across a double-page spread, but this is normally blown up

from an 8x10in print or taken directly from a transparency; rarely if ever are we asked to make a larger print. But, as we say, it really doesn't matter very much at all, because the photo-mechanical reproduction process is a great leveller of quality anyway.

SUBTLETY

The differences between good prints and excellent prints are often very subtle. Sometimes, they will be clear enough, even though they are hard to put into words; at other times, many people will not even notice them, unless they are pointed out. Either way, they are quite often lost in reproduction. We have, therefore, run very few 'comparison' pictures in this book: where they exist, the differences should be very clear, such as one being in colour and the other in black and white, or one cropped and the other not, or people in different places. Generally, we have relied on captions to explain what we did that we think was clever – and then simply hoped that it will show on the printed page.

To a large extent, therefore, we must ask you to believe what we say, rather than what we show you, in this book. With all this in mind, it is time to go on to the logical first step in the search for quality, which is choosing a camera.

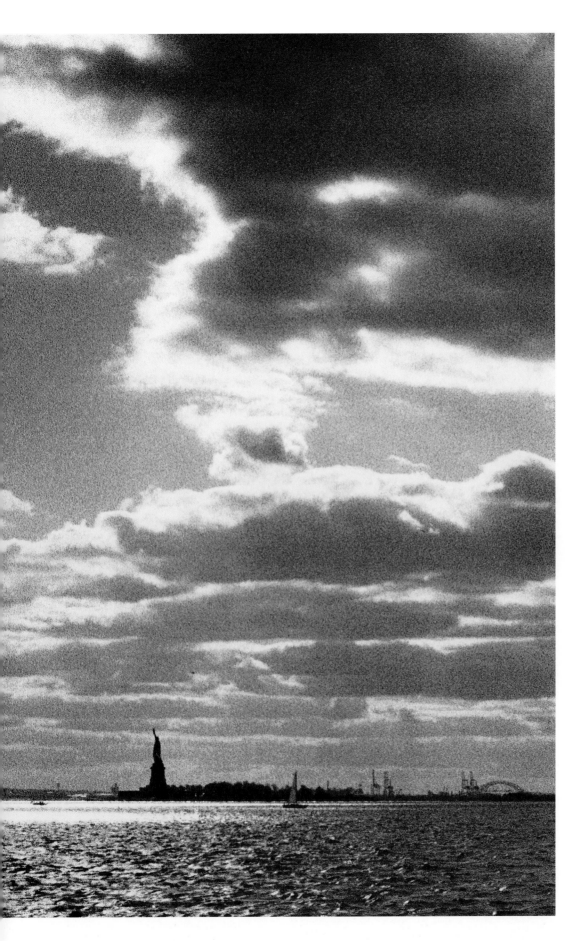

STATUE OF LIBERTY, USA
We forgot to to pack enough film for a long weekend in New York. On a Saturday, all the good (orthodox Jewish) camera stores are closed – so we cadged a couple of rolls of Forte 400 off the importer, Charlie Satter, at the show we were attending. The grain is nothing to write home about, but like its slower ISO 100 brother, it has a wonderfully vintage tonality. Burning in the sky made a real 1930s-style picture.
HAND-HELD NIKKORMAT FTN, 90/2.5 VIVITAR SERIES I MACRO. (FES)

CHAPTER THREE

CAMERAS AND QUALITY

To a very considerable extent, the 'digital revolution' is irrelevant to most photographers who seek the utmost quality. It is true that there are scanning backs which deliver exquisite quality, but they have three enormous drawbacks. The first is the cost, which is comparable with that of a modest car. The second is the way that they are tethered to large computer systems by substantial umbilical cables, pretty much restricting them to the studio. The third is the fact that they can only be used with stationary subjects, because an exposure takes many seconds or even several minutes.

Move down to the 'high-end' digital cameras, the ones with six-megapixel chips, and for many practical purposes, the quality is not too far below what is readily available from a 35mm transparency. Once again, you are looking at the price of a small car, or at least a very handsome motorcycle, and the quality will not be quite as good as you could get from a 1960s SLR

costing maybe one-hundredth as much. So-called 'megapixel' cameras, with imaging chips in the 1.5 to 2.3 megapixel range, deliver inferior quality to a good single-use camera, or a cheap compact; they can be ignored.

What, then, of the other great introduction of the 1990s, the Advanced Photo System? This, too, can safely be ignored. The film area is less than that of 35mm, and the lenses and emulsions are no sharper; the quality cannot, therefore, be as good as 35mm. No: for the best possible quality, the choice must be between 35mm, roll film, and large format. Each has its advantages.

THE STARTING POINT: 35MM

The advantages of 35mm need hardly be rehearsed. Because the format is so popular, the cameras and lenses are often extraordinarily good value. Film is readily available; cost per exposure is low; and processing is quick and easy.

BREAKING WAVE
It was a stormy day, and the waves were breaking dramatically. The only way to be sure of getting the picture you want with a subject like this is to guess when you think a wave is going to burst really high; shoot; and hope. With a reflex, which has a very long delay between pressing the release and taking the picture, you will need to shoot even more pictures than you will with a non-reflex like Roger's Leica M2; but either way, you are shooting 'for the percentages' and 35mm is quicker and a lot cheaper than larger formats.
CAMERA ON TRIPOD, 35/1.4 SUMMILUX, FUJI RA.

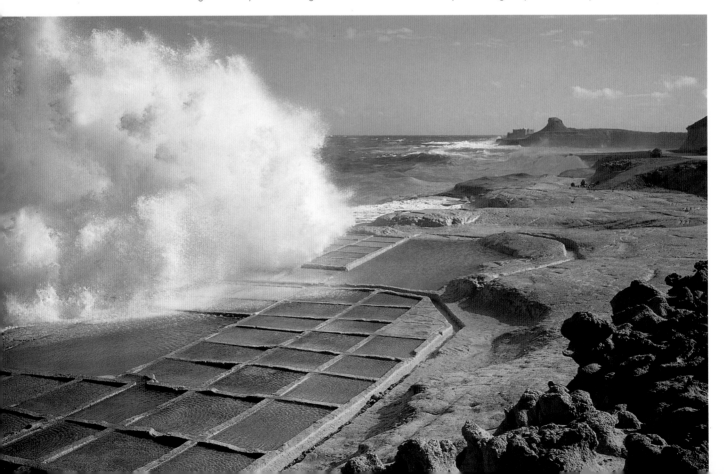

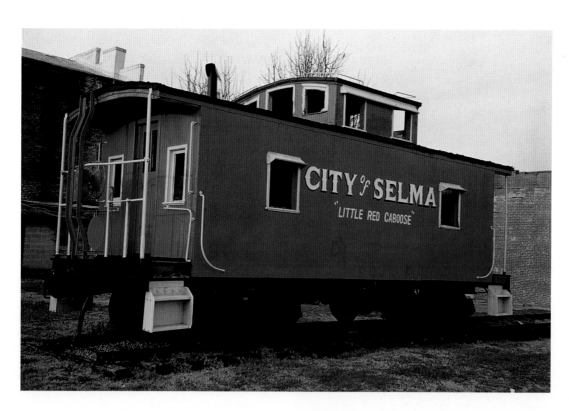

LITTLE RED CABOOSE
Frankly, this picture is not very sharp: it was shot with a zoom lens on a hand-held 35mm compact. But even at a 6x enlargement, which is the size of our original print, it doesn't matter much. The impact comes from the colours, and the sheer solidity of the subject. Shot with (say) an Alpa, the quality would have dominated the subject, and the picture would have been banal.
HAND-HELD 35MM COMPACT, SCOTCH COLOR 200. (FES)

On the other hand, the disadvantages are equally clear. Principally because of the half-tone effect (see page 22), you can never hope to get the same sort of quality as a larger format will deliver, and the very rapid handling of 35mm can discourage careful, considered photography.

It is possible, however, to use a 35mm camera on a tripod, as if it were a large-format camera, with slow films and fine-grain developers, and to get extraordinarily good quality. Provided your pictures are sharp and of high resolution, you can often get away with a modest amount of crisp, clear grain, at which point the half-tone effect becomes irrelevant.

It must be acknowledged, too, that there are many kinds of photography where 35mm is the only practicable format, or where it has so many advantages that you would need compelling reasons to switch away from it. If you need to use very long telephotos, then 35mm is your only logical choice. Ultra-fast films and ultra-fast lenses allow photography at lower light levels than any other format. If you are shooting 'for the percentages', as you often are in, for example, natural history or sports photography, then 36-exposure rolls of low-cost film are highly desirable. And there are times when big, bold grain is a positive advantage.

In other words, you should not be so blinded by the shortcomings of 35mm as to forget its advantages. If you want big, black and white exhibition prints with magical tonality, 35mm is not your best option; but this is not the only definition of 'quality'.

CHOOSING 35MM CAMERAS

There are two approaches to choosing a 35mm camera. Until a few months before we started to write this book, we had always clung to the first. Then we were lent a Contax outfit for review, and we switched to the other.

CANDLELIGHT VIGIL
For very low light photo-graphy, 35mm is often the best choice, because it offers the fastest films and the fastest lenses. If you want a longer-than-standard lens then 35mm is the only rational choice: depth-of-field problems are bad enough with 35mm, and longer exposure times would preclude hand-holding (as was done here) as well as introducing the risk of subject movement. This was shot on the tenth birthday of the Panchen Lama, the world's youngest political prisoner.
LEICA M4-P, 90/2 SUMMICRON, FUJI 1600 NEGATIVE FILM. (RWH)

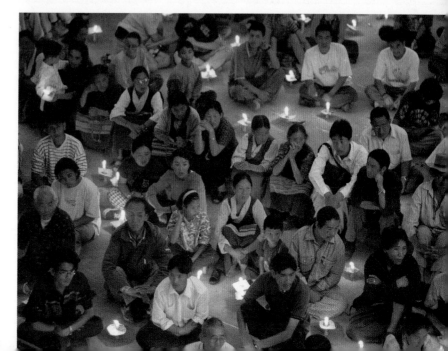

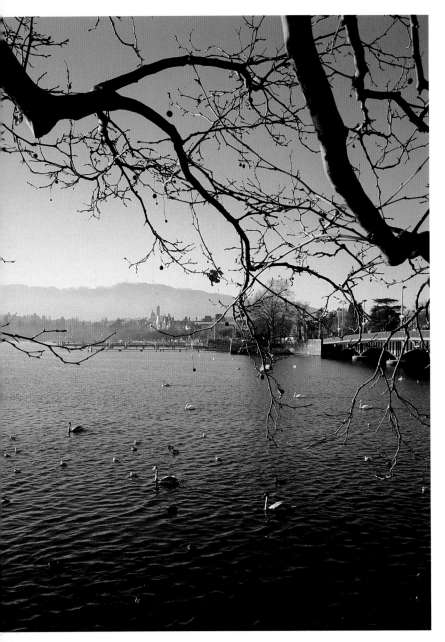

Leicas. The Nikons dated from the late 1960s; the Nikkormats, Nikon's second-string cameras, from the 1970s; and the Leicas are M-series range-finder cameras which first appeared in the 1950s, though we have two M2 cameras from the 1960s, and an M4-P from the 1980s.

Because Nikon's lens mounts have remained cross-compatible from 1959 to the present, and the M-series Leica's is unchanged since 1954 or so, immense numbers of first-class lenses are available for either. Among the simpler designs, lenses which are several decades old can be entirely satisfactory; and exotic new designs, such as Sigma's 14mm rectilinear-drawing wide-angle, are normally made available in Nikon fit from their introduction.

Although we have remained faithful to range-finder Leicas – actually, these are Roger's preferred cameras in 35mm – we have now switched to the second approach, which is to use the latest and the best; which, in our opinion, are unquestionably Contax reflexes.

We came to this conclusion for a variety of reasons. The original, and (as it turned out)

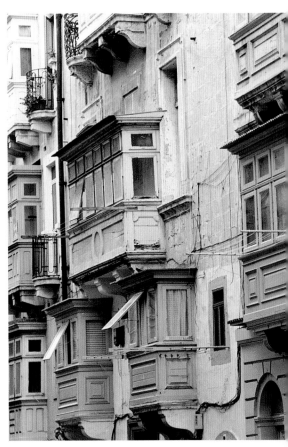

ZUERCHER ZEE
The 6x8cm format – actually 56x76mm, as espoused by Mamiya – deserves to be more popular, as it fits beautifully onto 8½x11in paper and allows a useful 9-on-120 instead of the 8-on-120 of 6x9cm. Next to 6x8cm, 6x7cm can look uncomfortably stubby, and 6x9cm looks too long and thin. The actual aspect ratios are 1:1.2 (most 6x7, 56x68mm), 1:1.3 (Linhof 6x7, 56x72mm), 1:1.4 (6x8cm) and 1:1.5 (6x9cm).
ALPA 12WA HAND-HELD, 58/5.6 SUPER ANGULON, KODAK EKTACHROME 100EPP. (RWH)

The first approach is a lot cheaper. It depends on the simple (and unanswerable) truth that a camera is essentially a dark box for holding film, with a hole in the front for holding lenses, and a shutter in between. As long as the film transport and shutter work; as long as the film and the lens flange are the right distance apart; and as long as you can fit good lenses on the front, then you need nothing more.

There are innumerable reliable cameras which meet all these criteria, many dating back to the 1960s and some even going back to the 1950s. We have already mentioned our Pentaxes, but in fact our main cameras were Nikons, Nikkormats and

actually the least pressing advantage, was that we wanted to try the focus confirmation system of the RX. We have yet to encounter any autofocus camera which could replace our old manual-focus machines: they are too big, too heavy, and too complicated, and they simply fail to focus too often, though the latest models are vastly superior to the earlier ones. But ageing eyes sometimes need help.

As soon as we started to use the Contaxes, a number of features commended themselves. Although the classical shutter speed range of 1 second to $\frac{1}{1000}$ second is adequate for the vast majority of applications, especially reportage, the extended range of the Contaxes (4 seconds to $\frac{1}{4000}$ second on the RX) can be useful in ultra-low light or with very fast films. Auto-bracketing, with a fast, built-in motor drive, is ideal for film testing or simply for trying different exposures. Unlike most other modern cameras we have tested, the Contaxes never throw us into strange program loops where we needed to read the instruction book to reset the camera: the controls are simple, logical, and self-evident.

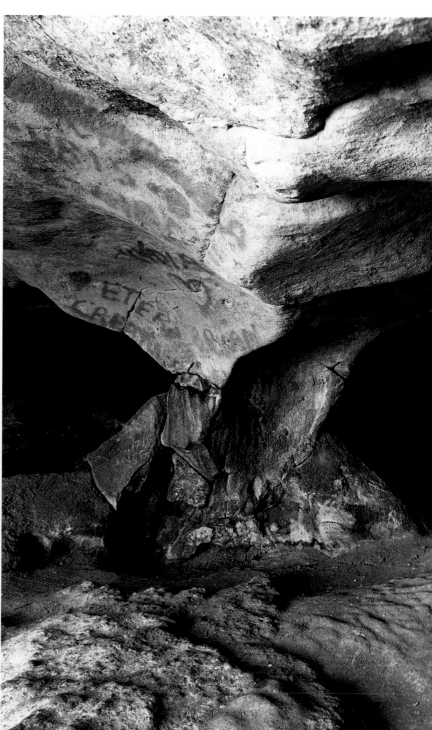

VALETTA
There are a few — a very few — medium-format cameras which would allow you to take grab shots like this, but even if you had one, you would be troubled by lack of both lens speed and depth of field. For these purposes, 35mm is a much better bet.
CONTAX ARIA HAND-HELD, 100/2.8 MAKRO-PLANAR, ILFORD XP2 SUPER. (FES)

▲ HASSAN'S CAVE
Use 35mm in the same way as you would use large format, and you may be amazed at the quality it can deliver. Frances used a 35/2.8 PC-Distagon on a Contax RX, tripod-mounted of course, and Ilford XP2 Super to record this cave (and, sadly, the graffiti in it).

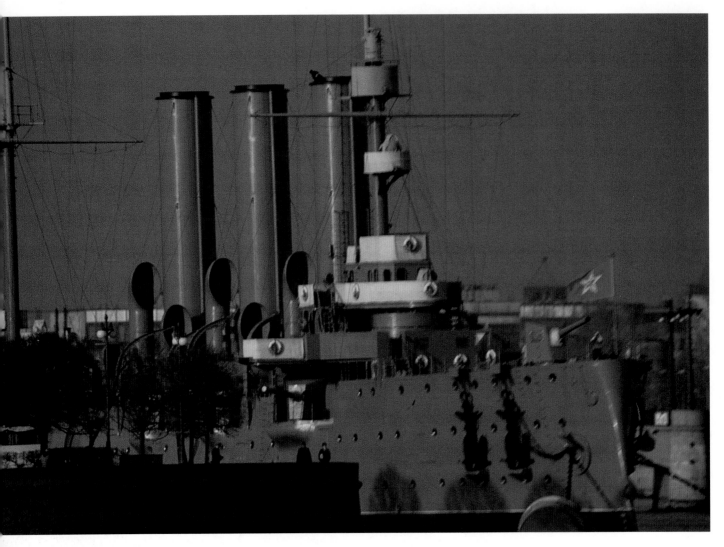

CRUISER AVRORA, SANKT PETERSBURG
If you want very long lenses – this was shot with an 800mm f/11 Vivitar 'Solid Cat' – then 35mm is the only choice: an equivalent lens on 6x7cm would be about 1700mm. On the other hand, the quality attainable with such lenses is often marginal, except under ideal conditions: this picture could be sharper, and it is redeemed only by the light and by the historical associations of this ship.
NIKON F ON TRIPOD, FUJI RF. (RWH)

And the cameras are reasonably light, they are also reasonably compact – the Aria is very compact – and ergonomic in layout.

Better yet, they are part of a full system which embraces both fully mechanical cameras (the S2, though this is now sadly discontinued) and an autofocus camera (the AX), though we have yet to find a use for the latter. No other high-end systems offered this sort of range; we have always had the uncomfortable feeling that we would be locking into a system which was designed by engineers who were more concerned with technological possibilities, rather than with what photographers actually wanted or needed. We were also worried about buying into a system which was here today, gone tomorrow; or where the lens mount might suddenly change; or where only autofocus lenses were available.

Best of all, the Contaxes' quality is second to none. Many of the Zeiss lenses are made in Japan,

though a few (such as the 35mm f/2.8 PC-Distagon) are still made in Germany. Regardless of where they are made, the quality of both bodies and lenses is superlative.

Having said all this, we have to acknowledge that once you are past the 'quality threshold' mentioned on page 8, the advantages of the latest and the best are not great, as compared with choice of materials and technique. In other words, if your budget is small, buy something like our old Nikons or Nikkormats, or even screw-fit Pentaxes. You will lose some versatility, and some convenience; but provided you stick with the right lenses, which are the subject of the next chapter, you will sacrifice little or nothing in the way of quality.

If you can afford it, on the other hand, the best cameras today will entail absolutely no loss of quality or versatility compared with the very best designs of the past, and will be a lot more

convenient to use. The assertion that 'they don't build 'em like they used to' is without foundation, provided you buy the right cameras. There is nothing wrong with using plastic on the outside of the camera – the Contax Aria is plastic clad – but a proper die-cast chassis (again as found in the Aria) will ensure the same sort of durability and precision as was customary in the best cameras of the past. What you don't want – though it is found in some cheap cameras – is a plastic chassis or – something which is at least as bad – a plastic lens mount.

Autofocus

In some areas, such as news photography, autofocus has swept the board. But quality never counted for much in news pictures, as evidenced by the rise of digital imaging. We are no longer so violently opposed to autofocus as once we were, but we still see no evidence of any advantage in autofocus for the vast majority of photography – indeed, for any photography where there is time to focus the lens – and we would suggest that often, autofocus delivers poorer quality than man-

MILLER
Shooting Delta 3200 in medium format gives similar grain, at a given enlargement size, as you would expect from shooting Delta 100 in 35mm. The great advantage is another 5 stops in speed, which allows you to stop down well for depth of field and to use a faster shutter speed to avoid camera shake.
ALPA 12 SWA ON TRIPOD, 35/4.5 APO-GRANDAGON ON 6X9CM. (FES)

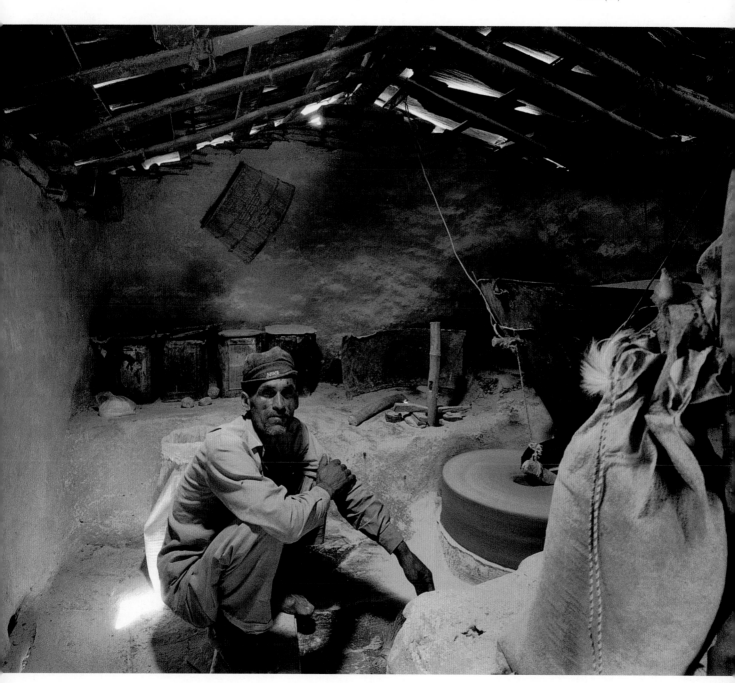

ual focus, because it discourages careful focusing and the use of depth-of-field scales.

THE COMPROMISE: ROLL FILM

To paint a caricature, roll film survives because professionals are lazy and penny-pinching. With a roll-film camera you can, with the minimum of effort, get the sort of quality which requires real energy and dedication with 35mm. You do not, however, run yourself into the kind of expense which is associated with 4x5in or still larger formats.

The numbers make it clear. Consider even the smallest 120 format, the so-called 645: 'so-called' because it is actually about 42x56mm. To make a 12x16in (30x40cm) blow-up from 645, you need an enlargement of just over 7x; an on-the-film resolution, sticking with our 8 lp/mm criterion (see page 19), of 56 lp/mm assuming a perfect enlarger lens, or maybe 60 to 65 lp/mm after allowing for losses during enlargement. This is no problem whatsoever, with a good camera and lens.

Admittedly, the half-tone effect may start to come in at as little as 8x10in(20x25cm), though by careful choice of film and developer you may be able to extend this to maybe 10x12in or larger. Alternatively, switch to a faster film – Ilford HP5 Plus is wonderful – and live with the grain at 12x16. What 645 does, as compared with 35mm, is tips the balance: quality is no longer anything like so hard to achieve.

Move up to the largest common 120 format, the so-called 6x7cm (typically 56x68mm to 56x72mm), and a 12x16in (30x40cm) enlargement is rather under 5.5x. You now need 5.5x8 = 44 lp/mm. Although it is harder to achieve high resolution over a larger area, both because of lens design constraints and because of reduced film flatness, it is still entirely feasible to achieve figures a good deal higher than 44 lp/mm. Also, although a 5.5x enlargement is around the size at which the half-tone effect may become apparent, it does not require much effort to suppress it: a slightly slower film, a fine-grain developer.

Among the other roll-film formats, the old

WAGON
Perhaps curiously, as noted in the text, we use more Delta 100 in 120 and 4x5in than we do in 35mm. Giving it a little more exposure and a little more development, in order to get the tonality we like, increases grain and reduces sharpness unacceptably in 35mm, but with the larger formats, the penalty is negligible.
ALPA 12WA, 38/4.5 BIOGON ON 44X66MM. (RWH)

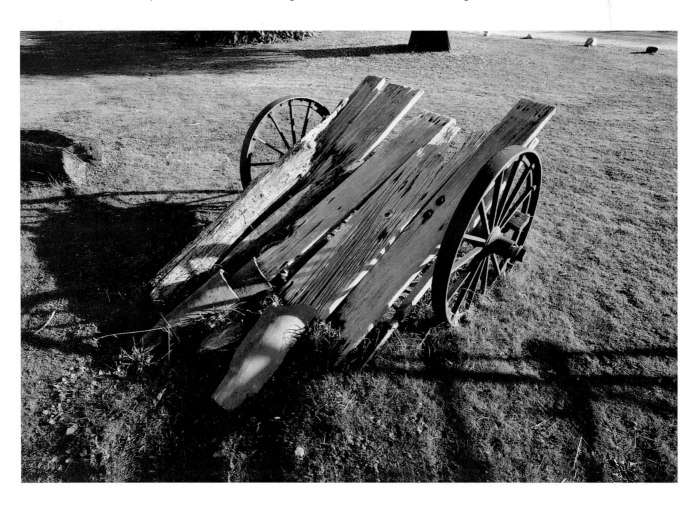

6x6cm format is effectively identical to 645 when it has been cropped to normal print sizes – though there are some people who like square prints – and the larger formats are only of use when you are dealing with relatively long, thin prints.

Fuji's 6x8cm fits very handily on to paper sized 8½x11in, requiring about a 3.7x enlargement instead of the 4x enlargement which is needed from 6x7cm, and 6x9cm requires the same enlargement on to 8½x11in paper (the short dimension of the negative is the limiting factor) but crops very nicely to make a panorama across the top three-quarters (or more) of an 8½x11in double-page spread: a 5x enlargement fills the width, and gives an image some 11in (28cm) deep, for what amounts to an 11x16.5in (28x42cm) print.

The advantages of still longer, thinner formats are disputable. They look impressive on the light table, and if your personal vision involves making long, thin pictures they are great; but film flatness is never as good as it can be for shorter formats, and the pictures often end up being enlarged to the same extent anyway. A double-page spread in an 8½x11in magazine is 5.3x off either 6x9cm or 6x12cm, because the short dimension (56mm) of the image is the determining factor. Reloading can become inconveniently frequent, too: 8-on (6x9cm) is not too bad, but 6-on (6x12cm) and 4-on (6x17cm) can be somewhat wearing. Although we own a 6x12cm back, we increasingly often crop 6x9cm or even 6x7cm instead.

Finally, the unique Alpa 44x66mm format, which is masked down from 6x7cm, was conceived as a way to get the best from the legendary 38mm f/4.5 Zeiss Biogon. This lens has an image circle of only 80mm, and is best known on the 6x6cm (56x56mm) Hasselblad format, which has an area of 3136sq mm, 8 per cent larger than the Alpa's

NIKON STAND
The 38/4.5 Zeiss Biogon is justly a legendary lens. On the 44x66mm format, it is almost exactly equivalent to 20mm on 35mm, and with Delta 3200 it makes a very interesting reportage lens indeed. This was at the Photo Marketing Association Convention in Las Vegas; the sculpture is entirely of sand.
ALPA 12 WA HAND-HELD.
(RWH)

2904sq mm. But print on to 8½x11in paper, and you can use 2738sq mm of the Alpa format, as against 2218sq mm of the Hasselblad format, an effective increase in area of well over 20 per cent, or an enlargement ratio of 4.8x instead of 5.3x.

CHOOSING ROLL-FILM CAMERAS

The biggest single choice is format, and we have covered several of the arguments for the different formats above. If you shoot colour, there is little reason to go beyond 645 unless you habitually make enlargements bigger than 12x16in (30x40cm), and even at 16x20in (40x50cm), a good 645 camera should deliver superb quality. In black and white, there is more to be said for the larger formats, largely because of the half-tone effect.

If you are shooting colour transparency, a point worth remembering is that 645 gives you five sets of bracketed pictures; 6x6cm gives you four; 6x7cm gives you three, plus a spare for mistakes; 6x8cm will give you three again; 6x9cm gives you two, and two spares; and 6x12 cm gives you two

sets with no spares. If you go to 6x17cm, you have just four shots per roll of 120: one set of brackets, and a spare.

Another point worth remembering is that all medium-format enlargers will cover 645, and all modern ones will cover 6x7cm; but surprisingly many will not cover even 6x8cm, let alone 6x9cm. At 6x12cm, you need a 4x5in enlarger, and at 6x17cm, you need a 5x7in enlarger.

Once you have picked your format, you have a choice of three types of camera: SLR, direct vision, and technical or monorail. Although SLR cameras may seem the automatic choice, remember our cynical remarks about professionals: these cameras are designed to give good results, easily. This is not the same as saying that they will give the best possible results for all kinds of photography.

Among direct-vision cameras, there is an increasing polarization of the market into automatic 'point and shoot' cameras, and ultra-high-quality, fully manual versions. The former are, in effect,

CHURCH AND TREE
If you are going to shoot medium format with great depth of field, you need either a tripod or a fast film. In this hand-held shot, depth of field is adequate, but camera shake has taken the ultimate edge off sharpness, despite using Ilford HP5 Plus. Another advantage of using a tripod would have been that it would have made it easier to level the camera: the strongly angled tree is deceptive, and the church leans slightly to the left in the negative.
ALPA 12 SWA, 35/4.5 APO-GRANDAGON ON 6X9CM CROPPED ALMOST SQUARE. (FES)

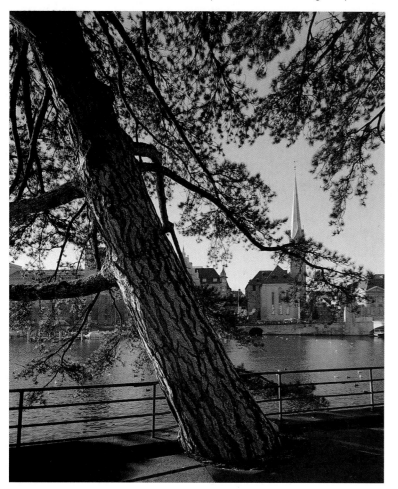

economical 120 film. This is especially true in the sphere of architectural photography.

Another possibility is to use roll-film backs on 4x5in cameras. These are bulkier and less convenient than purpose-built 'baby' technical cameras, but there is a wider choice of cameras both new and used, and prices are often lower than for 'baby' models which historically were made in smaller numbers.

Regardless of type, the important thing is to choose a camera which you like: unlike 35mm cameras, which are often indistinguishable from one another, MF cameras differ widely. All modern roll-film cameras, and most professional roll-film cameras made since the 1950s, can deliver all the quality you need and will last half-way to forever. They are not just a good compromise for professionals: they can be ideal for amateurs too.

THE ULTIMATE: LARGE FORMAT

Large format (LF) is fun, and delivers superb quality. Professional use of LF is declining, but 'fine art' and amateur use is increasing, so it is very relevant to our thesis here. The main points are that it is probably cheaper than you think; that it may well be easier than you think; that camera movements are wonderfully convenient; and that tonality, rather than sharpness, is the main advantage of LF.

◄ VIDEO GAME, DOVER DOCKS

This was one of our first shots on 120 Delta 3200, rating it at EI 6400, using an almost completely unsuitable camera (a 'baby' Linhof Super Technika IV with a 100/3.5 Xenar on 6x7cm). We were so impressed, however, that we bought a Graflex XL with a rangefinder-coupled 80/2.8 lens and a big, bright viewfinder, principally to use with this film.
(FES – Roger is in shot)

WALKER TITAN
If you look closely, you can see that the front is swung about the vertical axis, as well as tilted about the horizontal axis, and the back is swung though not tilted. The front is also raised (vertical shift). 'Movements' such as these allow enormous control of image sharpness and shape, and generous bellows extension allows extreme close-ups, or the use of quite long lenses.

bigger versions of 35mm compacts, and the bigger image means better quality; but the latter are *sui generis* and deliver superb quality, often among the finest you can imagine. We use Alpas extensively, and we also have (old) Linhofs and a Graflex XL. Some of these cameras have some movements – Alpas and Horseman 6x12cm cameras are available with and without a rising front, for perspective control – and others, like our old Linhof Super Technika IV, can be used either hand-held as direct-vision cameras or on a tripod as technical cameras.

'Baby' technical and monorail cameras have the kind of movements that are discussed below for large-format cameras and once again can deliver astonishingly good quality, along with the advantage of control of image shape. More and more professionals are changing down from 4x5in to 6x7cm or 6x9cm technical cameras, which deliver all the quality they need but are quicker and easier to use, and run on

COST OF CAMERAS AND FILM

New LF cameras and lenses are undeniably expensive, though they are no more expensive than new top-end 35mm equipment or professional MF cameras, and they can be a lot cheaper, especially if you start buying shift lenses – and remember that with LF, almost all lenses are shift lenses. On the used market, there are incredible bargains to be had: the price of a new, mid-range SLR outfit will buy you a complete, used 4x5in outfit, with two or three lenses.

And although film costs more per exposure than 35mm or MF, you make far fewer exposures. It is quite easy to shoot half a dozen rolls of 35mm in a day, but with large format, half a dozen shots would represent a good day's work for many people. This is a quarter of a 25-sheet box of film. Even in 8x10in, where a box of film costs the same as 15 to 20 rolls of 35mm, half a dozen sheets equates to less than five rolls of film. In 5x7in, it costs about the same as a couple of rolls, and at 4x5in, it is comparable with one roll.

EASE OF USE

When Frances first started to use LF, she said, 'These are cameras for lazy people!' It is true that there are no interlocks and no idiot-proofing, so that you have to remember to cock the shutter

CHECKLIST FOR OPERATING LARGE-FORMAT CAMERAS

1. Open shutter; set lens to maximum aperture.
2. Focus and compose, using movements as necessary.
3. Close shutter; set to working aperture; check shutter cocked.
4. Insert film-holder; remove dark-slide.
5. Take picture.
6. Replace dark-slide, black side out (to denote exposed film).
7. (optional) Open shutter and re-check picture on ground glass.

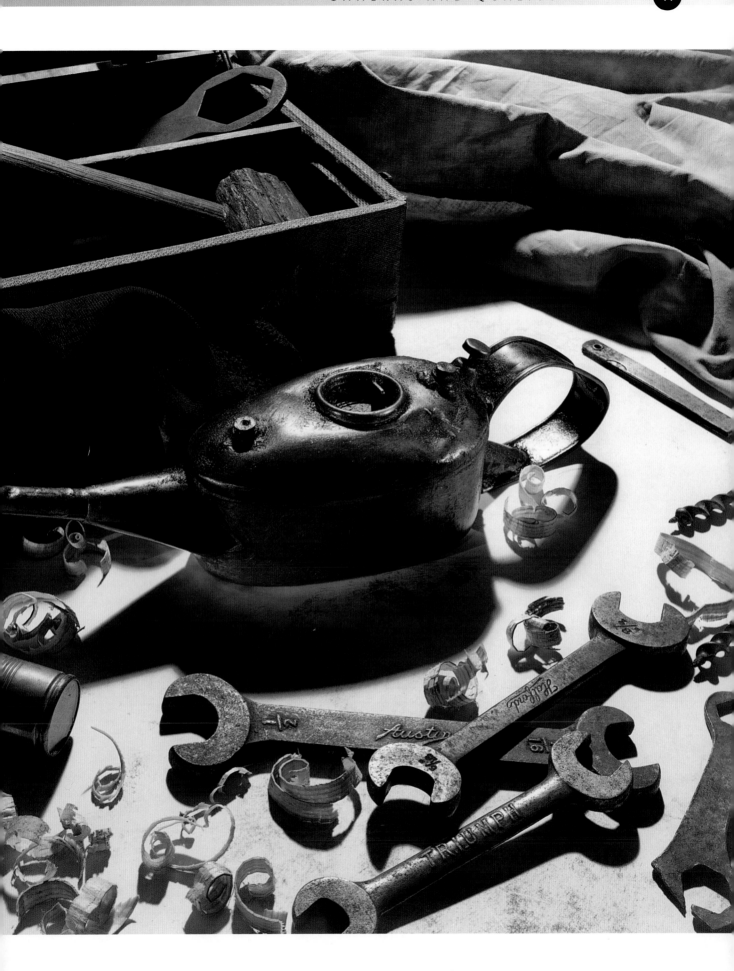

and close the lens and remove and replace the dark-slide and so forth, but to begin with, you can use a checklist (see panel on previous page), and after a while, it all becomes pretty much second nature. The great thing about LF is that you put the camera on a tripod; use the movements to get precisely the image you want; scan the big, beautiful ground-glass; and take the picture when you are good and ready. This whole process of slowing down is invaluable in many sorts of photography, especially still lifes, architecture and landscapes.

MOVEMENTS

Camera movements are arguably the biggest single reason (including tonality) for considering LF. They fall into two groups: shifts, where the lens panel moves parallel with the film; and swings and tilts, where parallelism is destroyed.

Shifts are (reasonably) familiar to the 35mm user in the guise of 'shift' or 'PC' lenses. Rather than tilting the camera backwards, resulting in the familiar 'falling over backwards' effect, you can move just the lens upwards, and keep verticals parallel. This is 'rise' or 'vertical shift'. In the studio, you may have the opposite problem: when you are looking down on your subject, verticals splay outwards instead of tilting inwards. In that case, you need 'fall', which is like 'rise' only downwards.

You can also use 'horizontal shift' to achieve a similar effect horizontally. In English, where 'rise/fall' are applied to vertical shift, horizontal shift is usually called 'cross' or just 'shift'.

Tilts are typically used to hold a receding plane in focus. A moment's thought will reveal that if you are trying to focus on something which is close to the camera at one end, and further away from the camera at the other end, the part which is closer will need different focusing from the side that is further away. Tilts allow you to do exactly this. If you are focusing, for example, on a table, then the lens–film distance for the lower part of the camera will need to be shorter than the lens–film distance for the upper part. Remember, the image is upside-down, so the nearer part of the subject, which requires more extension, will be at the top, and the part that is further away, which requires less extension, will be at the bottom.

Swings are exactly the same thing as tilts, but in a vertical plane. If you wanted to hold a receding wall in focus, you would use the swing.

Many cameras have shifts, swings and tilts both at the front and at the back. Often it does not matter whether you use front or rear shifts, but with extreme close-ups, a front shift moves the lens and therefore the apparent viewpoint, while a rear shift leaves the viewpoint the same, but changes the apparent perspective. With swings and tilts, front movements change sharpness but not image shape, while rear movements change both.

By using front and rear tilts (or swings) together, you can achieve 'indirect' movements, which increase your effective rise or fall. This is easily grasped as soon as you see a diagram.

SCHEIMPFLUG RULE
When the subject plane, the image plane, and the plane of the lens panel all coincide at a single line, then everything will be in focus, even at full aperture. Of course, with smaller formats, it is often enough merely to stop down.

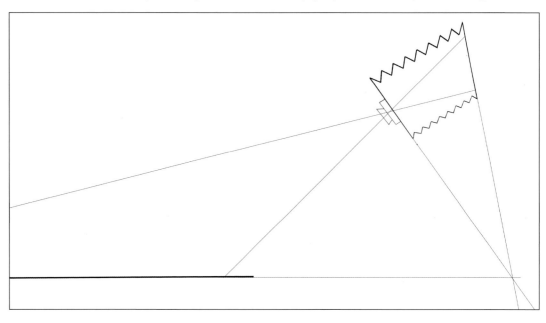

INDIRECT MOVEMENT
By tilting both the front standard and the rear standard, as shown here, it is possible to get considerably more rise than is available at the front standard.

A very important point about movements is that shifts, in particular, can result in strange-looking perspectives if carried to extremes. It is almost always better, if at all possible, to use a tall tripod and minimal shift from a higher viewpoint, rather than a shorter tripod and more shift from a lower viewpoint.

TONALITY AND SHARPNESS

A 12x16in (30x40cm) print is little more than a 3x enlargement off 4x5in (there is a small negative rebate, which takes the actual image size down from the nominal size), and the half-tone effect is simply not going to be visible at this size, or even at 16x20in (40x50cm), which is just over 4x.

Although modern lenses can often resolve 80 lp/mm centrally, and at least 60 lp/mm at the edge, older lenses may fall to 48 lp/mm or less and in any case, on-the-film resolution is limited by film flatness and by discrepancies in film plane register. This is why tonality is the big reason for using LF; resolution is likely only to be marginally better than from a high-quality roll-film camera enlarged to the same size.

CHOOSING LARGE-FORMAT CAMERAS

Probably the most important point about choosing large-format cameras is that you need one which suits you personally. At the end of the twentieth century there were over 30 manufacturers of large-format cameras worldwide, many of whom made a bewildering range of models in a variety of formats, so there is no shortage of choice.

Buying an LF camera is more like buying clothes than buying an appliance, and most (though not all) manufacturers will actually steer you away from their products if they believe that you would not be happy with them: better to lose a sale, they feel, than to gain an unhappy customer.

Another important point is that it is important not to get caught up in 'specmanship'. An inevitable temptation among novices is to buy a camera with the maximum possible movements, just in case you need them. In practice, unless you have very specialist requirements, just about any large-format camera will do just about anything that you need.

You can buy old LF cameras with confidence, subject to three conditions. One is that they should be in working order: there should be no juddering, stickiness or play in either movements or focusing, though cleaning and lubrication can work wonders. The second is that the camera should be adequately rigid. Most large-format cameras will flex if you push hard enough, but as long as they flex back to the same place as they started, this does not matter. It is only if they slop from one position to another, and stay there, that you need to worry. The third thing to look out for is that the bellows should be whole, with no pinholes; the easy way to check is to put a powerful torch (flashlight) inside the bellows in a darkened room, and look out for the tell-tale spots of light. It is not, however, particularly difficult to replace bellows, which are readily available from a number of suppliers.

WHICH FORMAT IS BEST FOR YOU?

The conclusions are not hard to draw. For ultimate quality in monochrome, LF is impossible to beat. In colour, it is a toss-up between LF and roll film, and the larger roll-film formats can (with minimal effort) deliver excellent quality in monochrome as well.

If you want to use 35mm – and we do – then you are going to have to work slightly harder at getting the finest possible quality, especially in monochrome if you want really 'creamy' tonality, but it can be done, especially if you are prepared to keep your enlargement sizes down; which, as we have repeatedly suggested, is not necessarily a bad idea.

CHAPTER FOUR

LENSES

When it comes to choosing a lens, a lot depends on what you want the lens for, and even more depends on how you use it.

For 8x10in portraits in black and white, especially with ortho film, we occasionally use a 21in (533mm) f/8 Ross that is well over a century old. It still works perfectly well. It is uncoated, and the glass is no longer flawlessly clean, but a little extra development gives perfectly adequate contrast for contact prints.

At the other extreme, we can actually see an extra 'sparkle' in pictures taken with Zeiss and Leica lenses in 35mm and 120 – though in all fairness, numerous manufacturers are well above the 'quality threshold' described on page 8.

There are, however, plenty of bad lenses around, from a wide variety of manufacturers. Most bad prime lenses are now quite old, and are principally of historical interest: even Zeiss Tessars are somewhat overrated, except the f/6.3 versions. But there is absolutely no shortage of bad zooms, old or new.

This is not the same as saying that all zooms are bad. Indeed, more and more zooms are astonishingly good. There are three main reasons for the bad ones, though. They may be built down to a price, because people won't pay more. They

YAK BROOCHES
Although many medium-format cameras, and most large-format cameras, allow you to focus very close indeed, there is no doubt that using 35mm with a macro lens such as the 100/2.8 Makro Planar is quicker, easier, more convenient and entails less prolonged exposures because the image is not enlarged so much on the film. Unless you know the picture will be grossly enlarged, 35mm and a sharp, fine-grain colour film (this is Fuji Velvia) is the way to go.
CONTAX RX ON TRIPOD. (FES)

TREASURE ISLAND, LAS VEGAS
Arguably, you can learn more by choosing a lens – any lens – and working exclusively with that for several rolls, than you will ever learn if you are constantly chopping and changing: you concentrate on taking pictures, rather than on deciding which lens to use. Roger uses a 38mm Biogon with an Alpa 12 WA and a 44x66mm back: although this is the equivalent of 20mm on 35mm, it is surprising how fast you can adapt to it as a 'standard' or 'universal' lens.
CAMERA HAND-HELD, FUJI ASTIA.

may be built down to a size and weight, because people don't want to carry anything bigger or heavier. And they may, principally for advertising purposes, be 'stretched' to a specification which they cannot support: typically, too long a zoom range, or too fast a maximum aperture. Even quite expensive zoom lenses, costing as much as a medium- to high-range SLR body, may well suffer from the third problem, and there are plenty of lenses which suffer from all three.

The consequences are all too obvious:

resolution is low, contrast is low, sharpness is low. Whenever we see a picture with one or more of these faults in a photo magazine, we check the technical data. Where it is given, we almost invariably find that the shot was made with a zoom. Even the very best zooms cannot quite compete with the best prime lenses, and anything less than the best zooms is not really worth bothering with.

Among prime lenses, there are three things to consider. The first is that newer lens designs tend, if they come from the same manufacturer, to be better than old designs. The second is that the gap between good and bad lenses was a lot wider in the past, so that a good lens from the 1970s or even the 1960s may well compare very favourably with its modern counterpart, while a poor lens of the same vintage may barely be fit to use as a paperweight. The third is that some lenses are much easier to design and build than others, so that if you stick with modest speeds and modest apertures, and eschew ultra-wides, you can find some astonishingly good lenses, astonishingly cheaply, on the second-hand market.

CHEAP QUALITY

If you want cheap, high-quality lenses for 35mm cameras, look for 'standard' lenses (around 50mm) and 'short tele' lenses (typically 85mm to 105mm). Look too for modest apertures: f/1.8 or f/2 for 'standard', f/1.8 to f/2.8 for the short teles. There are exceptions, but these lenses will generally offer very high quality at very modest prices.

In roll film, the same arguments apply, *mutatis mutandis*. Now, you are looking for lenses in the 80mm to 150mm range, typically f/2.8 and f/3.5. And with cut film, just about any coated lens made since World War II is likely to be very good for monochrome, though in colour especially, older lenses may well lack the contrast and 'sparkle' which you find with the latest and best multi-coated lenses.

The lenses to avoid, in all formats, are old wide-angles. There are exceptions, but they tend to be only from the very highest-quality makers: Zeiss Biogons from as far back as the 1950s, for example, are still astonishingly good. But even among new wide-angles, you need to avoid some of the cheaper offerings, especially for 35mm cameras.

◄ **TREES, CALIFORNIA**
*These two pictures
were taken within seconds
of one another, with
two different lenses on two
different formats. The one
Roger took with the 38/4.5
Biogon (on an Alpa WA,
44x66mm) exhibits much
less flare than the one
Frances took with the
35/4.5 Apo-Grandagon (on
Alpa SWA, 6x9cm). At least
in part, this is because the
Biogon is a simpler design:
the image circle of the Apo
Grandagon is around
50 per cent greater, with
a focal length almost
10 per cent less.*

MONTREUIL-SUR-MER
The overall flatness and blue tinge of this picture is typical of what you can expect from older lenses – even first-class older lenses such as a Linhof-selected 105/3.5 Xenar on a (tripod-mounted) 'baby' Super Technika IV. You can do a certain amount with an 81C or 81EF filter and a higher-saturation film, but in colour, a newer lens such as a 100/5.6 Apo-Symmar is easier. In monochrome, older lenses present fewer problems. On the other hand, Frances, who shot this picture, maintains that it is exactly what she visualized.
KODAK VPS 6X7CM. (FES)

LENSES AND MAGIC

There is no doubt about it: some lenses have a certain 'magic' which is not really quantifiable. One of the most astonishing is the 38/4.5 Zeiss Biogon on Roger's Alpa. Two more Zeiss examples are the 35m/2.8 Zeiss PC-Distagon and the 100/2.8 Makro Planar on Frances's Contax. Yet another is the 210mm f/5.6 Rodenstock Apo Sironar which we use on various 4x5in cameras. 'Magic' combines contrast, resolution, tonality and more.

Although all of these lenses seem to be 'magic' with all films, there are others which may be 'magic' in black and white, but are less so in colour. There are quite a lot more of these, and they include a number of older lenses from the 1960s and even earlier. A few examples include the 58mm f/1.4 Nikkor which we wish we had never sold; our 65mm and 120mm f/6.8 Angulons; and our 85mm f/1.9 Super-Takumar, which cost us next to nothing.

LENS COATING

Today, when all lenses are coated, there is little need for an in-depth discussion of the concept. It is, however, worth pointing out that the big difference is between uncoated lenses and plain coating; multi-coating matters mainly with exotic glasses, deep curves, or lenses with numerous

CALCULATING REFLECTIVITY

The formula for the light reflected from a normal ray (that is, one that is perpendicular to the glass surface) is

$$\text{Reflected light} = \frac{(1-x)^2}{(1+x)^2} \times 100 \text{ per cent}$$

where x is the ratio of the refractive indices. The refractive index of air is 1.

The perfect coating would itself have a refractive index equal to the square root of the refractive index of the glass. This is very hard to achieve, but the most usual traditional coating material, magnesium fluoride (MgF), has a refractive index of 1.39. This would work perfectly on glass with a refractive index of 1.93, which is higher than any normal optical glass, but it still provides very useful suppression of reflections with other glasses, as the following table shows:

Refractive index of glass	Reflectivity (per cent) for uncoated surface	Reflectivity for single-coated (MgF) surface
1.5	4.00	1.40
1.6	5.34	0.74
1.7	6.72	0.31
1.8	8.14	0.10

Happily, the maximum effect occurs exactly where it is needed, with glasses of high refractive index: reflectivity of a glass with a refractive index of 1.5 is reduced by about 65 per cent, but with a refractive index of 1.8, it is reduced about 99 per cent.

air-spaced elements, and it is more important in colour than in black and white.

The reflection at a glass/air surface depends on the refractive index of the glass: the higher the refractive index, the greater the reflectivity.

Coating works in two ways. The first is by providing a thin film of lower refractive index than the glass. That way, although you get two reflections (one at the air/coating interface, one at the coating/glass interface), the sum of the two is much less than the single reflection would be at a glass/air interface.

The other way it works is by being one-quarter of the thickness of the wavelength of light. This means that as the light is reflected back out, 'interference' takes place and the reflection is suppressed.

A single coating can only suppress reflections for a single wavelength. So as to suppress additional wavelengths, it is possible to stack coatings of different materials; this is 'multi-coating', the

ROAD AND TRUCK
To a considerable extent, lens sharpness is a snare and a delusion in black and white, because it encourages us to blow images up more than they can stand – the limit, as discussed on page 22, normally being set by the half-tone effect. Even so, there is no such thing as too much sharpness; when the wonderfully vintage-looking truck on the left of the overall picture is blown up, the loss of quality in itself adds to the vintage appearance.
LEICA M4-P HAND-HELD, 90/2 SUMMICRON, ILFORD XP2 ON ILFORD MG IV WARMTONE IN AGFA NEUTOL WA. (RWH)

OLIVE PRESS, RABAT, GOZO

It may seem perverse to use an ultra-fast film (Ilford Delta 3200, at EI 3200) with a 35mm camera on a tripod; but given the need for considerable depth of field (with the 35/2.8 PC-Distagon well stopped down), and the very dim light, this allowed a 2-second exposure at f/11 instead of the full minute which would have been required with Delta 100, or even the 15 seconds which would have been needed with HP5 Plus.
CONTAX ARIA. (FES)

Indeed, many people (including us, as already noted) use very old uncoated lenses, especially on large format.

COATING AND FLARE

The most obvious variety of flare is the brightly coloured patches of light caused by internal reflections off the lens elements, most usually of the lens diaphragm; but more insidious, and arguably more important, is veiling flare.

This is light which bounces around between the lens elements, and inside the body of the camera. Some of it is reflected back out of the lens; some is absorbed by the baffles and blacking inside the camera and lens; and some ends up on the film, where it gives falsely high shadow densities. The 'flare factor' is the ratio of this enhanced shadow brightness to the shadow brightness which would exist in a perfect lens/camera combination (with no flare).

It cannot be assigned a single constant value, because it depends on the distribution of the light and dark areas in the original image; on the number of glass/air surfaces; on the coating; and (which is often forgotten) on the camera in use. Very roughly, an uncoated lens in a 1930s roll-film camera might have had a flare factor of 4; a 1960s single-coated standard lens in a typical SLR of the period might have had a flare factor of 2 or less; and a modern multi-coated lens in a well-blacked large-format camera can have a flare factor which closely approaches unity, that is, no flare at all.

COATING, FLARE AND COLOUR BALANCE

Because coating has a detectable colour of its own – typically straw or purple for single coating, or green for multiple coating – it inevitably affects the colour of the image. This matters very little in black and white, but with colour film, there are two things worth noting. One is that colour balance may be 'fine tuned' by choosing the appropriate colour of coating: even 'multi-coated' lenses often have some elements which are only single-coated, partly for this reason. The other is that different manufacturers' lenses may have slightly different colour balances, though this is also influenced by the glasses used. Historically,

first experiments in which date back to Germany during World War II. The first production lens to have been multi-coated seems to have been the Leitz 35mm f/1.4 Summilux in the 1950s.

With simple lens designs, the benefits of multiple coating are much less than they are with complex multi-element lenses, or with lenses incorporating elements with very deep curves. Although even a simple lens (such as the Rodenstock Geronar, an air-spaced triplet) will benefit from multi-coating, single coating is perfectly adequate, especially in black and white, and a sufficiently simple lens design can give quite adequate performance without any coating at all.

Japanese lenses have been 'warmer' (more yellow) than German, though this may be as much a consequence of glass impurities as of coating.

Regardless of the colour of the coating, the colour of veiling flare (as described above) is typically blue out of doors, because it takes its colour from the sky, and reddish (for tungsten) or greenish (for fluorescents) indoors. These colour shifts can be controlled with the appropriate filters: an 81-series out of doors, and very weak blue or magenta filters indoors, though indoor lighting is usually much less of a problem. With the appropriate filter, lenses which are flat and blue when used out of doors with colour will not only lose their blue cast; they are quite likely, in most cases, to appear to increase quite significantly in contrast.

GETTING THE BEST FROM A LENS

Regardless of the lens you use, there are several things you can do in order to get the best possible quality from it. One is to use it on a tripod, and another is to use a lens shade. There is more about these indispensable accessories in Chapter 5. There are three other things which concern us here. One is choosing the right focal length; the second is using it at the right distance; and the third is using the lens at its optimum aperture.

Choosing the right focal length may sound like an odd consideration. Surely, the right focal length is the one which covers the right field of view? Well, yes, except that you can often cover the same field of view with a longer focal length, by moving further away, or a shorter focal length, by coming closer. Unless you use a very high-quality wide-angle, it will deliver inferior quality to what you would get with a less extreme lens, and with any very long lens, there is a greater risk of image degradation as a result of vibration, atmospheric haze or even atmospheric movement. We got rid of our 1200mm lens because atmospheric shimmer was clearly visible in the viewfinder except early in the morning on cool days.

Likewise, choosing the right distance may seem odd, but it is important to remember that lenses are optimized for different focusing distances. A typical, average sort of optimization will be anything from 25 focal lengths (2m/6ft 7in for an 80mm lens) to 'infinity', which may in turn range

from 20m (60–70ft) to 100m (330ft).

Most lenses perform very well across a far wider focusing range than that for which they are optimized, but some deteriorate quite markedly, especially when they are focused very close. The 'magic' 58mm f/1.4 Nikkor mentioned above, for example, suffered from severe curvature of field when focused close, so that it was impossible to hold both the centre and the edges of an image in

ROPE WORKS, CHATHAM DOCKYARD
Extreme wide-angle lenses – this is a 14/2.8 Tamron – require care in both levelling and composition if they are to be used successfully. Once you start to use them, however, it is all too easy to become addicted to them.
CANON EOS 5 ON TRIPOD, ILFORD DELTA 3200. (FES)

focus at the same time. Other lenses may have more or less chromatic aberration, or more or less distortion, at different distances.

For even quite modest close-ups, you will often do best to use a specially computed 'macro' lens. Not only will this give better sharpness and field flatness in the close-up range: it will normally be a slightly slower-than-average design, so that the correction remains excellent even at longer distances. The 100mm Makro-Planar for the Contax, for example, is an f/2.8 where a conventional (non-macro) lens of similar complexity would more likely be an f/1.8 or an f/2. The extra complexity is put into maintaining maximum quality across the largest possible focusing range, rather than into maximum speed at more normal focusing distances.

On the other hand, with large-format lenses, you may be surprised at how well 'process' lenses can perform in general photography: we use a 14in (356mm) f/9 process lens all the time, for formats up to 8x10in, though there is not much movement available on this format. These lenses can often be bought cheaply, because 'process' cameras have now been almost entirely replaced by scanners.

OPTIMUM APERTURE

The question of optimum aperture is more complex than many people realize. Few lenses perform at their best at full aperture, though there are some exceptions, and no decent lens should perform at its best at its minimum aperture. The trick therefore lies in choosing the middle aperture which will give the best results.

The resolution of any lens is limited, ultimately, by the nature of light itself. This is known as the diffraction limited resolution, and depends on the aperture in use. The actual numbers are given in more detail in the panel.

Very few lenses deliver their maximum resolution at maximum aperture, and of the few that do, most are fixed at that one aperture. In

DIFFRACTION LIMITS TO RESOLUTION

The limit of resolution, in line pairs per millimetre (lp/mm – see page 18) is given by the formula

$$\text{Limiting frequency} = \frac{1}{(\text{wavelength} \times \text{f/number})}$$

For green light (the mercury e line, 546.1nm), this equates to 1832 divided by the f/no (strictly, it should be the numerical aperture, but as we are dealing with approximations, this does not matter much). The actual figures for the mercury e line are as follows:

f/2	916 lp/mm	f/11	167 lp/mm
f/2.8	654 lp/mm	f/16	114 lp/mm
f/4	458 lp/mm	f/22	83 lp/mm
f/5.6	327 lp/mm	f/32	67 lp/mm
f/8	228 lp/mm	f/45	42 lp/mm

While this is an excellent guide, it needs to be treated with some reserve. If instead of the mercury e line we choose the hydrogen C line (red light, 656.3nm), the corresponding figures would be 1524 divided by the f/no, giving limits from 762 lp/mm at f/2 to 34 lp/mm at f/45. Also, this is the figure for zero contrast. In the real world, in order to get meaningful contrast, it might make more sense to use anything from 1500 divided by the f/no to 1000 divided by the f/no.

Whatever criterion you choose, diffraction limits make it clear why lenses do not stop down further than they do. For green light, the diffraction limit (at zero contrast) at f/64 is 28 lp/mm with a perfect film – and the film itself introduces its own limitations, as does the enlarger lens. For the kind of on-the-print resolution described on page 19 (8 lp/mm), 28 lp/mm would allow barely a 3x enlargement. This would be fine for an 8x10in negative, acceptable for 5x7in, and tolerable in some cases for 4x5in; but it equates to about an 8½x11in print off 6x9cm roll film, or a postcard off 35mm.

the real world, the very best lenses may conceivably be diffraction limited at f/2.8 or faster, but normally, one should not look for this before f/4, and f/5.6 may be more appropriate.

Once a lens reaches its diffraction limit, its resolution cannot improve; it can only deteriorate. With 35mm, where resolution is obviously at a premium, it is inadvisable to stop down below f/8 unless depth of field demands it, and f/16 should only be used when absolutely necessary. With larger formats, where standards for on-the-film resolution are correspondingly relaxed, smaller apertures are less of a problem.

This does not mean that stopping down has no adverse effect on resolution with larger formats: it just means that the losses matter less. As a general rule, we prefer not to stop down below f/11 with roll-film formats, and although we often work at f/22 and even f/32 with 4x5in, we know that after f/16, we can see the decline in ultimate resolution.

RULES OF THUMB

From all the above, it is quite easy to distil three rules of thumb. First, you should never use extreme lenses – be they extreme telephotos, on extreme wide-angles, lenses with extreme movement, or ultra-fast lenses – unless you have good reason, as such lenses will rarely deliver quality as good as less ambitious designs. If you do use extreme lenses, you need to go for the best on the market.

Second, you should always use a lens inside its design parameters wherever possible. If you want to use it for other applications, you should test it first. In particular, a lens computed for use at normal distances may or may not work well for close-ups, while a lens computed for close-ups may or may not work well at infinity.

Third, you should work at middling apertures whenever possible, preferably at f/5.6 or f/8 with 35mm (though a few lenses may be diffraction limited at higher speeds); at f/5.6 to f/11 with roll film; and at f/8 to f/22 with 4x5in. There are of course many reasons why you might want to use other apertures, including differential focus, maximum depth of field, and the need for slow or fast shutter speeds; but if none of these provides an overriding reason to do otherwise, you might as well work at the optimum aperture.

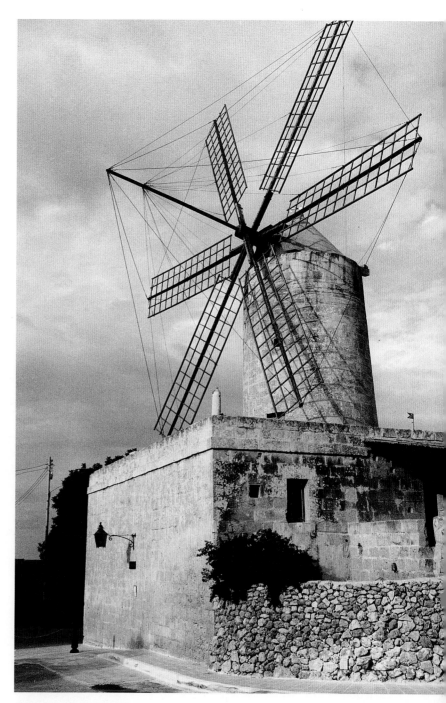

WINDMILL, XAGHRA, GOZO
The shadows have frankly been sacrificed here, principally to get the contrast in the windmill, but the difference between grain and sharpness is abundantly demonstrated. The lens is one of the sharpest available, the 35/2.8 PC-Distagon, on a tripod-mounted Contax. The film, Ilford SFX with a deep red filter, is very sharp but (in the original 6x blow-up) detectably grainy. The same picture appears as a bromoil on page173; here, it is on selenium-toned MG Warmtone. (FES)

CHAPTER FIVE

ACCESSORIES

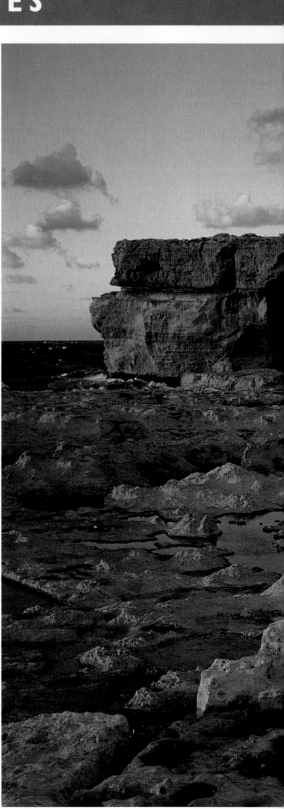

As already mentioned elsewhere, a tripod is the single most important accessory in the search for quality. Lens hoods (lens shades) can also be extremely useful; separate, hand-held meters can make it a great deal easier to get the right exposure, especially in black and white; filters are often underrated; for many kinds of photography, lighting is indispensable; and there are several other accessories which can help in this quest.

TRIPODS

More pictures are made unsharp by camera movement than by just about anything else, even at 'safe' speeds for hand-holding: nothing is likely to make as much difference to the sharpness of your pictures as a tripod.

A popular rule of thumb for 'safe' speeds for hand-holding is 'one over focal length'. In other words, you can 'safely' hand-hold a 50mm lens at $^1/_{50}$ (near enough $^1/_{60}$), or a 200mm lens at $^1/_{200}$ (near enough $^1/_{250}$). This is better than no rule at all, but it applies only to 35mm, and it is not very reliable anyway. The pressmen of yore with their Speed Graphics and VNs would quite cheerfully hand-hold $^1/_{10}$ second or even $^1/_5$ second with 127mm and 135mm lenses, but with our half-frame Olympus Pen W, with its 25mm lens, even $^1/_{30}$ second would be optimistic.

The logic is simple. The degree of blur depends solely on the degree of camera shake, regardless of format. A vibration of just 4 seconds of arc (about the film/subject axis) would therefore give about 0.02mm of blur with a 150mm lens. On a 35mm negative, this might well be enlarged 8x, giving 0.16mm of blur in the 8x10in print. That same amount of blur on a 4x5in negative would only be enlarged 2x: 0.04mm of blur. The former would almost certainly be obvious; the latter might well not. Remember that the human eye can resolve 8 lp/mm, at which point each black or white line is approximately 0.06mm wide.

Even with full-frame 35mm, the rule is not very

'AZURE DOOR', GOZO
This suffers from the same problem as the salt pans on page 10: stupidity and laziness. It is a good enough shot as it stands, but it would be considerably better if Roger had used a tripod, as the ultimate edge in definition is lost to camera shake. But the terrain was difficult, and it was too far to go back...
He rationalized himself out of getting what he really wanted.
LEICA M2, 35/1.4 SUMMILUX, FUJI RA.

reliable for two reasons. One is that it depends on how relaxed and calm you are. The other is that it is too generous – and it gets more so as the focal length increases. Thus, $1/30$ with a 28mm lens is not too bad, but even $1/250$ with a 200mm lens may not be adequate.

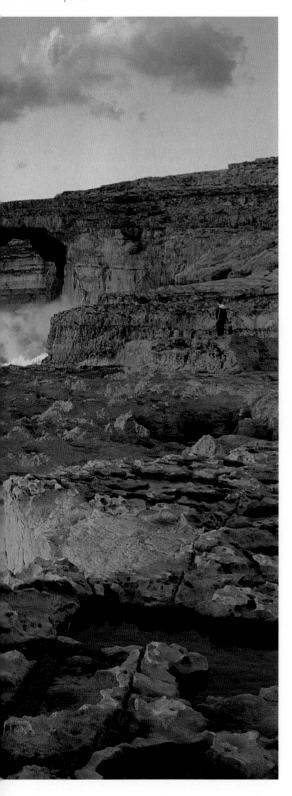

To make matters worse, most of us tend to kid ourselves that $1/50$ second for 50mm is near enough $1/30$, when in reality, even $1/60$ is unlikely to give us the same sharpness as $1/125$. At 500mm, even $1/1000$ is optimistic; though moving in the other direction, you can, if you are lucky, sometimes get away with $1/15$ with a 21mm lens.

If you are going to hand-hold your camera, you will almost invariably do better to use a faster film such as Delta 400 or XP2 Super, and a faster shutter speed, rather than a slower film such as Delta 100 or Pan F and a longer shutter speed. With a tripod, on the other hand, you can fully exploit the sharpness of the slower films.

CHOOSING A TRIPOD

The best tripod is the one that you use, not the one you leave at home because it is too heavy and too inconvenient. This is the first and most fundamental rule.

The second rule is that the tripod must be strong enough to carry your camera. In practice, unless you favour very heavy cameras, you rarely need very heavy tripods. Our favourite tripods for travel range from about 1.1kg (2½lb) to about 2.1kg (4½lb).

FRANCES WITH CAMERA ON TRIPOD, MARSAXLOKK
Why would anyone use a tripod on a day like this? First, because it allows time to set the shot up, and to wait for everything to come right; second, because it makes it far easier to use heavy filtration, which can drastically increase exposure times, to the point where camera shake is once again a risk. The picture she was shooting appears on page 157.

The third rule is that you tend to get what you pay for. Our 1.1kg (2½lb) tripod, a Slik Snapman De Luxe, costs four times as much as superficially similar tripods, because it is made properly. Very cheap amateur tripods are seldom worth the tinfoil they are stamped from.

If we are driving, instead of flying to a destination and then renting a car, or if we are working in the studio, then we often use somewhat heavier tripods, up to about 3.5kg (7lb); but our 3.5kg tripod is adequate even for most 8x10in cameras. It is of wood and alloy 'crutch'-type construction, with each upper leg section made of two wooden laths, fastened at the top to the tripod boss and with an extensible light alloy tubular leg at the bottom. It has no centre column, which restricts its height but also makes it much lighter and more rigid. With those of our tripods which have a centre column, we prefer to keep its extension to a minimum; and the only tripod we own with a geared centre column is a Linhof which weighs around 10kg (22lb), because geared centre columns on lighter tripods add weight and expense and normally detract from rigidity as compared with a plain sliding column.

STUDIO STANDS

Although they are feasible only if you do not have to put them away, pillar-type studio stands are immensely convenient and very quick to use. They consist of a tall pillar, anything up to about 2.5m (8ft) high and about 10–12cm (4–5in) in diameter, with a sliding, counterbalanced collar bearing a cross-arm which cantilevers anything up to 1m (40in) out from the side. They are set on massive cast bases and are enormously heavy – few weigh under 50kg (110lb) – but they allow very rapid positioning of the camera and they are admirably solid: the only concern with ours is the 100-year-old wood floor of the studio, which vibrates and flexes as you walk on it.

MONOPODS

At the opposite extreme from studio stands are monopods, which are designed to be light, portable and convenient. We have mixed feelings about them. Roger uses a very light monopod, the CamCane (just 350g/12oz), especially when he has to wait for the decisive moment and a tripod is impractical or not permitted. The longer you hold a camera to your eye, the more tired your arms get, and the greater the risk of camera shake. A monopod takes the weight of the camera, and greatly reduces this. It also reduces vibration, by increasing mass, and effectively eliminates movement in one plane, up and down.

Frances, on the other hand, feels that all too often monopods seduce the photographer into thinking that pictures will be sharper than they are: the camera can still pitch, roll and yaw about the monopod head. At best, she feels, a monopod counteracts the natural tremors which are accentuated by exercise, and allows the photographer to use maybe 1 step longer on the shutter speed dial than would have been possible without it; $1/60$ instead of $1/125$, say, or $1/30$ instead of $1/60$.

VARIABLE SPLAY TRIPOD
Variable leg splay can be extremely useful, as it allows you to adjust the tripod more easily to uneven terrain. This old MPP wooden tripod has no centre column, a price we cheerfully pay for greatly reduced weight and increased rigidity. The head is the 'inside out' Novoflex ball and socket, which saves less weight than you might think but is a great deal smaller than the conventional design.

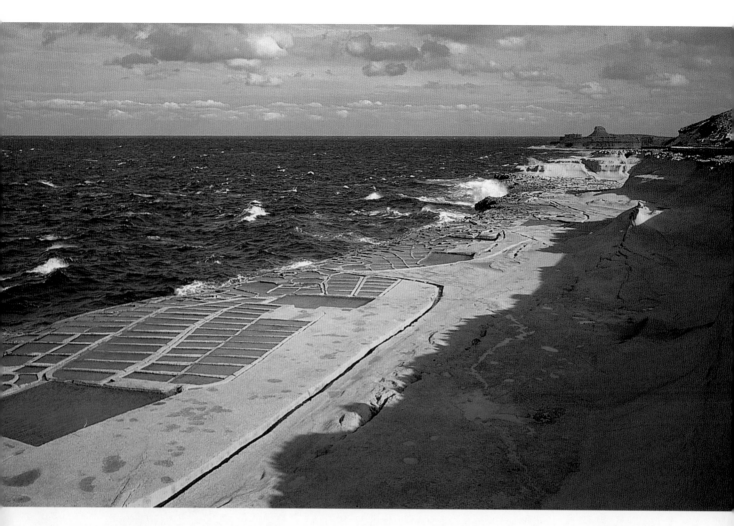

Arguably, monopods increase in usefulness with focal length, allowing a closer adherence to the 'one over focal length' rule which was disparaged above: certainly, sports photographers seem to find them very useful, though this must be at least partly because they take up less space and partly because panning with a monopod is generally easier than panning with a tripod.

TRIPOD HEADS

It would be a slight exaggeration to say that a tripod without a removable head is not a professional tripod, but only a slight exaggeration.

As with the tripods themselves, you generally get what you pay for. We tend to use a reasonably substantial (35mm ball) ball-and-socket head; or a three-way head; or the unique NPC Pro Head, which to a large extent combines the advantages of both. We find pan and tilt heads bulky and inconvenient. The cheapest head we use is about the same price as a complete, cheap amateur tripod with built-in head. The most expensive is the same price as a good, professional tripod without a head.

For the biggest cameras, we use the integral levelling bowl on our big wooden tripod, which also has a pan and tilt head built in; but we have removed the pan arm (which has no locking function), and the absence of three-way movements does not matter with the reversing backs on the 5x7in and 8x10in cameras which we use with it.

We also have a couple of interchangeable levelling heads, which allow us to level the base of any other head – they fit between it and the tripod – so that panning is much easier. The one we use most is a remarkably small, light Linhof which is, alas, once again discontinued. With the Benbo three-way head, there is no need for a levelling bowl because there is an additional pan movement on the top camera platform.

One little professional trick which is worth knowing is that if you have a heavy camera, and a

studio stand (see above), it is often easier to hang the camera from the head, rather than supporting it on the head. Not only is locking often better: it also has the advantage that if the lock does give way, the camera won't crash downwards, but will just swing like a pendulum.

QUICK RELEASES

At first sight, quick releases are an excellent idea: the camera can be mounted or demounted in a flash. In practice, there is not much point in using them for 35mm, because they add considerably to the bulk and weight of the camera (if they don't, they are unlikely to be substantial enough) and they are marginal with roll-film cameras: to our taste, the few seconds they save, as compared with using the tripod screw, rarely justify the extra weight, expense, bulk and complexity.

With 4x5in cameras and above, however, we are firm believers in quick-release plates, as it is much more difficult to balance a big, heavy camera on a tripod head while fiddling with the tripod screw.

THE BAG MYTH

The theory of hanging a bag under a tripod is that the extra mass stabilizes the whole rig. With wooden or other well-damped tripods (such as carbon fibre), it may just do this, provided the bag doesn't start swinging around, and provided the wind doesn't start humming through the strap that you have hung the bag from, thereby setting the whole thing vibrating.

The only time we normally use this technique is when we are using a wooden tripod with the feet close together in order to get a little extra height; the bag reduces the risk of the whole thing toppling, especially if the bottom of the bag is dragging on the ground (which also improves the overall damping). With wooden tripods, too, the extra weight takes up the flex in the legs and the joints. But with a metal tripod, as often as not, it places an unacceptable stress on the whole thing and makes it harder to handle, as well as transmitting movement from the bag itself.

LENS HOODS

It is not hard to demonstrate that there are many situations — principally, when there are light

sources in shot — when lens hoods are of little or no use. On the other hand, it is equally easy to demonstrate that often they are invaluable: when light is shining obliquely on the lens, or you are shooting on a bright, overcast day, or in a white-painted 'cove' in a studio, which invites veiling flare (see page 50).

As well as reducing flare, lens shades provide useful protection against spray, dust, flying champagne, bird droppings, etc, as well as mechanical protection against knocks: a knock which could 'ding' a filter thread and possibly damage a lens will be distributed and absorbed by a lens hood. For these reasons, quite apart from flare reduction, they should be used whenever possible.

We use three varieties of lens shade. The simplest and crudest, which work on the principle

BAG UNDER TRIPOD
Hanging your camera bag – here, a Tenba Airline backpack – under a tripod is a time-honoured trick. Unless it is a completely still day, as it was here, the bag should drag on the ground for additional damping: if the bag swings in the breeze, it can be worse than no tripod at all.

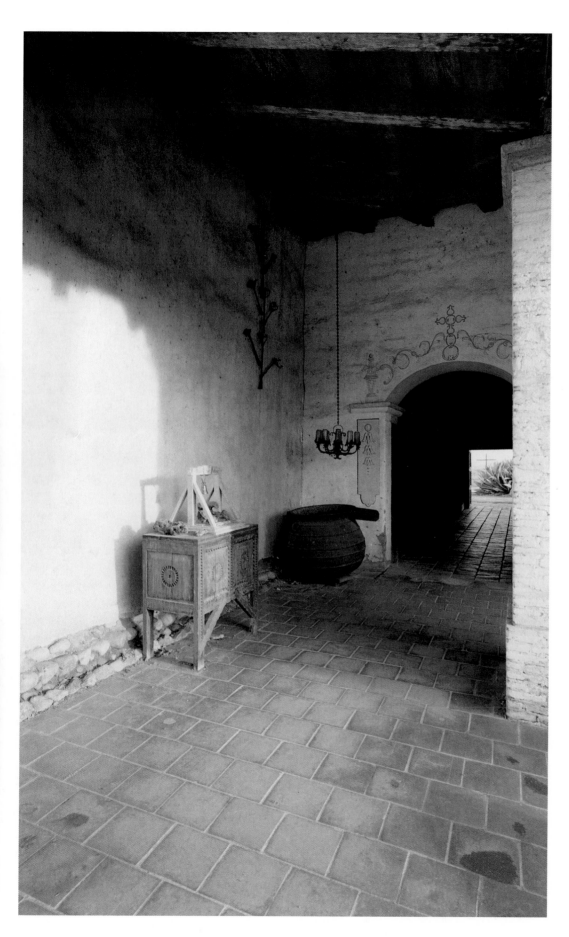

MISION SAN ANTONIO, CALIFORNIA
When the camera is shaded, as here, there is less need to use a lens hood than when the sun is shining on the lens. Even so, the glare from white walls (and from a white sky, when that is in shot) can still reduce contrast detectably, so it is a good idea to use a hood whenever possible.
HAND-HELD ALPA 12 WA, 38/4.5 BIOGON, 44X66MM, ILFORD DELTA 100. (RWH)

that at worst, a shade won't do any harm, are fixed-size shades. We have many varieties, in metal, plastic and soft rubber.

Wherever possible, we prefer to use self-supporting bellows shades from Lee Filters (also available with other brand names, such as Cromatek), set to precisely the right length for a given lens. If they cannot be made long enough, we use a matt black mask in the front of the shade, cut to the appropriate format.

The joker in the shading pack is the Flare Buster from Gran View in the United States. This is made in two versions, one to fit into an accessory shoe, and the other with a spring clip to clamp on to a convenient part of the camera. It is a flexible rod, with another spring clip at the business end, and it is used to hold a piece of black card (or anything else) to shade the lens.

We have found that these, and the somewhat similar Wiggly Worms, can be used to solve all kinds of shading problems where even a self-supporting bellows shade is not versatile enough; for example, when we are using a lot of movement with an ultra-wide-angle lens on a large-format camera. For general use, self-supporting shades are better, but there are times when the Flare Buster is the only feasible option.

LENS SHADES AND MULTI-COATING

Anyone who tells you that multi-coating has rendered lens shades unnecessary is relying on theory (and not very clever theory, at that) rather than on practical experience. It is true that multi-coating reduces the ill effects of not using a shade, but this is not the same as saying that it eliminates it!

METERS

Although modern in-camera meters are enor-mously clever, they still suffer from two major drawbacks. The first, which has to a considerable extent been overcome by multi-segment metering, is that they cannot 'know' the average reflectivity of the subject at which they are pointed: all they can do is measure the light reflected back from it. The classic problems are snow, where overall reflectivity is far higher than the average for which they are programmed, and subjects where the background is far lighter, or far darker, than the

principal subject which is to be 'correctly' exposed. Modern multi-sector meters generally achieve a good compromise for dark subjects against a light background, such as a backlit figure, but they are often a lot less successful when you have a light subject against a dark background, such as a spotlit figure on a darkened stage.

The other problem, which is irreducible, is that the vast majority of in-camera meters are designed to give the best possible exposure with colour slide film. But with colour slide film, the optimum exposure is pegged to the highlights, while with monochrome negative film it should be pegged to the shadows. The net result is that when in-camera meters are used uncritically for black and white photography, the result is commonly a picture with 'empty' shadows.

The obvious response is to give extra exposure, quite possibly an extra stop as compared with the meter reading. This can easily be achieved by setting a film speed which is one-half the ISO speed, which is what leads so many people to say that this or that film is not 'really' as fast as its ISO speed implies. In practice, they would probably be entirely happy with the actual ISO speed if only they were metering properly, that is, with due regard for the shadows. (There is more about film speeds on page 70.)

Although we have written an entire book called *Perfect Exposure* (David & Charles/Amphoto 1999), and although we would love you to go out and buy that as well, it is worth describing both incident light and spot meters here.

INCIDENT LIGHT METERS

An incident light meter does exactly what its name suggests: it measures the light falling on the subject, rather than the light reflected from it. This removes any variations resulting from different reflectivities. The reading is taken from the subject position, with the meter pointing towards the camera. If the subject position is inaccessible, it is often possible to take an equivalent reading from a point where the lighting is identical, again pointing the meter along an axis parallel to the subject/camera axis.

With traditional 'sun over the shoulder' lighting, incident light reading is 100 per cent reliable for colour photography; but the closer it approaches to side-lighting, the more difficult it becomes to

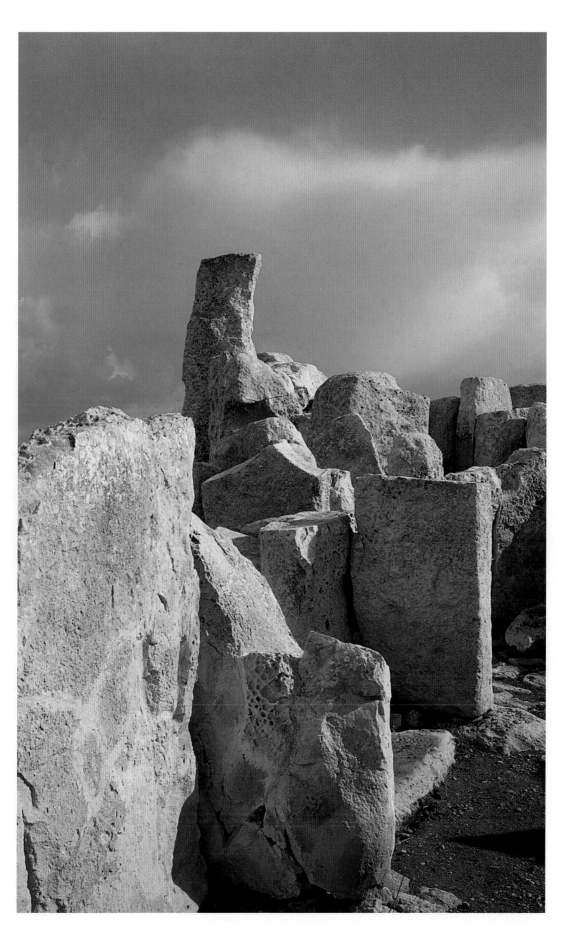

MNAJDRA
Compared with a reflected light reading, an incident light reading recommended about ½ stop more exposure – which was exactly what was needed to keep the bright, sunny feel. Remember that with a reflected light reading, the meter is influenced by the colour of the subject as well as by the amount of light that is bounced back.
LEICA M2 HAND-HELD, 90/2 SUMMICRON, FUJI RA. (RWH)

get a good reading. In this case, the best bet is often to take the best incident light reading you can, as described above, and the best reflected light reading you can, and split the difference.

If you have an incident light meter with a flat receptor (most are domed), then an alternative is to take one reading with the receptor pointing straight at the brightest light source, from the subject position, and a reflected light reading from the camera position with the meter pointing straight at the subject, and split the difference between these.

Whatever approach you use, it is essential to remain consistent in how you hold and read the meter. Always try to keep the 'sight line' of the meter on the subject/camera axis, as angling it up or down or left or right can make a considerable difference to the reading. Be consistent in rounding up or rounding down: if a reading is exactly half-way between two marks, do not choose the higher mark this time, and the lower mark next time. Remember that ¼ stop error in reading the position of a meter needle is not worth worrying about, and that another ¼ stop error in reading the scale of a calculator-type meter is not worth worrying about either – but if both errors are in the same direction, you have a ½-stop error, which definitely is worth worrying about.

SPOT METERS

If incident light meters are the 'quick fix' for colour slides, then spot meters will give you the best possible exposures with negatives. Just read the darkest area in which you want detectable texture, and give up to 3 stops *less* exposure; less, because you want the metered area to be darker than the 'average' for which the meter is calibrated.

Thus, if your meter reading is ⅟₃₀ second at f/8, you give anything from ⅟₁₂₅ at f/8 (2 stops less) to ⅟₁₂₅ at f/11 (3 stops less). The reason why we give a range, rather than a firm recommendation, will become clearer in the next chapter; but suffice it to say for the moment that if you want a rule of thumb which will give you first-class black and white negatives, settle on 2 stops and use the ISO speed – or just set the meter to 4x the ISO speed and use the shadow reading.

CONTACT SHEET
The best way to visualize exposures with negative films is to think of a contact sheet. Frames which have received more exposure will make light contact prints – just as an over-exposed transparency will be light – and frames which are under-exposed will make dark contact prints (again, just like transparencies).

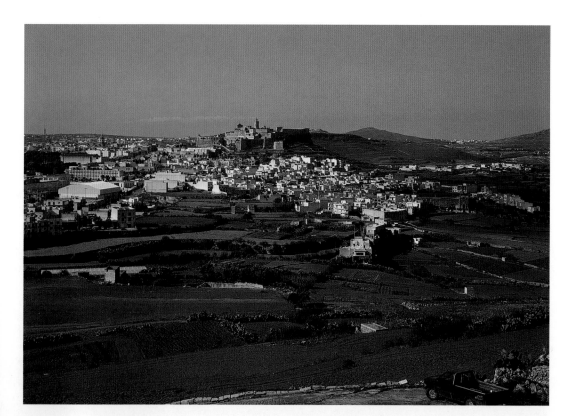

RABAT, GOZO
The Astia shot uses colour (logically enough) to differentiate the different parts of the picture; but if you look closely, you will see that the contrast is not very high. To make the 100 Delta shot equally sunny-looking, Roger used a strong red (25A) filter to cut through the haze, lighten the yellow, and darken the green.
LINHOF SUPER TECHNIKA IV ON TRIPOD, 100/5.6 APO-SYMMAR 6X7CM.

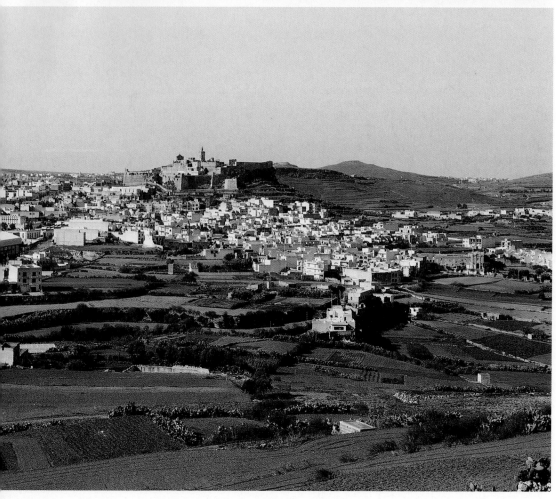

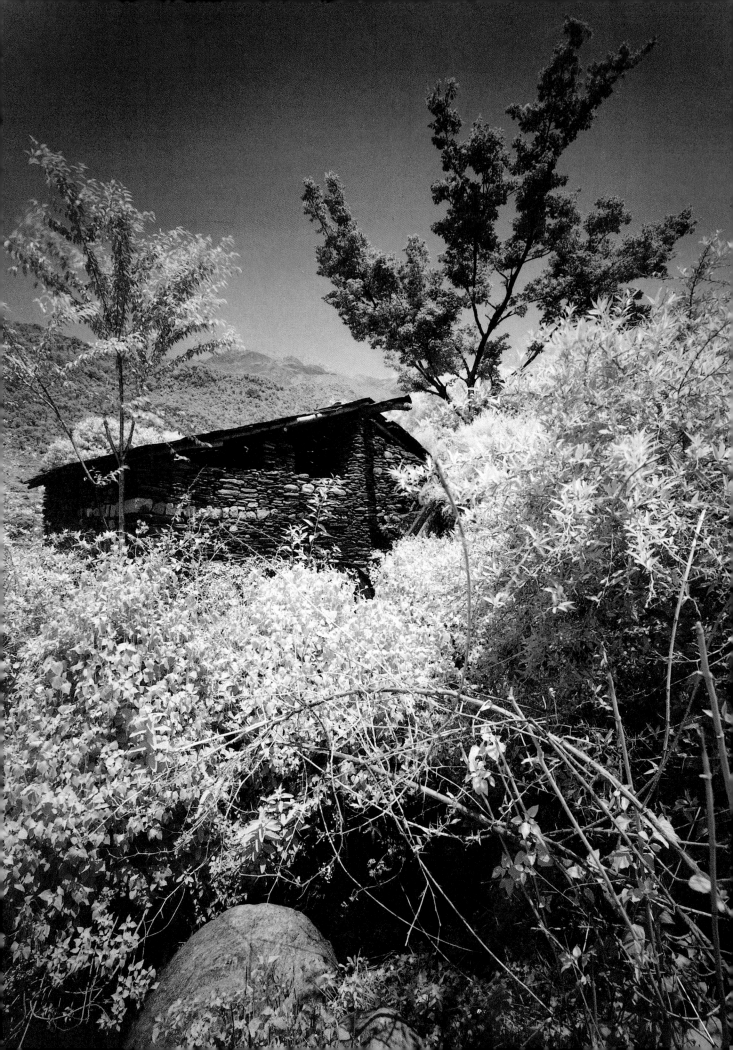

CAMERAS WITH SPOT METERING

If your camera has a spot metering option, explore it with negative films. You may even care to set a film speed which is 2 to 3 stops higher than the ISO speed; meter the shadows; and then give the recommended exposure. This is of course the same as using the ISO speed and then giving 2 or 3 stops less than the meter recommends. As we began this book, we were just coming to grips with our first camera to incorporate spot metering, the Contax RX, and we were still using our Pentax and Gossen spot meters more than the meter in the camera. By the time we had finished it, we were using the camera meter somewhat more.

When metering for colour negative film, an incident light reading will normally give a good exposure, but a spot meter reading of the shadows will be even better.

BRIGHTNESS RANGES

One reason why it is easier to use separate, hand-held spot meters, rather than in-camera spot meters, is that most spot meters make it easy to measure brightness ranges. The Pentax meter, for example, has an IRE (Institute of Radio Engineers) scale, which covers a brightness range of 100:1. If your darkest shadows with detail are at one end of the scale, 2⅓ stops below the mid-point, and the brightest highlights with texture are at the other end, 2⅔ stops above, then you should be able to 'hold' both on the same negative. If the brightness range is much greater, you must decide which to sacrifice – and reading a few mid-tones can help you to decide the best direction in which to bias your exposures.

FILTERS

Filters can be divided into three categories: subtle, dramatic and excessive.

Subtle filters include mild warming filters such as the 81-series, grey grads, most applications of polarizers, and (in monochrome) green or weak yellow filters for landscapes, and weak blue filters for portraits. The point with a subtle filter is that it never announces its presence. Even a skilled and observant photographer should be unable to say for certain that a filter has been used; the result should look like a happy confluence of luck and the right circumstances – though as a famous golfer is reputed to have said, 'The more I practise, the luckier I get.'

Dramatic filters are normally used in black and white: oranges and reds, to accentuate clouds against blue skies. Polarizers can also be used dramatically, to show boats apparently floating in mid-air (on clear water with the reflections removed) or to boost colour saturation. Knowledgeable photographers will almost always spot when they have been used; non-photographers will merely know that the skies somehow seem 'more real' than in real life. This is the important thing about a dramatic filter: it builds on what is already there, but lends it unusual emphasis.

Excessive filters superimpose something on the scene which was not there to begin with. They are epitomized by the utterly loathsome 'tobacco grad', which has stained cloudy skies an unconvincing amber-brown for years.

Filters, like tripods, are a hassle; but many good photographers use (or used) filters extensively: Ansel Adams used yellow, green, orange and even red filters surprisingly often. Some people shun filters because they are not faithful to the original scene, though this argument does not withstand examination: after all, how faithful to a whole, inhabited, rumbustious, windy landscape is an image frozen in time on a square of paper, or an image flashed on a screen?

We sometimes feel that we use filters less than we should: about 10 per cent of our pictures would probably be improved if we used them more extensively. This only applies to subtle or dramatic filters, though. There are only two reasons to use what we have called 'excessive' filters: one is to add interest to a dull scene, which is something that commercial photographers have to do from time to time. The other is because you are a bad photographer.

SOFT FOCUS SCREENS

If you cannot justify the expense of a purpose-made soft focus lens, there are numerous soft focus attachments on the market. The best are almost certainly Softars, originally made by Zeiss and long available only for Hasselblad, but now available in a wide range of fittings for all cameras. A much cheaper option, the results from

MILL AND FOLIAGE
A true IR filter means that you must use either a tripod, or a camera with a separate direct-vision finder, as the IR filter is visually all but opaque. The film here is Ilford SFX, which differs from both Kodak and Konica materials in having no 'green gap' between the residual blue sensitivity and the dye sensitization into the near infra-red, so a true IR filter is essential; with the other two, just about any deep red or even orange filter will suffice for many purposes. ALPA 12 SWA ON TRIPOD, 35/4.5 APO GRANDAGON, 6X9CM. (FES)

which seem to be just as good, comes from Pro4, and uses drilled 'optical resin' sheets.

GLASS, PLASTIC AND 'SYSTEM' FILTERS

Many photographers have an almost religious attachment to very expensive optical glass filters, especially from firms such as B+W. They say, 'There is no point in buying a $1000 lens and then ruining the definition by using a cheap filter.'

While there is no doubt that these screw-in glass filters will deliver excellent quality, and they are a pleasure to use, we have to report that even with 35mm, we have found no detectable degradation – let alone ruination – of image quality when using plastic or 'optical resin' filters.

If there is any degradation, it is incredibly small. Some photographers have told us that they can see the difference in 16x20in (40x50cm) prints from 35mm, but our view is that there are enough other problems in a 16x20in print off 35mm, most notably the half-tone effect, that the filter is the least of your worries. We also suspect that they are seeing what they want to see, rather than what is there. Suffice it to say that we will cheerfully use our Lee and Cromatek optical resin filters with a $4000 Zeiss Biogon, never mind a $1000 lens.

LIGHTING

As with metering, so with lighting; we would direct you to another of our books, *Learning to Light* (Collins & Brown/Amphoto, 1998). But we would also point out that for certain kinds of photography, most notably portraiture and still life, you can do a great deal more with even the most modest controlled lighting than you can by relying on daylight or other available light. Yes, it is perfectly possible to take excellent still lifes and portraits by available light; but it is vastly easier if you can set up the lights the way you want, and we would suggest that if you intend to specialize in either of these areas (or in related ones such as nudes, food, product shots, etc) you will do a lot better to buy some lighting.

OTHER ACCESSORIES

There are a number of other accessories which can help improve the quality of some or all of your pictures, and the quickest approach is to run through them in alphabetical order before we move on to film, which is the subject of the next chapter.

The easiest way to carry many of them is in a multi-pocketed photographer's vest, though some (such as brushes for cleaning cameras and lenses) can live in the camera bag.

Bags A good camera bag keeps your equipment clean, and protects it from damage. There are numerous makers, but we prefer to use only the very best bags, as they are more durable, easier to use, and generally offer better protection. For over-the-shoulder bags, we mostly use Billingham; for backpacks, Roger uses Tenba, and Frances uses Billingham and Lastolite. For hard-sides, we use Zero Halliburton and Porter Case.

Hard-sides are best for shipping; over-the-shoulder (preferably with a waist strap) for quick working; and backpacks if you have to walk any distance.

Cable releases For very long exposures, or with large-format cameras, these are essential. For shorter exposures with 35mm and MF cameras, up to about ¼ second, you will often get less vibration if you wrap your hands around the camera and use the camera body release.

Cleaning materials and equipment Sparkling clean lenses give better contrast, and clean cameras keep dust off the film; but both lenses and cameras can be damaged by over-enthusiastic cleaning. Ideally, both should be stored in Zip-Loc or similar plastic bags when not in use, or (if you can get them) chamois leather bags.

Brush dust off lenses with a soft anti-static brush – we use Kinetronics – before cleaning, to avoid scratching, which is the great risk with over-frequent cleaning.

If the lens still needs cleaning after brushing, we have found that the best cleaning 'cloths' are in fact photo-quality chamois leather (Hama does a good one), but there are all kinds of other possibilities including microfibre cloths and even an old, well-washed T-shirt. If you want to use a liquid cleaner, it is better to put it on the cleaning cloth (actually, we use lens tissues) rather than on the lens.

For very dirty lenses we sometimes use

Opti-Clean, which is painted on to the lens, left to dry, and then peeled off, removing all dirt and leaving the surface atomically clean. To protect a lens which will not be used for some time, leave the Opti-Clean on the glass.

To clean the camera, use a good-quality household paintbrush (about 12mm/½in) or an old toothbrush to brush off loose dust, before cleaning with a soft cloth (an old T-shirt is ideal). Paterson's Pro Clens lens cleaner works well on camera bodies as well as on lenses. Clean awkward areas with cotton swabs.

Compass A pocket compass can be useful for navigation, and also to tell you when the light on a particular building is likely to be at its best.

Lens and body caps Keep lenses clean, dust-free and unscratched by using caps front and rear, and use camera body caps as appropriate.

Pencil A soft pencil lets you note 'push' and 'pull' speeds on films; make notes; and lots more – we even write film types on the camera.

Screwdriver Not for field-stripping the camera, but for tightening screws which come loose, usually at the least convenient time. Remember to carry both plain and Philips-head if necessary.

Spirit levels A small, pocket spirit level can be very useful – or better still, use a T-level as sold for accessory shoe use by a number of manufacturers.

Straps Well-made, comfortable straps make your camera easier to carry and quicker to use. We prefer the variety with quick-releases, so that they can be removed quickly and easily when we want to use the camera on a tripod, leaving only short 'tails' attached to the strap lugs. The very best straps are curved to fit the neck: this distributes the load most comfortably.

Swiss Army knife These need hardly be extolled. All we would add is that it is a good idea to thread a ⅜–¼in tripod adapter on the split ring. You may also wish to consider the Leatherman and other high-quality belt tools, but always buy the best: cheap imitations bend and break.

Thermometer If you shoot Polaroids, a thermometer is a useful thing to carry. You can buy 'hardened' thermometers at some outdoor stores – they don't need to be very accurate – or we use an old Paterson spirit thermometer in a tough plastic outer case.

Timer Again for Polaroids. If you don't wear a watch, or if your watch doesn't have a seconds hand, a small seconds timer is a good idea. Polaroid makes an excellent one.

Zip-Loc or similar bags Self-sealing plastic bags hold film, accessories, cleaning cloths, and more, and keep cameras and lenses dust-free when not in use. Fabric or chamois leather bags offer better protection but harbour dust.

MELON
Roger shot this both with a 4x5in and with a 35mm (Pentax SV) on Ilford Pan F. A short extension tube, an accessory not mentioned in the text, was needed to make the 85/1.9 Super Takumar on the Pentax focus close enough.
TECHNICAL DETAILS CAN BE FOUND ON P155.

CHAPTER SIX

FILM

TEMPLE AND PRAYER FLAGS, DHARAMSALA
From past experience we knew that prayer flags often look faded and dull in pictures, so Roger chose Kodak's then-new E100VS to boost the colour – which it did, without 'blowing' the white highlights on the temple in front. The location is on the circumambulation path around Thekchen Choeling, seat of HH Dalai Lama.
LEICA M4-P HAND-HELD, 90/2 SUMMICRON. (RWH)

There are very few bad films, but there are plenty of films which suit one person better than another. For instance, many first-class photographers get superb results from Kodak T-Max 100, while others have nothing good to say about it. Modern monosize controlled crystal growth films offer far better speed/grain ratios than old cubic crystal films, but many photographers regard them as inventions of the devil. Current slide films offer truer, more saturated colour, and better tolerance of over- and under-exposure, than anything from the past; but there are plenty of people who still buy the flat, grainy, blue old Ektachrome 64, the continued demand for which puzzles even Kodak.

There are also films which are notoriously demanding in both exposure and processing, but which people learn to master because of the results they can extract from them. Another Kodak film, Technical Pan, is an excellent example. It was never intended for general photographic use, but when people found out about its very low grain and very high sharpness, they started experimenting with strange developers and highly personalized exposure indices, and managed to tame it.

To cap it all, new film introductions are, for the most part, genuine improvements on what has gone before – and fierce competition between the various manufacturers means that there is a

constant spur to make newer and better films. Unfortunately, many people continue to stick with what they know, so old films often stay in production for a very long time, and manufacturers' product lines grow more and more extensive and confusing.

'OLD' AND 'NEW' TECHNOLOGY

Most photographers are aware that there are two generations of crystal technology: the old 'cubic crystal' technology, and the new 'controlled crystal growth' technology. What they are less clear about is how these films differ.

With 'cubic crystal' films, film speed was controlled principally by limiting the size of the biggest crystals. Bigger crystals mean more speed (and of course bigger grain) but even a fast cubic crystal film such as Kodak's legendary 2475 and 2485 Recording films had a lot of small crystals as well. It is worth remembering that both crystal growth and crystal 'habit' (meaning essentially, crystal shape) were (and are) still controlled in these 'old technology' films; just not as accurately as with 'new technology' films.

A slightly more informative (though still somewhat misleading) name for 'controlled crystal growth' films is 'monosize crystal' films, and this gives much of the game away. The size of the crystals is controlled within much tighter limits, as is the shape. Perhaps surprisingly, though, the actual crystals are not necessarily smaller. Kodak's T-grain crystals are actually larger, but each has the potential for multiple development sites, and each site can be developed independently, with the undeveloped remaining halide being fixed out. This 'annular' development means that each big halide crystal has the potential to end up as several small silver grains.

Ilford's halide crystals are in fact smaller than those of 'old technology' films, but more efficient: a 'positive hole trap' reduces image regression, so a smaller crystal can be more efficient than a bigger one. The net result is a film which is not as fine-grained as Kodak's tabular crystal (T-grain), but which is far less sensitive to developers, and which is widely regarded as delivering better tonality. In the words of an Ilford spokesman, 'It's not necessarily a better technology [than T-grain], but it's a better-behaved technology.'

All 'new technology' films have, however, in the French phrase, 'les fautes de leurs qualités': the faults of their qualities.

First, they all have less inherent latitude. This is no surprise. With a cubic crystal film, under-exposure will affect disproportionately many large crystals, while over-exposure will affect disproportionately many small crystals. Either way, you get some sort of an image. With a monosize crystal film, the crystals are affected far more equally, so over- or under-exposure will have a much greater effect on image quality. The earliest monosize crystal films had far less latitude than later versions, which put many photographers off them so badly that they have never tried them again. Today, though, there is no real reason to worry about this; as long as exposure is reasonably accurate, you will get the same sort of results as with cubic crystal films, though gross over- and under-exposure will still be far more detrimental.

Second, and for much the same reasons, they are more critical of development times – though this is far more true of T-grain than of Ilford's technology. To be brutal, something like Ilford FP4 Plus or Kodak Tri-X is hard to ruin, even in a totally unsuitable developer where the photographer is following a totally unfounded pet theory on exposure and development times. A tabular crystal film is particularly susceptible to reduced image quality through over-development, where multiple image sites on a single crystal will join up to give excessive contrast and over-sized grain.

This does not mean that exposure indices and development times should not be varied. Manufacturers still say, with perfect honesty, that variations in both may well give you improved image quality for your particular applications, preferences and equipment. But it does mean that if a 'new technology' film does not give you better grain at a given ISO speed, still with excellent tonality, you are probably doing something wrong: usually, over-exposing or over-developing, or possibly both.

PERSONALIZING FILM SPEEDS

As noted elsewhere, many people will tell you that black and white films, in particular, are not 'really' as fast as the ISO speed would imply. This merely

betrays an ignorance of what ISO film speeds are, and of how they are determined.

In truth, ISO speeds are almost invariably honest, with one and a half exceptions. The main exception is that a few manufacturers specify particular developers in order to get the speed they claim: developers which would, in normal parlance, be regarded as speed increasing, so that, for example, Fomapan 200 would be ISO 160 or even ISO 125 in a non-speed-increasing developer. The major manufacturers do not do this.

The half exception is that some very fast films, sold for 'push' processing, are sold with an exposure index (EI) rather than a true ISO speed. The most popular examples in black and white are Fuji Neopan 1600 (EI 1600, ISO 500 to 650), Kodak TMZ P3200 (EI 3200, ISO up to 1000) and Ilford Delta 3200 (EI 3200, ISO up to 1250). Likewise, most ultra-fast colour slide films are in fact ISO 400 but designed for push processing. This constitutes only half an exception, because if you read the box, it does not claim the higher speed as an ISO rating, though salesmen (and even manufacturers' representatives, in the case of Fuji) may not always appreciate the difference.

This is not the same as saying that the ISO speed is always the speed that will give you the results you like best. Equipment variations can quite often mean that you need to vary the ISO speed by ½ stop or so, and sometimes as much as 1 stop. Personal variations in metering technique add another dimension; so does your choice of developer; and, of course, there is always the matter of personal preference.

Despite the penalties in sharpness and grain described on page 22, many photographers find that they are happiest rating negative films at speeds which are rather less than the ISO rating would imply: only a few find that they habitually rate films faster, though we have had considerable success (and fun) rating Kodak TMZ P3200 and Ilford Delta 3200 at EI 6400 and even 12500. With transparency films, speed adjustments may be necessary merely to get acceptable results, while with negative films, there are two reasons for changing film speed (assuming a constant development regime). One is getting enough shadow detail, and the other is tonality. The former requires little explanation, and the latter is a matter of personal preference.

With any film, personalizing the exposure index could hardly be easier. With transparencies, if they are consistently too light, then *increase* your film speed slightly until they come out the way you like; if they are consistently too dark, then *decrease* the film speed slightly. With negatives, if the shadow detail is not there on the negatives, then again *decrease* your film speed until you get the level of shadow detail you want.

This may sound backwards – increasing film speed to get darker transparencies, and vice versa – but of course you are not changing the film speed at all: you are leaving it the same, but telling the meter that it is faster (in which case the meter will recommend less exposure) or slower (in which case the meter will recommend more exposure).

By way of example, we find that with most black and white emulsions, and most of our cameras and lenses, we rate the film at its nominal speed when we use spot metering techniques, reading the darkest shadows in which we want texture and giving 2 to 2½ stops less exposure, as detailed on page 62. But with one particular leaf-shuttered ultra-wide-angle lens, we always give a full stop of extra exposure; and if we are using incident light metering with any lens, we rate the film ½ to 1 stop slower, depending on our assessment of how much shadow detail we need.

T-GRAIN, DELTA, ETC – AND COLOUR

Each manufacturer has a pet name for the controlled crystals in their own emulsions, but to the photographer, the details matter very little. What is important is whether the film in question does what you want. It is also important to realize that there are very significant differences in both philosophy and technology, and that if you don't like Kodak's T-Grain, you may like Agfa's APX, or vice versa. To write off 'new technology' films, as so many reactionary photographers do, is foolishness of the highest order; and to suggest that their sole *raison d'etre* is to reduce the amount of silver in the film emulsion verges on the pitiable.

Even a colour film, of course, starts out with a silver image; and the benefits of an improved speed/grain ratio are as important in colour as in monochrome, so the next thing to look at is how this affects quality in all emulsions.

MILL
With generous exposure on the right film, it is often possible to capture sky detail without filtration. This was Ilford Delta 100, exposed so that the deepest shadows were 2 stops darker (based on a limited-area reading) than the exposure given.
Grain was milled between the central stones, which were rotated by a donkey harnessed to a post passing through the loop on the upper stone: the circle is its path.
ALPA 12 WA HAND-HELD, 38/4.5 BIOGON ON 44X66MM, PRINTED ON ILFORD MG IV WARMTONE. (RWH)

AMERICA TRUE
Sufficient technical quality can show us something as if for the first time. Frances was fascinated by the starkness of this scene, and used her Alpa 12 SWA with a small degree of shift on the 35/4.5 Apo-Grandagon to keep the verticals parallel.
CAMERA HAND-HELD, 6X9CM, ILFORD XP2 SUPER PRINTED ON MG WARMTONE.

FILM AND QUALITY

The question of 'quality' in film is so subjective that it is all but impossible to make recommendations, but there are some objective qualities which can be quantified: grain, sharpness, tonality, contrast, colour saturation and colour balance. There is also the point that less exposure invariably equates to greater sharpness, though this is not the same as saying that it gives the best pictures.

The first three (grain, sharpness and tonality) have already been mentioned in Chapter 2, and the only important point to make about any of them here is that while fine grain is a depressingly simplistic criterion by which to judge any film, it is the easiest to see and to understand, so it is very nearly the only criterion adopted by many photographers and photo magazines.

GRAIN AND SHARPNESS

The distinction between grain and sharpness is most clearly demonstrated in chromogenic monochrome films. The way in which these work is that the by-products of film development transform dye precursors into a visible, coloured dye: the dye image builds in direct proportion to the silver image. The silver image is then bleached out, leaving only a dye image. The dye image is denser than the silver image, so the effective film speed is higher than it would be with a plain silver emulsion. This is why you will sometimes hear people drawing a distinction between 'dye speed' and 'silver speed'.

The dye image is far less grainy than the original silver image, but there are two prices to pay. One is financial – the film costs more – and the other is that the dye image is less sharp than the silver

image. This is because the dye precursors are normally carried in oil, and the oil means that the emulsion is thicker than it would otherwise be, and therefore gives less sharp images.

If the silver speed is low enough, the loss of sharpness is not a problem. This is why it is possible to make very sharp colour films. A film with a silver ISO speed of 25 or less can be made to yield a dye ISO speed of 50 or so with truly remarkable sharpness. By the time you get to a silver ISO speed of 100 to 200 and a dye ISO speed of 400 or 500, you may still have wonderfully fine grain – far finer than you could get with a conventional ISO 400 film, and indeed comparable with ISO 100 – but the sharpness is likely to be inferior even to an 'old technology' ISO 400 film such as Kodak Tri-X or Ilford HP5 Plus, and markedly inferior to a modern monosize crystal film such as Ilford 400 Delta.

CONTRAST AND COLOUR SATURATION

In monochrome, contrast is very much a consequence of development, and can be varied over quite wide limits without greatly altering the other qualities of the film (though grain will go up with increasing development, while sharpness goes down); this is a matter for Chapter 10. But in colour, where processing tends to be standardized, contrast is much more an inherent quality of the film.

The secret of controlling both contrast and colour saturation in modern films is the use of dye inhibitors. During the development of a colour film, dye precursors (as described above for chromogenic mono films) form coloured dyes in each of the three layers of the film: the red-sensitive, green-sensitive and blue-sensitive layers. In practice, there are often double layers for each colour, but this is another matter: the easiest way to think of things is to imagine three emulsions stacked one on top of the other.

Early dye precursors tended to wander about a bit in the emulsion, leading inevitably to a loss of contrast and saturation. Modern dye precursors are better anchored, and this is a part of why colour films are contrastier and more convincing than they used to be. Kodachrome used to have such a commanding lead because the dyes were not present as precursors in the emulsion but

were (and still are) added during processing; this is why it is known as a 'non-substantive' colour film, as distinct from the usual 'substantive' variety where the precursors are incorporated in the emulsion.

Today, improvements in substantive films mean that the grain and colour saturation of Kodachrome can be duplicated and even surpassed; and this brings us back to dye inhibitors. As the film develops, the dye precursors not only release dyes: they also release by-products which increasingly inhibit the formation of more dyes. This means that (for

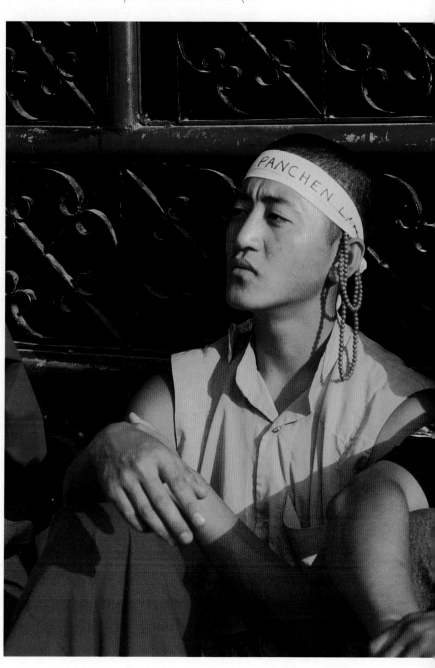

YOUNG MONK
The headband reads, 'Free the Panchen Lama', the second most important lama in Tibet after the Dalai Lama. He was abducted and imprisoned at the age of four; at the time of writing, six years on, no one had seen him since. Photographically, what is remarkable is that this is an ISO 200 film (Kodak E200) 'pushed' to EI 1000. The black could be more dense, but the other colours are astonishingly vibrant and saturated.
LEICA M4-P HAND-HELD, 90/2 SUMMICRON. (RWH)

BURNING TREE STUMP
Anyone who is honest will admit that often, film choice is more a matter of what happens to be in the camera than of careful planning and consideration. This was Velvia, which has given wonderful colours and saturation; the negligible depth of field is as much a consequence of the image size (about one-fifth life size) as of the need to use a particularly wide aperture.
NIKKORMAT FTN HAND-HELD, 90/2.5 VIVITAR SERIES 1. (FES)

example) heavy dye release in the blue-sensitive layer(s) is accompanied by a corresponding release of dye inhibitors. These automatically limit contrast, and by diffusing through the other layers, they also inhibit the release of other dye colours, resulting in improved saturation.

The contrastiest colour film of all time was probably the old East German Orwo material, now happily long forgotten. It gave lots of colour saturation (though not necessarily very convincing colours), but at the price of horrendous contrast. Of course this could be used creatively, but for many shots, it was totally inappropriate.

For the reasons given above, modern films deliver better saturation than old ones, without the grievous contrast penalty. The first of the new generation of high-saturation slide films was Fuji Velvia, which tended to be a 'love it or hate it' film: colour was wonderfully saturated, and still lifes of fruit and the like could be really eye-popping, but contrast was still higher than many people liked, and exposure was very critical. To make life still more interesting, few found that they could get results they liked at the rated speed of ISO 50: in practical use, Els of 40 and even 32 were quite common. Kodak's 100VS, introduced in 1999, marked the coming of age of this sort of film, still with powerful saturation – again, to be honest, more than many people liked – but with more believable contrast and surprising exposure latitude at its rated ISO 100 speed.

Colour negative films had, however, solved the problem somewhat earlier, via the adoption of a fourth, cyan-sensitive emulsion layer. Although this produced a bare minimum of dye, it produced a goodly amount of dye inhibitors, allowing still better control of contrast while retaining good saturation. All the latest colour negative films use similar technology, and the improvements are spectacular: films like Fuji's Reala series and Kodak's Portra are genuinely better in every way than their predecessors.

COLOUR BALANCE

This is almost entirely a matter of taste, though we always bear in mind a wonderful remark from the late, great Terence Donovan: 'Have you ever had a client complain because the picture is too ****ing warm?'

It is also worth bearing in mind that a

transparency film which is superb when slightly 'rich' (that is, under-exposed) may be milk-and-waterish when over-exposed, while another film may be light and airy when given a touch of extra exposure but dark and muddy with the same amount of under-exposure. As a (very) general rule, fast films tolerate over-exposure better, and slow films tolerate under-exposure better.

Colour balance is principally a matter of concern with slide films, as an immense amount can be done with negative films at the printing

LEAVES
One of the hardest things for any photographer to get used to is the discontinuation of a favourite film. This would win no prizes for sharpness, but the colours are wonderful. It was one of the last rolls of Fuji's ISO 50 RF/RFP, which was probably Roger's favourite colour film of all time.
NIKKORMAT FTN HAND-HELD, 90/2.5 VIVITAR SERIES I MACRO. (FES)

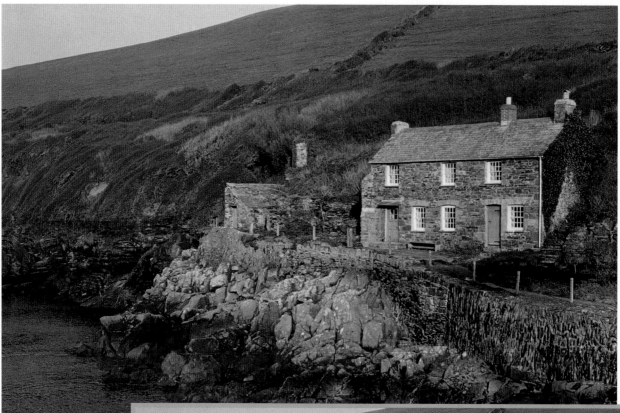

CORNISH COAST
One of these prints looks like high summer, the other like autumn. Neither colour balance is remotely 'correct', but each looks convincing enough at a glance – until you compare it with the other. Colours in nature vary widely, and besides, the human eye can accept almost anything as long as there are no obvious key tones such as human skin or a neutral grey.
LINHOF 'BABY' SUPER TECHNIKA IV ON TRIPOD, 105/3.5 XENAR ON 6X7CM, KODAK VERICOLOR. (FES)

stage; recent advances in colour print developer chemistry may also lead, in due course, to variable-contrast print developers.

Even so, there are detectable differences in the relationships of the colours in print films which cannot entirely be ascribed to saturation and contrast, and there is no doubt that some professional colour negative films (especially at ISO 160, the favourite of wedding photographers and portraitists) are balanced more with an eye to skin tones than with an eye to landscapes.

EXPOSURE AND SHARPNESS

Less exposure means greater sharpness, at least down to the point where the image density is too low to distinguish. On the other hand, as repeatedly noted elsewhere, many people prefer the tonality which they get from more exposure. The ideal compromise is clearly a matter of taste, but it is worth repeating that with 35mm, you cannot afford to throw away as much sharpness as you can with roll film or large format.

CHOOSING FILMS

From the above, it is clear why there is such an enormous choice of films. The market is driven partly by the sheer pressure of technological advance, and partly by photographers' desire for choice; the latter, it must be said, greatly tempered by conservatism, so that frankly obsolete films often continue in production long after they have been superseded.

The single most important point, reiterated throughout this chapter, is that you should choose a film which suits you. But what if you are not particularly happy with the film(s) you are currently using? And what if you have the suspicion that there might be something better out there? Should you change films? We ask (and also attempt to answer) that question in a few paragraphs; but before that, there are some general points worth making.

SLOWER FILMS ARE FINER-GRAINED

A perennial question is, 'Will I get finer grain by developing a faster film in an ultra-fine-grain developer, or by developing a slower film in a speed-increasing developer?'

The answer is that the slower film will almost always be finer-grained, unless you do something really strange in exposure or development. Speed may not be all that much different, either. Develop Ilford HP5 Plus in Perceptol, and you are unlikely to see better than ISO 250. Develop FP4 Plus in Microphen, and you may very well see ISO 200 – just ⅓ stop difference. The slower film will be finer-grained. The same would be true of FP4 Plus in Perceptol (ISO 100), and of Pan F Plus in Microphen (ISO 80).

SLOWER FILMS ARE NOT ALWAYS SHARPER

Although sharpness and grain are closely related, as noted elsewhere, they are not inseparable. Thus, for example, Ilford Delta 100 will, under most conditions of use, deliver better sharpness than Pan F Plus, despite the fact that Pan F Plus is 1 stop slower and somewhat finer-grained.

A less immediately obvious point, also made elsewhere, is that unless you are using a tripod, you may do better to use a faster film: the sharpness you lose with the additional film speed, you regain by avoiding camera shake.

LAZARETTO, MALTA
Until comparatively recently, the sixteenth-century lazaretto (leper hospital) on Manoel Island was still in use as an isolation hospital: Roger was treated there for diptheria in 1952. When this picture was taken in .1998, it was a crumbling, gutted ruin, largely as a result of some of the shorter-sighted policies of Dom Mintoff. Frances used an orange filter with XP2 Super to lighten the stone and darken the sky, then toned the print (on Ilford MG IV) in sepia.
CONTAX RX ON TRIPOD, 17/3.5 TAMRON SP.

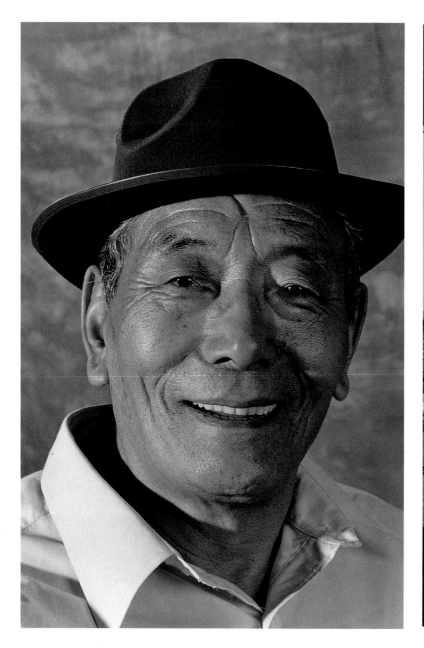

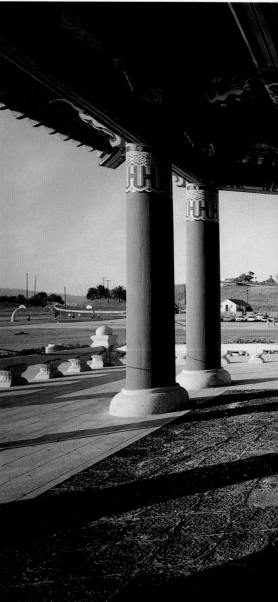

RESISTANCE FIGHTER
The Tibetan administration in exile wanted portraits of some noted people – this man was second-in-command in the Chushi Gangdrug resistance movement – and we had to work with what we had at hand. Although we would have preferred medium or large format, the famously sharp 90/2 Summicron on the Leica M4-P teamed up well with Ilford XP2 to give more than adequate results for a 'mug shot'.
CAMERA HAND-HELD PRINT ON MG WARMTONE, SELENIUM TONED. (RWH)

TONALITY IS A MATTER OF PERSONAL PREFERENCE

The examples given above, where a 'faster' film ends up with an ISO speed within ⅓ stop of a 'slower' film, might seem always to argue for the slower film; but you might (or might not) prefer the tonality which you get with the faster film in the ultra-fine-grain developer. You might also find that you preferred the tonality of either film in a 'normal' developer such as Kodak D-76/Ilford ID-11.

A perennial truth with black and white photography is that the only way to see if something works – or if you like it – is to try it.

IN MONOCHROME, BOTH OLD AND NEW FILMS HAVE ADVANTAGES

As already intimated, many photographers refuse to have anything to do with monosize crystal films: they put up with the inferior speed/grain ratio of cubic crystal in return for what they see as superior tonality. Also, as noted above, cubic crystal films are more tolerant of abuse than monosize crystal.

Paradoxically, we like Ilford 100 Delta much better in 120 and 4x5in than we do in 35mm, where the improved speed/grain ratio might seem to be much more important; and in 35mm, we shoot a great deal of 'old technology' Paterson Acupan 200, because we love the tonality.

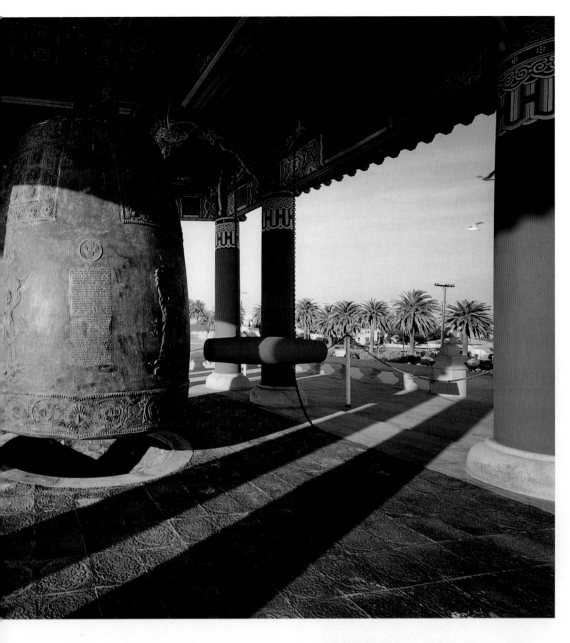

**KOREAN-AMERICAN
FRIENDSHIP BELL**
*This was one of the first
shots Frances took on
Kodak Portra 400 VC,
shortly after it came out;
it is now, without question,
her favourite colour
negative film. It is
impossible to try every-
thing new, but when
something comes out
which looks as if it might
suit your style of
photography, you owe it to
yourself to 'waste' a roll.*
ALPA 12 SWA ON TRIPOD,
35/4.5 APO-GRANDAGON
WITH SOME RISE, ON 6X9CM.

IN COLOUR, NEW FILMS GENERALLY HAVE THE ADVANTAGE

Although there are some wonderful old films such as Kodachrome 25, it is generally true that the newer a film is, the better its speed/grain ratio will be, and the more attractive the colours. This is, of course, assuming that you actually like the colours. Some people love highly saturated films; others hate them. Some greatly prefer a warm colour balance; others prefer something more neutral, though warmth is becoming more and more the norm. *De gustibus non disputandum est*, and newer films generally cost more money; but if you try them, you will often find that they are worth it.

SHOULD YOU CHANGE FILMS?

The choice of films is so wide that it would be entirely possible to spend all one's time shooting new and improved emulsions. This is especially true if you do not shoot much film – if you are the kind of photographer who rarely finishes one film in a day, let alone two or three. In fact, if you shoot fewer than a dozen or two dozen films a year, it is quite possible that the manufacturers will start gaining on you: new films will come out faster than you can try them.

There are, therefore, two possible approaches. One is that you stick with what you know, and eschew anything new. The other is endless

experiment. Each has its advantages. With the former, you can concentrate on making pictures; with the latter, you will have the benefit of the latest and best technology.

Neither extreme is ideal. We used to follow the first path. Then, by chance, we tried Ilford XP1 (as it was in those days). We suddenly realized that we had been missing out on a film with ISO 400 speed, and the grain of an ISO 100 film; so it joined our palette of films. Ever since, we have tried to keep the range of films which we use to a minimum, while trying at least the more

interesting-sounding films as they come out. Of course, the fact that we write for the photographic press means that we sometimes have to try more films than we really want to.

TOO MANY FILMS

It may sound odd to say that we have to try more films than we really want to, but the logic behind it is simple. Any picture has both an aesthetic and a technical dimension. With an unfamiliar film, there is always the danger of getting it wrong, technically: of wrong exposures or wrong develop-ment. There is also the danger that you simply will not like the film. If you have, in the meanwhile, used this new film to shoot a picture which you know would have been great on your old film, it can be mightily depressing.

The standard advice, of course, is that you should never shoot anything important on a new film. But how do you define 'important'? Whatever film we are using, unless we are looking for straight sensitometric and similar data, we like to try to make attractive pictures of the sort of subjects which we normally shoot. If we did not, after all, we could hardly make a meaningful comparison of the old and the new films.

What we do, therefore, is to go to the sort of place where we would normally expect to get good pictures, and then shoot at least two rolls of film: one of the old, and one of the new. We then accept that the new film may be disappointing (or, of course, that we may get it wrong).

This is, as far as we are concerned, the only way to test a new film: to blow a whole roll, straight off, alongside another film whose characteristics we know. A common reaction to this is, 'It's all right for you, but film is expensive.' Well, yes and no. A roll of film may not be a completely trivial purchase. But equally, it is not a fortune either. And if you want to learn what a film can do for you, there is no other way to do it meaningfully.

TOO FEW FILMS

The mirror image of endless experiment is sticking with a single film, or with a very limited range of films, for all your photography.

There are two disadvantages to this approach. One is that you will miss out on genuine technical advances, and the other is that you will become

ever more inward-looking, ever more preoccupied with your own pet theories or with those of some guru, with the result that the technical standard of your pictures actually deteriorates.

In large-format black and white, especially if you only ever make contact prints, you can pretty much get away with sticking with any one film. Sharpness and grain are hardly relevant, and you could get perfectly good results with the films of the 1950s or even the 1930s (though you might find the latter a little slow).

In medium-format monochrome, too, advances in sharpness and grain are far less important than they are in 35mm, and tonality is your main concern.

Move down to 35mm, and in our opinion you would be extremely foolish not to try new monochrome films from time to time. This is where magazine reviews come in handy. Oh, everyone knows that these tests are not always very objective; that all too many magazine articles are written by journalists, not photographers; that even the photographers may have a shaky grasp on how to test a film meaningfully; and that some magazines (not all) are unduly beholden to their advertisers and will not, therefore, even begin to hint that any new product is less than perfect. Even so, it is possible to read between the lines, and to form an opinion of whether a new film might, or might not, suit you.

In colour, our view is that you should always keep an eye on new films, regardless of format. At least once a year, a really good new film comes out. The most recent, as we wrote this, were Fuji Astia, and a whole slew from Kodak: the Portra negative series, the E200 Ektachrome which could be pushed to EI 1000, and Ektachrome 100VS high-saturation film. By the time you read this, there will be more.

OLD FAVOURITES

Trying new films most emphatically does not mean that there is no room for old favourites. In large format, we still use a great deal of Ilford FP4 Plus and Ilford Ortho Plus (the successor to Ilford Commercial Ortho), alongside Delta 100 and a constantly changing array of colour transparency films. In medium format, alongside Ilford Delta 100 again, Ilford's XP2 Super (which should really have been called XP3) replaced the old XP2 easily,

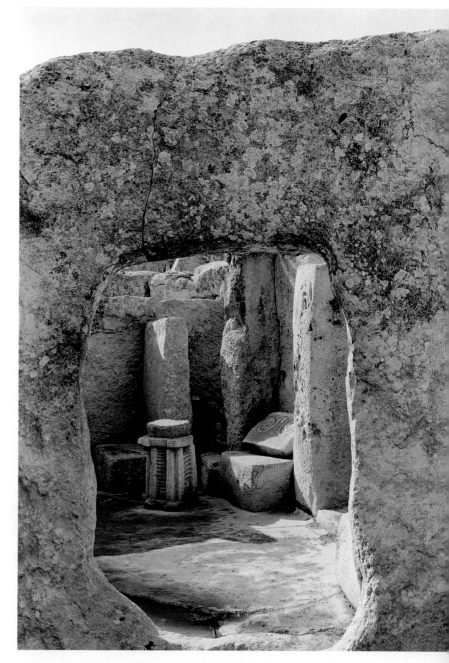

because it is an even better film which effectively offers more of the same. In this book, too, you will find a good deal of HP5 Plus, a film to which we had returned after many years' absence: we were given some to test a camera with, and found that the Plus version was much better than the pre-Plus version. In 35mm, along with the Ilford Delta 100 and XP2 Super, and Kodak's latest Ektachromes, we still have a weakness for dear old Kodachrome 25, the tonality and colour of which remain profoundly attractive to this day – even though Kodachrome long ago lost the easy lead which it once enjoyed in grain and sharpness.

HAGAR QIM
The vintage tonality here is the result of using a vintage-style ortho film, Maco Ort 25. We find that in order to get the tonality we like, without using special developers, we have to rate it at EI 6. Ortho films are of course insensitive to reds, and of limited sensitivity to the yellow of the sandstone from which this 5000-year-old temple is built.
LINHOF 'BABY' SUPER TECHNIKA IV ON TRIPOD, 105/5.6 APO-SYMMAR ON 6X7CM. (RWH)

BUYING FILM

Regardless of the film you choose, the most important single thing is that it should be fresh and well stored. There are few greater mistakes than struggling with outdated, foggy monochrome films which have lost a stop or so in speed, or with colour films where the colours are wobbly and you cannot rely on the same colour balance in the highlights and the shadows.

The only way to be confident that your film is of high quality is to buy it from a dealer with a good turnover and good storage facilities. But even with so-called 'pro' dealers, this may be problematical. In Las Vegas, for example, we found a store where Kodak and Fuji materials were cold stored, while the few rolls of Ilford material were not. They were suspiciously short-dated, too. This does not necessarily matter, but given that when we buy Ilford films we normally see expiry dates which are eighteen months or more in the future, we could not help suspecting that this particular store made no great effort to sell Ilford materials, and we know they made no real attempt to store them properly.

Even if a film is well in date, poor storage can wreck it. The classic example is storing it on top of (or next to) a radiator, where even a few days of excessively high temperatures can remove any chance of getting ultimate quality.

On the other hand, a really well-stored film, especially one which has been kept at under about 12°C (55°F), can remain eminently usable for months or even years after its 'best before' date. Some films keep much better than others, but we have used films which were as much as two or three years out of date with perfectly acceptable results. Normally, we will only use such films if they have been in our own refrigerator, but we quite happily buy outdated films from Freestyle in Los Angeles, who buy up manufacturers' old stock and then store it in refrigerated warehouses themselves.

From what we have been able to discover, freezing films does no harm, but unless you really need to do it for seriously long-term storage, there is no advantage: for a few months or even years after the 'best before' date, chilling is all you need. Slow films respond better to chilling that fast ones; with really fast films, one of the chief causes of image degradation is apparently background radiation, including cosmic rays. If you are going to freeze film (or paper, for that matter), use a frost-free freezer if at all possible, and double-wrap the material in freezer bags.

'AMATEUR' AND 'PROFESSIONAL' FILMS

Before 'professional' films were introduced, it was common practice among professionals to buy their colour slide film in quite large quantities, of the same batch number, and to shoot the same subject on one roll of the previous batch, and one roll of the new batch. This would show up variations in speed and colour balance, which could then be allowed for. Speed variations of up to ⅓ stop were not unusual, and colour variations of plus or minus 10 CC (Colour Correction) units were fairly common too. The studio in which Roger worked in the 1970s used to do this.

Then, again in the 1970s, came 'professional' slide films, where the actual, batch-tested speed was printed on the film instruction sheet alongside the nominal speed. This was almost invariably slower, so a lot of 64 ASA film was actually 50 ASA, but at least you knew what it was, and colour variations were more closely controlled, partially by reclassifying out-of-spec films as 'amateur' and partially by maturing the film to a given colour aim point and then putting it in cold storage to keep it there. Historically, fresh films were literally green, and elderly films were magenta; the manufacturers controlled colour by keeping them until they hit the colour aim point.

Next, with improved manufacturing techniques, all professional films came much closer to the nominal speed, and the practice of quoting separate speeds was dropped, though refrigeration was still used to ensure colour consistency.

Today, with still further improved manufacturing techniques, there is very little reason to buy 'professional' slide films unless you are going to use them under 'professional' conditions: that is, keeping them cold stored until a few hours before you use them, shooting the entire roll under controlled lighting where roll-to-roll variations in colour may be apparent, then having the roll processed immediately (or cold storing it until it is processed). What is more, you must stick to the same pro lab: there are tiny variations in colour

balance even between top pro labs, though any one good pro lab will normally remain consistent. For normal outdoor photography of varying subjects – a few frames of this, a frame or two of that – there is no sense at all in buying 'professional' slide films, especially if you have the films processed in different places.

In colour negative, some 'professional' films are designed for lower contrast and better skin tones than 'amateur' films, which are designed for bright, saturated colours; but apart from these (which are mostly ISO 160) there are more variations in processing than there are in films, though 'pro' labs do tend to be more consistent than amateur labs. In monochrome, the term 'professional' is pretty much meaningless. Provided you buy your film from a reasonable dealer with a good turnover, and provided the manufacturer has not made any changes to the film (which are normally signalled with words like 'Plus' or 'Professional') there is absolutely no need to batch-test your films, even though there may have been such a need in the 1940s, when the Zone System first came into vogue.

OFFICE INTERIOR
Shooting Delta 3200 in a medium-format camera will not, in one sense, give any better quality than shooting Delta 100 in 35mm; but it gives that quality more easily, with at least equal depth of field, and better action-stopping. What is more, the bigger negative is more resistant to abuse or to commercial printing (which are often the same thing).
ALPA 12 SWA ON TRIPOD, 35/4.5 APO-GRANDAGON ON 6X9CM. (FES)

A chapter on non-photographic skills may seem a little eccentric in a book on photography; but the simple truth is that a lot of the things which lead to high-quality pictures have very little to do with photography. They can be divided into three categories: personal, aesthetic and organizational.

There is (or can be) considerable overlap between the three, but the basic premise is this:

often, unsuccessful pictures are not the result of any particular lack of conventional photographic skills. If you have taken technically sound pictures of other subjects before or since, or of the same subject at other times, then there must be some other factor at play.

You can ascribe your failures to bad luck, and your successes to good luck, and there is no doubt that luck plays as large a part in photography as in

DORMITORY
It is often difficult to gain admission to a refugee camp. Gaining admission to a girls' dormitory can be even more difficult, especially for a male photographer. But we were shooting with the backing of the Tibetan Government in Exile, and had both a letter of introduction and a Government 'minder' (Tenzing Dandul). We asked the girls to move during the exposure, so that they could not be recognized: some may return to Tibet, where they would risk rape, torture and death if the Chinese found that they had been to India, and not (as they said) on pilgrimage.
ALPA 12 SWA ON TRIPOD, 35/4.5 APO GRANDAGON, ILFORD XP2 SUPER. (RWH/FES)

many other aspects of life. But equally, there is something more perceptible, more under the photographer's control: it is very difficult to take good pictures if your heart is not in it. Fortunately, 'heart' in this sense can, and to a considerable extent, be acquired and manipulated.

PERSONAL QUALITIES

Perhaps the most important personal quality, unless one is touched by genius, is passion. As discussed on page 14, it is much easier to take pictures of something you care about, than it is of something for which your appreciation is primarily intellectual.

A secret here is working with what you have: for

us, for example, a picture with an historical slant to it, even if it is a still life or an interior, is easier than something with no history. It does not have to be very remote history, but it has to be a part of a continuous thread, an historical context. Tibetans in exile, for example, are part of an historical context; a shopping mall, continuously re-inventing itself, is not, at least to us.

By the same token, neither of us is particularly drawn to portraits; but we both like reportage, so if we put a person in a man-made environment, or photograph them in a reportage style, we can make acceptable portraits. Marie Muscat-King, several of whose pictures appear in this book, is far better at portraiture, turning out pictures we could not hope to emulate except very occasionally, with a lot of luck. But ask her to shoot a room interior, and she would need to put a person in the room to get the best possible picture, where we would probably shoot a highly formal empty room.

PERSEVERANCE

One of the stupidest sayings of all time is that quitters never win, and winners never quit. This is the exact opposite of the truth, because knowing when to quit – realizing that you are not getting anywhere, and that you are not going to get any-where – is the essence of knowing how to win.

The mirror image of knowing when to quit is, however, knowing when not to quit. You may have to visit a place a dozen times; you may have to buy or rent different equipment, or try different techniques, or learn new skills; you may have to apply again and again for a permit to go somewhere... That's all fine, as long as the game is worth the candle. But periodically, ask yourself whether you might not get better pictures elsewhere, with the same (or less) effort.

Also, try to separate picture-taking possibilities from the other attractions (or indeed drawbacks) of a place. We love the Greek islands: the whitewashed cubist houses, the tiny churches, the occasional ruins, the food, the wine, the wild-flowers in spring, the scent of the air. And for sheer delight in being in a place, Dharamsala in the Himalayas is hard to beat: it is the seat of the Tibetan Government in Exile, and we probably have more good friends there than in any other city or town in the world. Malta, too, is one of the

TIGER BAG
It is amazing what people will lend you, if you take the time to talk to them and explain why you want the shot; we were once lent a 600g (20oz) gold nugget, though the owner did stay nearby as we photographed it. Things like this wonderful tiger bag make ideal souvenirs, and good illustrations for travel articles – but you don't want to have to buy every souvenir you shoot.
CONTAX RX ON TRIPOD, 100/2.8 MAKRO-PLANAR, FUJI VELVIA. (FES)

most magical places in the world, its history as many-layered as an onion. We get good pictures in all three; but when it comes to good pictures per week's stay, Malta comes out well ahead.

DEALING WITH PEOPLE

Some people are easier to get on with than others – and your attitude to a whole organization or even a whole nation can be affected by the first few people you meet, like the Turkish immigration official who barefacedly stole £10 (about half a million Turkish lire) when we entered the country.

The point here is rather like the one made above, about knowing when to quit. Don't make too many promises that you can't keep (there will always be some that fall through, with the best will in the world), but equally, don't underestimate the goodwill that even a small or incomplete gesture can generate: a picture, an introduction, a good word. If you are shamefully late in doing something, do not just abandon it: apologize for being shamefully late, and do it anyway.

If you have to deal with someone you really cannot stand, then if he is a mere stepping-stone, grit your teeth and deal with him; but if he is the final arbiter, then ask yourself if there is not another line of attack.

Make at least a modest attempt to fit in with an

alien culture, whether it is half-way around the world or at your local camera club; trying to tell other people how to organize their lives is a sure and certain way to lose friends unless you are a management consultant or other religious leader, in which case people pay you to do it.

AESTHETIC SKILLS

Once upon a time, photographic books like this one used to set out, in all seriousness, 'Rules of Composition'. Applied as hard-and-fast rules, these were a complete waste of time. Not only is it possible to apply every rule in the book, and still end up with a totally dull picture: the 'rules' were often mindlessly applied to every picture submitted for judging in club (and to a lesser extent, even magazine) competitions, and unless it fitted the 'rules' it was marked down, frequently to the benefit of a dull, sterile picture which did follow them.

Unsurprisingly, this led to the rules falling into contumely. But the problem is that there is a lot of truth and value in them. They will not make a formulaic picture good (though they may make it easier on the eye), but surprisingly often, successful pictures will illustrate that the rules are good guidelines. It is worth skimming through these, and through other specifically photographic considerations of composition, in a moment; but before that, there are two other suggestions which may improve your pictures.

LOOK AT PICTURES

Do not just go to photo galleries, as advised on page 11: go to art galleries, museums, displays of cartoons, anything where visual awareness is at a premium. Look at how Rembrandt handled the light in *The Company of Captain Frans Banning,* or at how Van Gogh handled it in *The Potato Eaters* or *Starry Night.* Look at the flatness of Greek and Russian Orthodox icons; at the dramatic chiaroscuro of Joseph Wright of Derby.

Do not confine yourself to conventional, figurative art, for that matter: look at work by Wassily Kandinsky, Bridget Riley, Mark Rothko, Jackson Pollock. Some shapes, lines and arrangements of colours are more attractive than others. Why? It is all but impossible to say; but after a while, you start getting a feeling for it.

Read books and magazines. Again, this does not just mean photography books and magazines. Look at newspapers: the *Financial Times* has some of the best non-photographic illustrations in the business. Look at the use of shape and line and masses of light and dark, even in the cartoon strips.

TRY AN ABSTRACT EXPERIMENT

Cut a few shapes out of black card: circles, squares, triangles. Cut some more out of white card. Arrange the shapes on a large rectangle of grey card. Try compositions with just one or two elements; then try them with multiple elements. Try white on black, black on white, grey on black; cut out colours and see how they work.

This is an extension of the advice given above to look at non-figurative art. It sounds a little precious, but it is surprising how well it works. It can also be a surprisingly relaxing way to spend a few minutes while you are waiting for something, or watching a more than averagely tedious television programme.

PRACTICAL COMPOSITION

Composition in photography begins with choice of format and focal length. Format is particularly interesting, in that many people seem to believe that there is an inherent virtue in refusing to crop. They therefore adhere religiously to the long, thin 35mm format (1:1.5), or the stumpy 4x5in format (1:1.25), without deviation. They even print the black film border, as proof of their 'integrity'.

While black borders, or for that matter Polaroid processing artefacts from the pos/neg films, are perfectly good compositional adjuncts, it is of course the case that if you change formats, you can also change image shape, and quite possibly, the whole look of the picture. *Aficionados* of 5x7in (1:1.4), in particular, will tell you that this is the most perfectly proportioned of all formats.

Another straitjacket into which photographers force themselves is standard paper sizes; again, most particularly, the stubby 8x10in/16x20in format, 1:1.25. The 11x14in size, popular in the United States, is only fractionally longer at 1:1.27, while the old 12x10in size is even closer to square at 1:1.2. Then there is the 12x16in format, which at 1:1.33 comes closer to 5x7in. These are only

the imperial formats: popular metric sizes include 18x24cm (1:1.33 again), 30x40cm (effectively 12x16in) and 40x50cm (1:1.25 again).

For some reason, the rational, 'halvable' DIN A-series (1:1.414, such as A4, 210x297mm) has never caught on as a photographic paper, though arguably it is both aesthetically and practically superior to 1:1.25 formats, and it is of course the international standard for documents and even ink-jet paper (except in the USA).

If, for reasons of convenience, you use a format which does not suit either your personal preferences or the demands of a particular composition, you should not hesitate for one second to crop.

BAND PRACTICE AT MURPHYS, CALIFORNIA
An important skill for any photographer is being unobtrusive, or perhaps more accurately, not being obtrusive. We have seen people stand up suddenly, old-fashioned motor-drives clacking, at the holiest points of religious ceremonies, or during quiet passages at a concert. These are the acts of a barbarian: having a camera in your hand does not exempt you from the normal rules of decency. HAND-HELD LEICA M2, 90/2 SUMMICRON, KODACHROME 64. (RWH)

Two crops which we do all the time are 8x10in to 7x10in (or thereabouts) and 6x12cm to 5x12cm (or thereabouts). We find that 8x10in is too stubby, while 6x12cm is too long for a normal rectangular composition, but too short for a panorama. After years of trying both 6x12cm (1:2) and 6x17cm (actually about 56x170mm, 1:3), we have come to the empirical decision that something close to 1:2.5 is about the best shape for most panoramas, so we also crop 35mm to 16x36mm; 6x7cm (56x72mm, 1:1.29) to 30x72mm; and 6x9cm (56x84mm, 1:1.5) to 34x84mm.

THE 'RULES' AND PRINCIPLES OF COMPOSITION

The two most basic considerations are the concepts of tonal mass and of picture elements.

Tonal mass is what you see when you half-close your eyes, or squint at the picture: the broad areas of light and dark. Picture elements are a more complex consideration, because, for example, two people standing side by side could be a single picture element if they are distant from the camera, close to each other, and dressed alike; or two picture elements if they are the principal subject of the picture, or if one is wearing grey and the other bright red. A picture element is perhaps best defined as a 'thing that you notice', which is a pretty loose definition, but easy enough to understand in practice.

Balance A large mass of tone on one side of a picture was supposed to be 'balanced' by a smaller mass on the other. Some people, with Ankh-Morporkian literalism, even drew little sets of scales, with a fulcrum in the middle and the large mass on a short arm counterbalanced by the smaller mass on a longer arm. This is almost certainly taking the idea too far.

Centre [of attention] Not literally in the centre of the picture, this is a picture element which immediately draws the eye. From that initial position, the theory goes, the eye will explore the rest of the picture; without it, the picture will lack 'focus' (again, not in the usual sense of lens focus) and it will not be as interesting. People make an excellent centre of attention, as the eye is always drawn to them first, but it can be something as trivial as a wheelbarrow or a mail-box.

Compositional shapes These are the broad shapes of the principal areas of light tones (against a dark background) or dark tones (against a light

PACIFIC COAST HIGHWAY
The all-in shot is attractive, but as we were scanning the transparency in order to make a reference print, we noticed the crop. Seeing pictures inside pictures may or may not result in technically successful crops – sharpness can never be as high as 'all in', though softness works well enough here – but it may lead to more pictures, and better composed pictures, another time.
NIKON F ON TRIPOD, 35/2.8 PC-NIKKOR, KODACHROME 64. (FES)

THE 'THEATRE' AT KNOSSOS
Foolishly, we did not pay the (relatively modest) tripod fee which is charged in addition to the admission fee at Knossos, so the range of pictures which we could take was limited. When we go back, we shall not make the same mistake again. Although this is called the 'theatre', and is believed to be the oldest purpose-built performance space on the planet, no one knows what it was actually for.
LEICA M2, 35/1.4 SUMMILUX, FUJI RFP. (RWH)

background); or alternatively, the shapes formed by the principal picture elements. Traditionally, a circle was seen as a unifying composition, suitable for combining members of a family or a group; a triangle on its base as a stable but dynamic composition; a triangle on its point as an unstable composition; and a square as a restful or even dull composition.

Diagonals These are supposed to be 'dynamic', as against horizontal or vertical lines which are 'stable'.

Horizontal and vertical compositions Horizontal compositions were always reckoned to be restful, stable, enduring, earthbound, peaceful; vertical compositions were described as aspirational, soaring, heavenly, energetic. This sounds like complete twaddle until you start thinking about the different ways in which you might perceive pictures of a castle, say, or a nude, in the two orientations.

Leading the eye into the picture This consists of using a line which leads from the edge of the picture, preferably the lower half of the front of it, to the principal subject, or to the subject to which you wish to draw attention.

Rule of thirds Probably the most useful of all the 'rules', this suggests that you should mentally divide the image area into thirds, vertically and horizontally, like a noughts-and-crosses (tic-tac-toe) board. This will give four intersections: upper left, lower left, upper right, lower right. The principal subject (or again, the subject to which

the photographer wishes to draw attention) should be at or near one of these intersections.

S-curves A popular sort of line for 'drawing the eye into the picture' as described above. Garden paths, streams, any sort of wavy line: all have been pressed into service as 'the S-curve', known to its detractors as the S-bend.

ORGANIZATIONAL SKILLS

The organizational skills required of a photographer may be taken to include the 'people' skills

FLOWERS IN VASE
All right, it's a bit chocolate-boxy, but it also has considerable impact, principally as a result of placing the bright flowers against the shaded background — a common trick among painters of still lifes. You can learn as much from painters as from other photographers. The backdrop is home-made from a painter's drop-cloth and some fabric dye.
LINHOF TECHNIKA 70 SPECIAL ON STUDIO STAND, 105/5.6 APO-SYMMAR ON 6X7CM FUJI VELVIA. (FES)

mentioned above, but here we are concerned with two other aspects. One is the degree of organization that is required to make sure you have all the equipment and materials that you need, and the other is how you spend your money in order to get good pictures.

The former is most easily solved with checklists. We have found these particularly valuable when we are tired and packing our kit late at night for a trip the next day, or when we are in a tearing hurry because we have decided to go somewhere at short notice. We have also seen the same sort of problem among our friends, when the rest of the party is ready to go, and the photographer is still agonizing over equipment.

Our checklists live on the computer, where they can be printed out in multiple copies and where (equally importantly) they can be updated to reflect changes in our equipment. To help you create your first checklist, don't rely only on memory. Make a 'dry run' as if you had just arrived at your location and were about to take a picture. This is the time to find that you need a ¼–⅜in tripod adapter, or a camera strap for the second body – not when you arrive for real!

SPENDING MONEY TO GET PICTURES

It is remarkable, as noted elsewhere, how photographers will spend a fortune on cameras and lenses, and then try to economize on film. No less remarkable is the way in which they will begrudge other ways of spending money in order to get pictures; and we do not exclude ourselves.

For instance, we find it difficult to bring ourselves to spend a bit extra on a hotel room

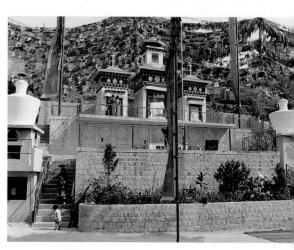

CENTRE OF ATTENTION
In one of these pictures, the eye goes first to the woman on the stairs, with the basket on her head; then to the child below her; then to the figures in front of the door. In the other, the figures are all in the wrong places and are a mere distraction.
CONTAX ARIA HAND-HELD, 100/2.8 MAKRO PLANAR, ILFORD XP2 SUPER. (FES)

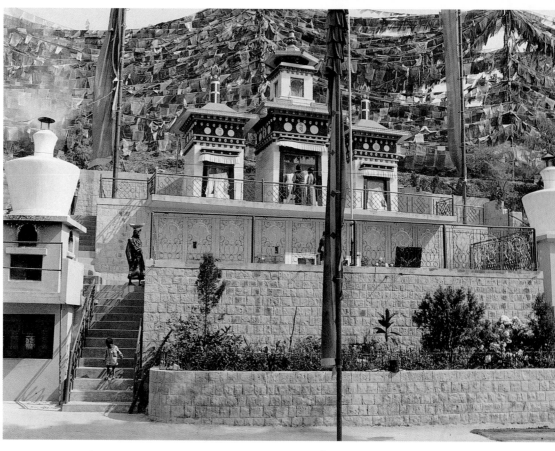

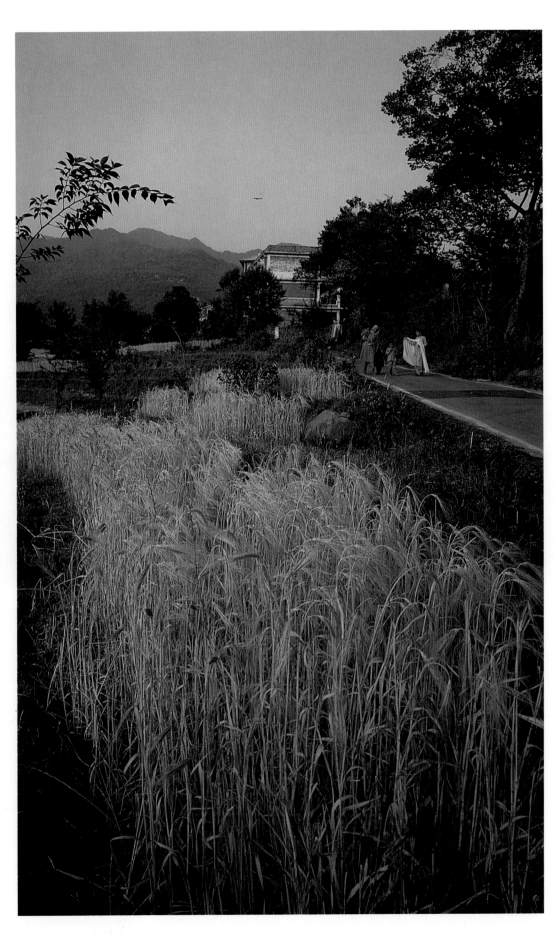

BARLEY FIELD
Without the vivid colours of the salwar-kameez outfits, this would be a very dull picture; but we could hardly have had better colours if we had hired models. Because Indian roads seem always to be busy, we had to wait only a few minutes until someone came along.
ALPA 12 WA HAND-HELD, 38/4.5 BIOGON ON 44X66MM, FUJI ASTIA. (RWH)

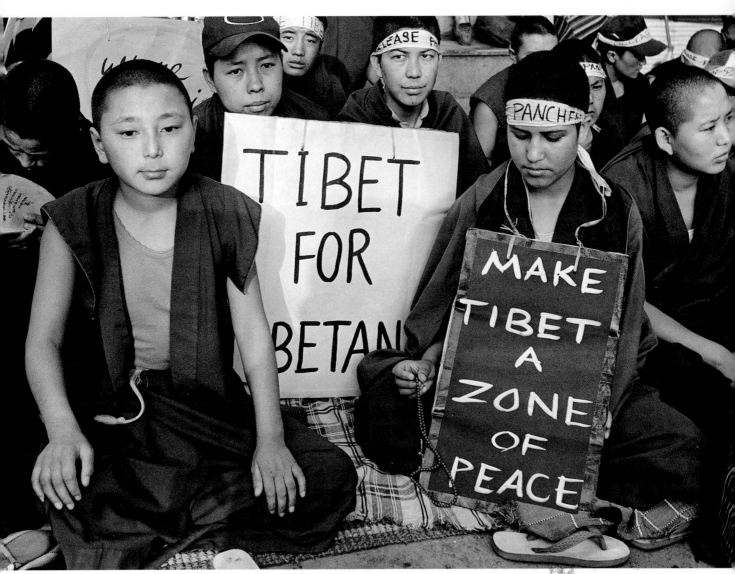

TIBET FOR TIBETANS
A horizontal composition emphasizes the enduring nature of the protest: here we are, and here we stay. One should never let theoretical considerations like this become hard-and-fast rules, but it is surprising how often they apply.
CONTAX ARIA HAND-HELD, 35/1.4 DISTAGON, ILFORD XP2 SUPER. (FES)

which is nearer the place where we want to take pictures in the morning; or to lay out the (usually absurdly modest) fee that is normally required for a tripod permit; or even to pay admission fees.

Admittedly, in one way, we have to keep our costs down, in that this is what we do for a living; but in another, if we stop and think about it, we are often surprised at the effort we go to in order to save ridiculously small amounts.

We find it less difficult to make sure that we are well rested and well fed. Both of us need a lot of sleep, and (unfortunately for our figures) we are altogether too fond of our food. But even so, we sometimes have to make a conscious effort to spend a little more money on a room, or what we regard as too much money on too little food, or on food of inferior quality, in order to be where we need to be.

Examples can be multiplied. Good, warm clothes

are essential for some sorts of photography: a four-hour religious service, starting before dawn, out of doors, at 1800m (6000ft) in the Himalayas, can be pretty chilly. Strong, comfortable boots are needed for walking; high boots are advisable in snake country, or where there are thorny bushes; a hooded rain-cape is ideal during the monsoons.

One thing we have very rarely done, and cannot recommend, is bribery in order to take pictures. To begin with, bribery, like blackmail, feeds on itself, and you will often face further demands – often from people who crowd into the picture, under the entirely mistaken impression that you actually want to photograph them or, sometimes, in the hope that you will bribe them to go away. Second, bribery may work at one level, and be blocked at the next – in which case your initial bribe may have been wasted. Third, we have always found

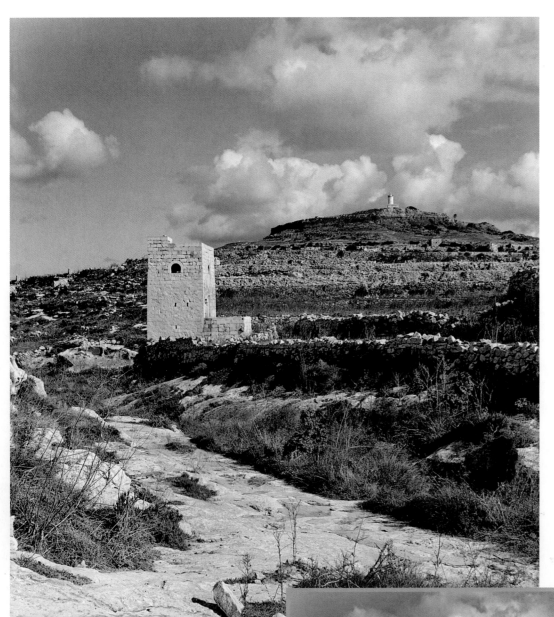

NORTH-WEST GOZO
The 'rule of thirds' is far from binding, and even when it is used, the centre of interest does not have to be precisely on the thirds; both the tower and the lighthouse would be regarded as being 'on the thirds' by most camera-club judges. Two other compositional tricks are illustrated here too: 'balance' (the tower and the lighthouse) and 'leading the eye into the picture' (the road in front). Arguably, the picture is strengthened by cropping as shown – when both 'thirds' and 'balance' are better demonstrated.
LINHOF 'BABY' SUPER TECHNIKA IV ON TRIPOD, 100/5.6 APO-SYMMAR ON 6X7CM ILFORD DELTA 100. (RWH)

that a genuine interest in the subject, a decent respect for the culture, and (where necessary) a little judicious flattery are simply more effective techniques to employ.

We don't have any great moral problem with small bribes, which in many instances are indistinguishable from charitable donations, or at least from tips, because in most cases, you are simply dealing with someone who is trying to make the best living he can.

CHAPTER EIGHT

SHOOTING

A photograph is not, never was, and never can be an objective representation of the world at large; and anyone who says it is, is either a fool or a liar. At the very least, the photographer decides first, to take a picture; second, where to point the camera; and third, when to press the shutter.

The only realistic choice, therefore, is between visualization – having a clear idea of what the final picture will look like, before you press the shutter – and seizing the moment without necessarily having any very clear idea of exactly what the picture will look like; a technique which might fairly be described as 'shoot first, ask questions afterwards'.

In practice, this is not a clear choice: there is a spectrum between total control (such as a studio still life, or a carefully composed landscape) and raw chance (the unexpected picture, grabbed in a moment). The trick is to move the aim point as far towards control as possible, without sacrificing spontaneity when that is necessary.

The classic example of combining the two approaches is, perhaps, Ansel Adams's most famous picture, *Moonrise, Hernandes, New Mexico*. Apparently he saw the scene while driving along; more or less screeched to a halt; and set up his 8x10in camera as quickly as possible. In one sense, it was a grab shot. In another, it is a textbook example of visualization: he saw the shot, knew what he wanted the final picture to look like, and composed and exposed accordingly.

At this point, it may make sense to stand the search for quality on its head: instead of looking at what you want to achieve, look at what you want to avoid. The first thing you want to avoid is extraneous (or insufficient) material in the picture: this is essentially a matter of composition,

BOTTLE AEROPLANES
These wonderfully vivid and inventive toy aeroplanes were a hundred yards from the oldest ruins on the planet, Ggantija at Xaghra in Gozo. Roger reckoned that with Fuji RA, he could easily afford 1 stop of under-exposure (as compared with an incident light reading) to 'pop' the colours without leading to problems with the glaring white plastic; this was the resulting image.
LEICA M4-P HAND-HELD, 35/1.4 SUMMILUX.

which was covered in the previous chapter, but it also has a good deal to do with choice of focal length, and viewpoint. The second is camera shake and poor focus, and the third is poor exposure.

FOCAL LENGTH AND VIEWPOINT

Although our conviction wavers, we have increasingly come to believe that most photographers (including us) use too many focal lengths. In 35mm, we both find that the vast majority of our pictures can be taken with just two focal lengths. Roger uses a 35mm/1.4 Summilux and a 90/2 Summicron, while Frances uses two 35mm lenses (f/1.4 Zeiss Distagon and f/2.8 Zeiss PC-Distagon) and a 100/2.8 Zeiss Makro-Planar.

We do much the same in larger formats. For both 4x5in and 5x7in, the choices are 110mm (in 35mm terms, about equivalent to 28mm on 4x5in or 21mm on 5x7in) and 210mm (about equivalent to 60mm on 4x5in, or 45mm on 5x7in), though we sometimes add 300mm for 5x7in (about equivalent to 60mm on 35mm again). On 8x10in, the 300mm is our standard lens for almost everything, replacing an older 360mm, though we have been known to use a 21in (533mm) f/8 Ross from the 1890s for portraiture.

Of course these are personal choices, but equally, we have found that restricting our range of lenses means that we spend more time taking pictures, and better pictures at that. Yes, we may occasionally see shots where we wish we had a longer lens, or a shorter one; but in general, there is a compositional 'fix' which can be applied, or we can simply walk closer, or go further away.

In fact, when we started using Alpas, we found that even a single lens could do far more than one might reasonably expect. Roger most frequently uses a 38mm f/4.5 Zeiss Biogon on 44x66mm, almost exactly equivalent to 20mm on 35mm, while Frances normally uses a 35mm Rodenstock Apo-Grandagon on 56x84mm, almost exactly equivalent to 15mm on 35mm; because the 44x66mm and 56x84mm formats are 1:1.5 like 35mm, exact comparisons are possible, whereas with different formats, they are less meaningful.

Despite the fact that these are extreme wide angles, and therefore preclude many types of shot, we have found that surprisingly often, we can find pictures which suit the cameras and lenses we are carrying. We are talking, after all, about taking pictures for personal pleasure, or to illustrate travel and similar articles. The news or sports photographer may well have a need for extreme telephotos, but our argument (as rehearsed on page 34) would be that extreme telephotos are, for the most part, incompatible with the ultimate in technical quality anyway. Equally, the Alpas are completely unsuitable for portraiture, except perhaps for a certain kind of reportage or environmental portrait; but for these, 90 or 100mm lenses on 35mm, or an old 150mm lens on 6x7cm (roughly equivalent to 70mm on 35mm), will suffice.

There is, after all, a real difference between having to take a picture of a particular subject, and taking a picture for the picture's sake. 'Pictorialism' has acquired a bad name over the years, with overtones of formulaic camera-club photographs which adhere slavishly to the Rules of Composition outlined on pages 88–9, but inherently, pictorialism is what this book is about. A photograph which derives its primary impact from its content does not have to be technically very good; but a picture which shows something more or less familiar, as if for the first time, must be technically excellent.

MOVING ABOUT

'Your legs are the best zoom lens,' runs an apposite saying, and there is more to getting the picture than merely moving closer or further away.

AFTERNOON SUN ON TERRACED FIELDS
Roger is still unsure about cropping this picture. As it stands, it has three broad, dramatic areas of tone. With the bottom quarter cropped out, it focuses much more attention on the meticulously terraced fields and the sky. In this case, there was no real choice (in the absence of a 6x12cm panoramic camera with a 110 or 120mm lens) but in general, it is better to shoot both the 'all-in' image and the close-up. After all, you can always crop the surplus, but you cannot add what is not there.
LEICA M2 HAND-HELD, 35/1.4 SUMMILUX, FUJI RA.

SPA, RHODES
This spa was built (badly) by the occupying Italian forces in the early twentieth century; now, it is falling apart. A tripod would have allowed more depth of field and better sharpness, but it does not seem to matter: the picture is a glimpse, as if in a dream, and the slightly wobbly quality (plus the deliberate over-exposure) reinforces the unreality.
LEICA M4-P, 35/1.4 SUMMILUX, KODAK ELITE 100. (RWH)

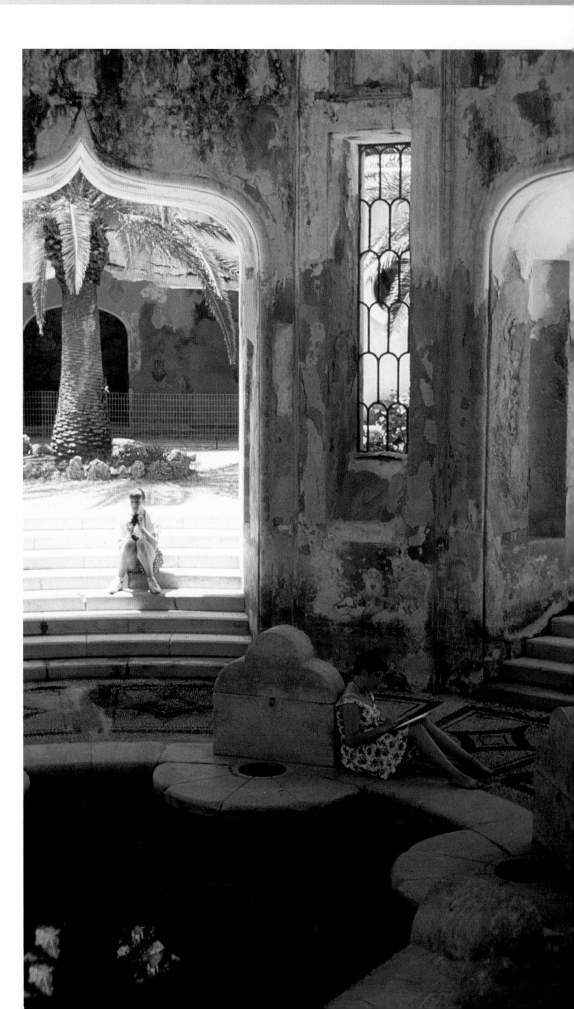

You can also move from side to side, and up and down. This may seem utterly obvious, but an awful lot of pictures are spoiled because the photographer does not do so.

A fundamental law of photography is that the viewer doesn't know what is outside the frame. He may guess, but often, the photographer's job is to make him guess wrong. In the picture, the pastoral scene is not ruined by the trash bin on the left, the parked car on the right, the beer-cans in the foreground. They may only be a few millimetres out of shot, but they are out of shot. That mass of flowers in the foreground: it hides another car, as well as the graffiti-covered signpost to the visitor centre.

Climbing up on the trash bin, or ducking down a little lower so that the flowers are a little more prominent, are both perfectly legitimate ruses. Of course, it is also a legitimate ruse to use a wider lens, a gritty black and white film, and show the mess that people have made of what must once have been a rural idyll; but this is, in a sense, as much 'pictorialism' as the faux-romantic scene. The photographer is not showing people things they have not seen before; he is merely showing them something anew.

LOOKING THROUGH THE VIEWFINDER

Regardless of format and focal length, you need to pay real attention to what is going on in the viewfinder. The tree growing out of someone's head is the classic example; so is the glaring sign, indicating the nearest car park or public toilets, which somehow manages to be so inconspicuous until you see it in the final photograph.

At first, you have to train yourself to look at everything in the viewfinder: you simply do not notice the telegraph wires across the sky, the trash bin nailed to the wall. Slowly, though, it becomes second nature. You learn what the common problems are, and how to avoid them – usually by moving.

'PORTRAIT' AND 'LANDSCAPE'

Most beginners tend to hold their camera in one orientation all the time: with 35mm, normally 'landscape' (horizontal) format, rather than 'portrait' (vertical). While there is a good deal to be said for maintaining a single orientation in a slide show (see page 181), it is much better to work in both orientations for exhibitions and publication. For publication, particularly, 'portrait' has a better chance of being run bigger, as a whole-page image. Roger shoots so much 'portrait' that he habitually leaves the backs on his Alpa in this orientation (they can be installed either way).

THE DECISIVE MOMENT

Unless you are photographing a totally static scene under unchanging lighting, there is always something happening in the viewfinder. People wander in and out of shot. Clouds cover the sun,

WOODWORKER'S BENCH
The ideal solution here would have been a camera with movements to allow the application of the Scheimpflug Rule (see page 42), but as the only suitable camera to hand was a Leica M4-P with a 35/1.4 Summilux, the best compromise was to stop down for depth of field, using the d-o-f scale on the lens as a guide. An unforgivable omission on many zooms and autofocus lenses is the absence of a d-o-f scale.
KODAK E200. (RWH)

THE DECISIVE MOMENT
*Roger was waiting for a
figure to come into the
shot, to add scale and a
centre of interest – then,
of course, he got two in
quick succession. In our
opinion, the left-hand shot
is more successful than
the one on the right: the
pose looks more natural,
and while the red is eye-
catching, it is also
something of a cliché.*
LEICA M2 ON MONOPOD,
35/1.4 SUMMILUX, FUJI RA.

and then uncover it again. A butterfly lights.

'The decisive moment,' in Cartier-Bresson's famous phrase, is when everything comes together in the viewfinder. Often, you know that you want someone just *here*, or the sun to come out and illuminate *that*, or a particularly ugly tourist who has been loitering, seemingly forever, to go away. At the risk of sounding pretentious, the decisive moment is the temporal extension of physical composition: everything is correct in both space and time.

GOING BACK

You cannot cross the same river twice, or so it is said; the reason being that when you go back, it is not quite the same as it was. Sometimes, this can be lamentably literal. There used to be a beautiful stamped-earth towpath alongside a particular part of the Kennet and Avon Canal. Then someone surfaced it with cement, completely destroying the picturesque prospect under at least one bridge which fortunately we had photographed before the vandalism.

On the other hand, there are many places which well repay repeat visits. When we lived in California, we used to go quite often to the Mision de la Purisima Concepcion in Lompoc, and we could as happily return to the Mision San Antonio.

In Kent, we have an annual pass to Chatham Dockyard, now decommissioned and turned into a combination of a museum and a business park. In France, we return repeatedly to Montreuil, and we want to get back to the Luberon, with its wonderful walled villages and narrow crooked streets. There are many other places: Birgu in Malta, pretty much the whole of Gozo, or Mertola and Trás-os-Montes in Portugal. Sometimes the changes we see are for the good, sometimes they are for the bad – but always, there is something to photograph in a new way, or in the same way but better.

SHARPNESS

To pose an unappetizing choice, the quest for sharpness often comes down to a fight between depth of field, and camera shake. On a bad day, you can add subject movement: even if the camera is on a tripod, wind can stir flowers, or people can wander in and out of shot.

This is why a fast film will, in many cases, give you better quality than a slow one. If you are hand-holding the camera, it allows a faster shutter speed, or a smaller aperture, or both. If the camera is on a tripod, it freezes subject movement, gives you more manageable exposure times, or (at the very least) makes it easier

for you to choose your decisive moment.

We sometimes use Ilford Delta 3200, even with the camera on a tripod, for precisely these reasons. In very low light levels, where with an ISO 100 film you might need 10 seconds at f/11 (the latter dictated by the need for depth of field), Delta 3200 at 3200 allows you to use ¼ second at the same aperture. In a museum, for example, a lot can go wrong in 10 seconds, from someone wandering into shot to someone kicking your tripod leg, to say nothing of the embarrassment of people who wait politely for what they think will be a moment, and then find you requesting them to hold off for several seconds more.

To be sure, we use slower films if we can – but even then, the trade-offs may be unacceptable. On a bright, sunny day in Zuerich, for example, we chose to use Ilford HP5 Plus at its rated ISO 400 speed, partly because we were hand-holding the cameras, and partly because we wanted to 'freeze' the birds that swoop and squabble over the river, and we needed ⅟₅₀₀ second (the fastest on the leaf shutters of our Alpas) to do so. This allowed us to shoot at f/11 and f/8; with ISO 100 film, we should have been limited to f/5.6 and f/4 at the same speeds, and even with the ultra-wide lenses we were using, this would not have allowed adequate depth of field.

CUMULATIVE EXPOSURES

A trick which is of limited interest, but useful if you can do it, is making cumulative exposures. A 'press' (self-cocking) shutter on a large-format or medium-format camera may be fired repeatedly, effectively without vibration, and without having to touch the camera. So may some (though far from all) cameras with a 'multiple exposure' facility.

This is especially useful if you are photographing, for example, the interior of a church, where you need a 10-second exposure but people keep wandering in and out of shot. Chop the exposure into ten, 1-second segments, and you can shoot while the church is 'empty'. Another application is photographing a landscape on a windy day. Foliage normally goes back very close

DORMITORY
This is from the same series as the other shot of the dormitory on pages 84–5; the girls are moving for the same reason. The visualization was however imperfect: there should have been girls on the nearest beds, which are all too empty otherwise.
ALPA 12 SWA ON TRIPOD, 35/4.5 APO-GRANDAGON ON 6X9CM, ILFORD XP2 SUPER. (RWH)

to its original position when the wind drops, so a ¼-second exposure can be chopped into eight exposures of ⅟₃₀ second each. Yet another use is in the studio, when you are shooting a still life with a flash that is insufficiently powerful: you need f/16, and the flash can only give you f/8. Give four 'pops', which add up to the f/16 required.

METERING

We have already looked at meters in Chapter 5, and mentioned *Perfect Exposure*, so there are only two points that need to be made here. The first is a reminder that for transparencies (whether colour or black and white), incident light metering is the quickest, easiest way to go, while for negatives, limited area (preferably spot) metering will give you the best negatives. The other is that for the best possible quality, you often need to adjust or interpret your meter reading. As we said before in *Perfect Exposure*, there is no such thing as a 'correct' exposure, but a perfect exposure is the one that gives you the effect you want in your picture.

The easiest readings to correct are incident light readings. Follow the meter's recommendations, but give a little more exposure (up to 1 stop) if you want to lighten something dark, like a black cat or dark clothes, and give a little less exposure (again, up to 1 stop) if you want to get detail in something white, like a white cat or a white dress. Normally, just ½ stop will suffice.

The corrections needed for spot meter readings take longer to internalize, but the logic is equally compelling. The meter gives you a reading which will result in a mid-tone. If you take a *shadow* reading, you want the shadows to be *darker* than a mid-tone, so you give 2 to 3 stops *less* exposure. If you take a *highlight* reading (in which case you might as well take an incident light reading), you want the highlights to be *lighter* than a mid-tone, so you give up to 3 stops *more* exposure.

Broad-area reflected light readings are much more difficult to correct, because you rarely know exactly what you are reading, and because you often need to make two corrections in opposite directions. First, you need to compensate for the reflectivity of the overall scene (more exposure than the meter indicates for a light scene, less exposure for a dark scene). Second, you need to compensate in order to get texture

in a light principal subject (cut exposure) or in a dark principal subject (increase exposure).

For a snow scene, for example, following the meter reading will normally give you leaden, grey snow, but you often want the snow to read a little bit darker than a pure white, in order to get some texture in it. You need to add 2 to 2½ stops to compensate for the snow's reflectivity, then knock off up to 1 stop to get some texture in the snow; about 1½ to 2 stops more than the meter reading is a good starting point.

High-tech multi-sector in-camera meters are the most difficult of all to correct, because you do not know, except after long experience, what sort of correction algorithms have been built into the camera's metering program. They will work wonders with average subjects; but with subjects that are even slightly difficult, they may be less impressive. The best answer is to switch on the autobracket...

HOW MANY PICTURES SHOULD YOU TAKE?

Bracketing brings us to a very vexed question: how many pictures should you take?

A common statement is that film is cheap, and that it is therefore better to over-shoot than to under-shoot. Although this may be true for a professional, where the cost of film is normally quite a small part of the overall cost of organizing a shoot, it is far from the case for many amateurs, especially with some of the more expensive films: most slide films, infra-red, ultra-fast films and so forth. While accepting this, it may be a good idea to put film costs into perspective.

If you are genuinely struggling, using the cheapest decent second-hand cameras you can get, then there is little more that can be said. Try to keep costs down by bulk-loading; use good films of modest specification and price (such as Freestyle's own brand monochrome); do your own darkroom work (this can save a fortune in black and white); and economize as far as you can. You may be amazed at the generosity of your fellow photographers, too: people will actually give you darkroom equipment, and may let you have their old tripod at a nominal price when they buy something better. Save every penny that you can on equipment, and spend it on film and materials – but buy outdated materials only if you know that

they are OK, because trying to work with inferior materials is a snare and a delusion.

Most people, though, are not quite this desperate. A roll of slide film, plus processing, costs about as much as three or four drinks in a pub or bar; or as much as a middling pizza; or between two-thirds and one-fifth as much as a new pair of jeans or a meal in a restaurant. For the price of an often illusory 'upgrade' of your cameras or lenses, you could buy ten rolls or even a hundred rolls of film. What are your priorities?

Let us assume that you want to strike a middle course, somewhere between parsimony and profligacy. Then, there are three reasons to shoot more than a single shot of a subject. These are insurance; bracketing; and variations on a theme.

'INSURANCE' SHOTS

Most professionals today shoot 'insurance' shots as a matter of course. Oh, the old and crusty will talk about the days when they used to shoot six pictures on six sheets of film (six plates, if they are old enough), but most people will take two shots, just against the chance of a drying mark or a flaw in the film or a stray hair. The older you get, the more things you see that can go wrong.

BRACKETING
This is from one of the first rolls of Kodak's E100VS that we ever shot, with 1-stop rests (on auto-bracket, using a hand-held Contax RX). The lightest bracket is probably most similar in colour rendition to a traditional film, but it is clearly over-exposed, as witness the burned-out 'private fishing' sign. The middle bracket is like a traditional film but more saturated, while the darkest bracket is spectacularly vivid – maybe ½ stop under what most people would want, even for 'vivid colour'. Learning a film's response is an essential reason to bracket at least the first roll or two.
100/2.8 MAKRO-PLANAR. (FES)

When you are starting out, it is probably best not to shoot 'insurance' shots, as you are merely putting your film costs up to no great purpose. You may have the occasional disappointment – but only when you miss a really great shot because you didn't shoot 'insurance' should you consider changing your approach.

BRACKETING

'Process one, hold one' is clearly a variety of bracketing, but most people, most of the time, use rolls of film, whether 35mm or 120. Deciding when and how to bracket, and by how much, is extremely difficult.

There are, after all, three reasons for bracketing. One is because you do not know the exposure. The second, which is very close to the first, is because you are reasonably confident

IMPROVISING A CAMERA SUPPORT
In Old Goa, tripods are strictly prohibited, but no one seems to mind if you balance your camera on a wall, a display case (as here) or even a sixteenth-century tomb. The neck-strap makes a useful cushion for aligning the camera, in the absence of a tripod head.

Normally, when we are shooting negatives, we will shoot two pictures, the second for 'insurance', on the grounds that film is not all that expensive and we would really kick ourselves if we missed a picture because we didn't. The only exceptions are pictures which are not repeatable, especially reportage, and reference pictures where we are not planning on making a good print anyway.

In transparency, we tend to rely more on bracketing: even if the metered exposure is not right, the bracket will probably be acceptable. The principal exceptions are pictures which we really, really like, where we may shoot two of each bracket (or use half-stop brackets instead of whole-stop), and studio set-ups on 4x5in, where we will quite often shoot three sheets, all at the same exposure.

The latter is a variation on the procedure known as 'process one, hold one'. We have the first sheet of film processed (or process it ourselves), examine it carefully, then process the second one, making any necessary adjustments to the first development time, to change the effective film speed. This will, we hope, give us the perfect transparency. The third sheet is the insurance.

Where we can, though, we just shoot the one sheet, and get it processed, leaving the shot set up. If that sheet is OK, no problem. Otherwise we shoot the second sheet, adjusting the exposure as necessary.

about the exposure, but you also know that slight variations will each have their own mood, their own attractions. And the third is when you are trying a new film, and are unsure of the optimum exposure index.

There is rarely any point in bracketing with anything other than transparency film, except perhaps when you are getting to know a new film. With negative films, follow the fine old advice attributed to David Vestal: 'When in doubt, over-expose. When in extreme doubt, bracket.'

Formerly, our principle with negatives was 'When in doubt, bracket', giving two exposures: first, our best guess, and then, 2 stops more. The negative with 2 stops more was almost invariably better, so we just stopped bracketing and just gave 1 or 2 stops more, even in 35mm. Although this meant less sharpness and more grain (see page 22), it was normally a small price to pay for a much richer, easier-to-print negative. Today, when

SHERAB LING
Even when you shoot 'insurance' shots as described in the text, they are rarely identical – and it is a law of nature that the best shot will always be the one with the scratch or hair on it... It can be retouched, but it is tiresome to have to do so.
LEICA M4P, 35/1.4 SUMMILUX, ILFORD XP2 SUPER. (RWH)

ROLLER SKATES
In New York, where this was taken, we feel much more comfortable working together, so that each can keep an eye on the other. We have never had a problem in New York, but we have been pick-pocketed in Paris and Moscow and had a camera bag stolen in Delhi, so we do pay attention. We also carry quite serious insurance.
NIKKORMAT FTN, 90/2.5 VIVITAR SERIES 1 MACRO, ILFORD HP5 PLUS. (FES)

WHEELBARROW, PELOPPONESE
We have a particular weakness for the tonality of Paterson 200, which Frances used here in her Nikkormat FTn. In the original, there is excellent texture in the sand behind the wheelbarrow, as well as in the darkest areas, without the picture looking flat and lifeless.
90/2.5 VIVITAR SERIES I MACRO.

we use spot meters, we can determine the exposure we want more accurately, so we don't need to over-expose or to bracket anything like as often.

With transparency films on location, where we are genuinely unsure that we have determined the best possible exposure, we firmly believe that the ideal bracketing interval is ⅔ stop. In general, a transparency that is within ⅓ stop of perfection is close enough; and a ⅔ stop bracket means that with three transparencies, there is bound to be one that is within ⅓ stop of perfection, across a range of -1 stop to +1 stop.

Half-stop brackets (within ¼ stop of perfection across a range of -¾ stop to +¾ stop) are generally a smaller interval than is needed, except with very touchy films such as Fuji Velvia. With most modern films, you can cheerfully use whole-stop brackets. These guarantee only that you will be within ½ stop of perfection, albeit across a range of -1½ to +1½ stops, but with something like Fuji Astia, a wonderfully forgiving film, this is enough.

When you are getting to know a new film, whole-stop brackets are probably the best starting point, though with monochrome, you may care in addition (or instead) to bracket 2 full stops over the metered exposure.

Whether you are tyro or expert, bracketing with a new film is all but obligatory. As a beginner, though, you may or may not decide to bracket all your shots if you are using a film with which you are already familiar. It triples your film bill, and in any case, are your shots worth it? As you improve, you will probably decide that yes, they are worth it; and then, as you gain still more experience, you may actually find that you need to bracket less.

Increasingly we find that we really need to bracket in one direction only, if at all. Partly as a result of improved metering technique, principally taking more care in aligning incident light meters, and partly as a result of sheer practice, we find that we can arrive at a 'best guess' exposure where there is still a lingering suspicion that it might work better with a bit more exposure or a bit less. In this case, a 1-stop bracket is normally ideal.

VARIATIONS ON A THEME

In the great days of the picture magazines, it was apparently quite common for only one picture in a thousand to be used on a story. And to this day, there is a school of fashion photography which holds the shutter release down, with the motor-drive on the maximum speed, and sorts out the pictures afterwards.

With many varieties of reportage or sports and action photography, to say nothing of much natural history, you are either shooting 'for the percentages' (hoping that a reasonable number of pictures will be a success) or on the principle that while there may be better pictures later, this is your best opportunity so far, so you would be wise to capture it.

There are also people who 'shoot themselves into' a subject, accepting that the first few frames (or even rolls) may contain little of value.

GANGES, EARLY MORNING
As mentioned overleaf, we shot far too much material on the Ganges in the early morning; but it is hard to regret it unduly. This is one of Frances's shots, using a 150mm lens on her Mamiya 645 and the old, blue, grainy Ektachrome 64 which remains inexplicably available to this day. The camera was of course hand-held; a tripod is of limited use in a small boat.

The exact opposite of this approach is of course found with those large-format users who spend half a day setting up a single shot, then shoot just two sheets, one for insurance. But exactly the same approach can be adopted with 35mm or roll film as with cut film; and if you do try to use your 35mm camera in the same way as a large-format camera, on a tripod, with a slow- or medium-speed film, you may well be able to make prints which will be the envy of many users of larger formats.

How far you care to pursue any of these approaches will depend on your personality, the depth of your purse, and the subject you are shooting. Both of us would have some difficulty in shooting an entire 36-exposure roll of substantially the same pose in a portrait, and even more difficulty in sorting out the best pictures afterwards; but equally, we have in our files far too many pictures of the shores of the Ganges, shot from a boat in the early morning (actually, across three early mornings) because we found the subject all too fascinating.

THE DANGERS OF OVER-SHOOTING

The Ganges was probably our worst ever episode of over-shooting, and came down simply to over-enthusiasm. We probably shot 20 or 30 rolls of 120 (in a Mamiya 645) and another 15 or 20 rolls of 35mm: a total of something between 500 and 1000 pictures. This was both stupid and expensive, but also understandable and very enjoyable. Equally stupid and equally understandable, but a good deal less enjoyable, is over-shooting from under-enthusiasm, the result of a desperate attempt to find some good pictures.

This afflicts professionals more than amateurs, for obvious reasons. There are times when the assignment calls for pictures of a subject with which you have no sympathy – some of the less interesting battlefields of the American Civil War spring all too readily to mind – and there are times when you have gone somewhere to shoot stock pictures, and find either that

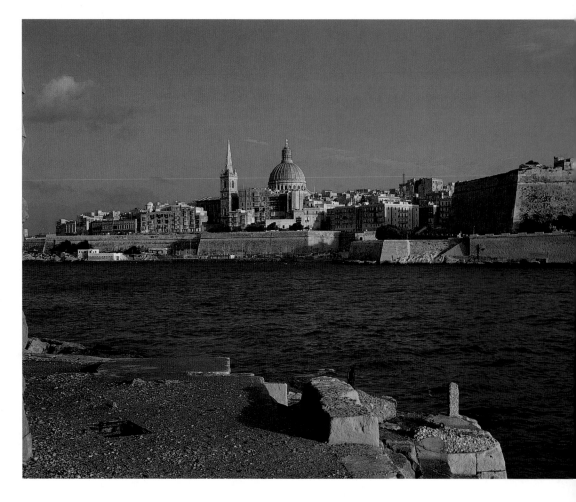

VALETTA FROM MANOEL ISLAND (RIGHT) SLIEMA FROM MANOEL ISLAND (FAR RIGHT)
These two shots were next to one another on the same roll of film, Fuji Astia 6x7cm from a 'baby' Linhof Super Technika IV with a 100/5.6 Apo-Symmar. They were taken perhaps half an hour and 300 yards apart, but the content and mood could hardly be more different. One is romantic and pictorialist; the other is a brochure shot for a fairly down-market holiday brochure.
(RWH)

you have no sympathy for the place or that there is in fact far less to photograph than you had expected: Gran Canaria and Istanbul both affected us that way. Even a single roll of film – even half a roll – can be 'over-shooting' if you feel that you have to take pictures, but cannot see the pictures to take, and therefore force yourself.

If there are no pictures, don't take them. Go somewhere else – and accept that a lot is going to depend on your mood, the turns your life has taken, your influences... In early 1999, we tried (and failed miserably) to shoot pictures in San Francisco; but a couple of days later we visited the Mision San Antonio for the first time, and shot film like there was no tomorrow. And a few days later we went back to the Mision for another all-day shoot. For us, at that time, there were no pictures in San Francisco, but lots in the Mision. Learning to accept that sometimes there are pictures, and sometimes there aren't, can make it much easier to get the pictures you want, and the quality you want.

ORDINARY, DAYTONA
The penny-farthing or (in true cyclists' parlance) 'ordinary' bicycle is the focus of this picture, but part of its appeal is the sheer crowdedness of the frame: wherever you look, there is something else going on. We fitted in reasonably well in Daytona during Cycle Week because Roger has been riding motorcycles since 1966 and Frances has been riding since 1983.
NIKKORMAT FTN, 35/2.8 PC-NIKKOR, ILFORD XP2. (FES)

CHAPTER NINE

DEVELOPERS AND DEVELOPMENT

From a purely practical point of view, this chapter is of limited relevance – except for one thing. If you understand some of the theory behind developers and development, it can save you an immense amount of time which might

otherwise be spent in chasing whole flocks of wild geese, and it will better enable you to evaluate the claims which may from time to time be made by the unduly excitable. It will also enable you, if you are so inclined, either to modify existing formulae on the basis of slightly more than blind hope, or even to try your own formulations.

The chemistry and physics of conventional silver photography are mind-bogglingly complicated and are not (to this day) fully understood: the exact mechanisms of some of the catalytic processes are still a matter of dispute.

Broadly, though, the principle is well established. Silver halides – compounds of silver with the halide group, namely, iodine, bromine, chlorine and fluorine – are sufficiently unstable that under the influence of light, they disassociate into metallic silver and the halide in question. This has been known since the eighteenth century, and to this day, 'printing out' relies only on light to create an image: the image is fixed by dissolving out the remaining halide (which otherwise would continue to darken under the influence of light), leaving only a stable silver image.

Long before the image darkens visibly, light creates a 'latent image'. Instead of a whole halide crystal being converted to silver, a 'development site' of a few atoms of metallic silver is created. The exposure required to do this is a tiny fraction of the exposure which would be required to produce visible darkening: maybe a millionth as much. The latent image is, like the visible image, proportionate to the amount of light falling on the halide.

Under the influence of the developer, this development site spreads, converting more silver halide to metallic silver. The longer the development time, the more silver is converted.

There are countless chemicals which can act as developers, but many are impractical because of toxicity, cost, sloth of operation, low energy, high fog, dangerous by-products, short life in solution, tendency to stain, excessive sensitivity to contaminants, or any combination thereof.

LACOCK
Colour fidelity is often an overrated aspect of colour processing: often, all that is needed is that the colours should be believable. This was shot in the early 1980s on Ektachrome 64 (when it was still one of the better films on the market), and processed professionally. As long as the whites are reasonably white, who knows whether the floor was greenish or not? Roger doesn't remember, and he took the picture.
LINHOF TECHNIKA 70 ON TRIPOD, 100/2.8 PLANAR ON 6X7CM BACK.

It is in fact true that commercial formulae may sacrifice ultimate quality in return for predictability, low toxicity and long life, but this is not the same as saying that 'trick' or 'pet' formulae are necessarily better than commercial ones. Indeed, the exact opposite is often the case. Many 'pet' developers and development techniques do not work very well, or suffer badly from one or more of the problems listed above. Some may have been suitable for the large formats and thick emulsions of the past, but are pretty much irrelevant nowadays. Probably the only non-commercial formulae which warrant serious examination are 'pyro' staining developers and paraphenylene diamine (PPD) fine-grain developers, both of which are fairly unpleasantly toxic, but can deliver excellent speed/grain ratios with (if they are used correctly) excellent tonality. We shall return to both later.

Otherwise, developer formulae are excellent illustrations of two important points. The first is that there is more than one way to skin a cat: substantially the same result can normally be obtained in many different ways, some of which are much easier (and much less toxic) than others. The second is that to this day, photography owes very nearly as much to alchemy as to chemistry, and the only way to see if a particular developer works well with a particular film (or paper) is to try it.

THE INGREDIENTS OF A DEVELOPER

Most (not all) developing agents will only work in an alkaline solution, and to a reasonable extent, the more alkaline it is, the more energetic they will be. Very energetic developers often use sodium hydroxide (caustic soda) as the alkali instead of the weaker sodium carbonate.

Depending on the developing agent, there may however come a point where the agent itself breaks down unacceptably rapidly in too strongly alkaline a solution. This is why, for example, phenidone derivatives (instead of plain phenidone) are used in highly concentrated liquid developers: plain phenidone is hydrolysed too fast. With a powdered developer, made up to a less alkaline stock solution, plain phenidone can be used equally well: plain phenidone is half the price of

the more stable variants, twice as active, and will not hydrolyse at modest pH values (see panel on page 112).

A very interesting thing about developers – and one of the things that is not fully understood – is that if you use two developing agents in the same developer, you will often find that the resulting mixture is far more active than you would expect from merely adding together the two activities; hence the term 'superadditivity', which is used to describe the phenomenon.

After the developing agent(s) and the alkali(s), the other essential ingredient in a normal developer is a preservative, which is usually sodium sulphite. This is itself a weak alkali, and may be the only alkali in some formulations, but in addition it protects the developing agent(s) against oxidation, helps to prevent the formation of staining by-products in development, and acts as a silver halide solvent – the latter being an

QUANTITIES OF DEVELOPER

The actual amount of developer which is required to develop a film or a sheet of paper is minute – rather less than a tablespoonful. The rest of the developer is necessary in order to wet the whole film (or paper) quickly and evenly. This is always true, even with highly dilute developers.

While this fact is indisputably true, it is not immediately obvious, and many photographers will argue bitterly with it; but if you want a clear proof, consider a two-bath developer. The first bath contains all the developer; the second, the energizing alkali. In a typical small stainless steel tank, no more than 15 to 20ml of the first bath is retained, and much of that is merely wetting the tank and the inside of the reel: at most, about 10ml (and quite possibly as little as 5ml) is actually retained in the emulsion. This is all you need.

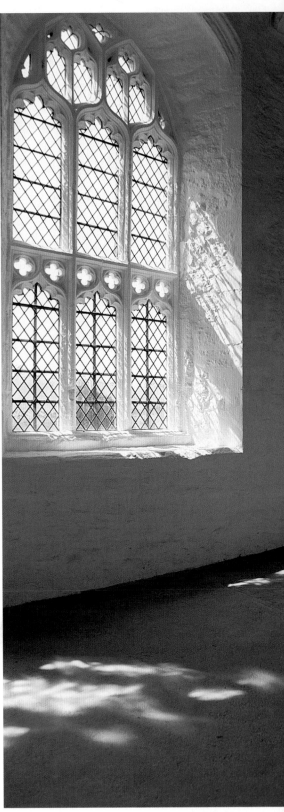

MOOD AND EXPOSURE
The mood of these two pictures is rather different; and yet, it would have been possible to achieve much the same effect as was achieved here by bracketing, by varying the first development time for two identically exposed 4x5in sheets. Or, of course, you could clip-test the first frame of a roll. This is quite a strong argument for processing your own film.
LINHOF TECHNIKA 70, 105/4.5 APO LANTHAR. 6X7CM EKTACHROME 64. (RWH)

apparently undesirable characteristic which is, in practice, highly desirable, as discussed below under the heading Film Developers.

The fourth ingredient, which is far from always found, is a restrainer or anti-foggant. Even unexposed silver halide grains can be developed, and this gives rise to excess uniform density. Restrainers are particularly important if high contrast is required: without them, the development process will sooner reach 'gamma infinity', the maximum possible contrast, after which contrast will falter (as unexposed and exposed crystals develop at the same rate) and then fall (when most exposed crystals are developed, leaving mainly unexposed ones to develop).

Historically, the most usual restrainer was potassium bromide, but there are other alkaline bromides as well as organic anti-foggants – though the latter are so powerful that they are relatively

with storage or use. The buffer is the alkaline salt of a weak acid; sodium carbonate (above) functions as a buffer, as do sodium metaborate and sodium phosphate.

There may be other ingredients, but if there are, they often fulfil a highly specific role (such as alcohol as a solvent for large quantities of developing agent), or they are leftovers from someone's pet theories.

Acid and neutral developers

The best-known developing agent which can work in neutral or acid solution is amidol, which does give very rich blacks in prints. Unfortunately, we have also found that it can also cause staining – though this may have been the result of a less than perfect batch of amidol, which tends to be synthesized in limited quantities in some fairly unlikely places. Metol will work in a neutral solution, though the developer must be buffered in order to make sure that it does not slide into acidity during development. Ferrous oxalate developer, the only inorganic developer which still finds any use whatsoever, apparently works in neutral solution.

FILM DEVELOPERS

The standard by which all other film developers are judged is Kodak's D-76, which was formulated in the late 1920s. It is often reckoned to be the best all-round compromise, for most films, for sharpness and grain and tonality. The basic D-76 formula, also known as Ilford ID-11 and Defender 4D, is as follows, though commercial formulations may differ slightly:

Metol	2g
Hydroquinone	5g
Sodium sulphite (anhydrous)	100g
Borax	2g
Water to make	1000ml

There are two developing agents which demonstrate superadditivity, as mentioned above; because hydroquinone is also known as quinol, D-76 is known as a metol-quinol or M-Q developer, while those which substitute phenidone for metol are known as P-Q developers. The sulphite acts as a preservative, a weak alkali and a

rare in film developers, because they depress the film speed too far.

Some developers are also 'buffered' to ensure that the alkalinity remains reasonably constant

halide solvent, and the borax is the alkali. The buffered version (D76d) uses 8g each of borax and boric acid.

The importance of silver halide solvents is twofold. First, they help reduce grain by dissolving it, and second (rather surprisingly) some can actually increase speed: sodium suphite at 100g/litre, for example, gives both finer grain and higher speed. Seemingly, the speed increase derives partly from the way in which the solvent uncovers internal development sites, and partly from physical development: some of the halide that is dissolved is redeposited on the development sites.

COMPENSATING DEVELOPERS

Most films, developed in D-76 at normal strength, have a distinct toe to the D/log E curve (see page 25) and then a long, reasonably straight, straight-line portion. Any shoulder is found well beyond normal printing densities, and is therefore irrelevant.

Normally, though, you will get better tonality (without 'runaway' highlights) if the curve is S-shaped, so that the shoulder is inside the range of printing densities.

This is most easily achieved by using a weak, one-shot developer which exhausts in the highlights (the densest part of the negative) before it exhausts in the shadows. This is known as a 'compensating' developer.

ULTRA FINE-GRAIN DEVELOPERS

If you want finer grain than D-76 can deliver, you need an ultra-fine-grain developer. This inevitably means a reduction in film speed, regardless of what the developer manufacturer says.

The classic approach in this situation is to use a low-energy developing agent (usually PPD, paraphenylene diamine) in a weakly alkaline solution, which gives extremely fine grain. Development times are however prolonged, and film speed is greatly reduced, by as much as 2 or 3 stops. The classic formula is 10g of PPD and 90g of anhydrous sodium sulphite in a litre of water. Adding more energetic developing agents gives more speed, but the grain is not as fine; you can't get something for nothing.

Metol in a sulphite solution – Kodak D-23 is 7.5g of metol and 100g of sulphite in a litre of

water – is half-way to this sort of developer, delivering fine grain (but not as fine as PPD) with less loss of speed (under ⅓ stop). Buffering this sort of developer to neutrality (Kodak D-25 is D-23 buffered with 15g of sodium bisulphite) gives still finer grain but a greater speed loss: ½ to ⅔ stop as compared with D-76.

The other approach to ultra-fine grain is to add another silver halide solvent to a metol or metol-hydroquinone developer. The traditional choice was potassium or sodium thiocyanate at around 0.01g/litre, though common salt (sodium chloride) is more appropriate to modern films and is less likely to cause dichroic fog (fog which looks one colour by transmitted light, and another by reflected light – hence 'dichroic'). Speed losses of up to 1 stop are normal.

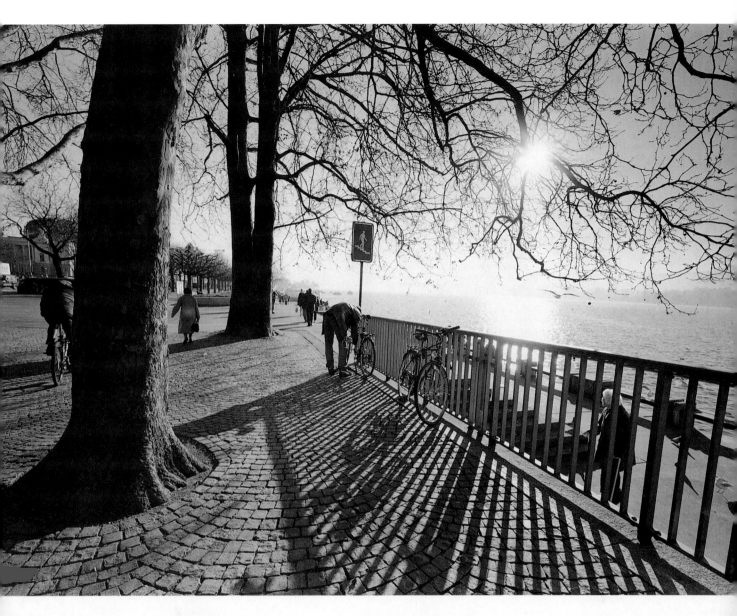

ACUTANCE DEVELOPERS

Some developers improve 'acutance' or edge sharpness by enhancing boundaries between light and dark areas: see the drawings on page 17. This gives higher micro-contrast and (usually) a higher apparent resolving power, though actual resolution is likely to be lower than with conventional fine-grain developers such as D-76, and grain is likely to be slightly coarser. Acutance developers are relatively dilute, with a low solvent action, and may contain exotic ingredients such as desensitizing dyes or water-soluble polymers, or various iodides, in order to enhance the acutance effects. Acutance developers are best suited to slow or very slow films (under ISO 200).

PHYSICAL AND POST-FIXATION DEVELOPMENT

Physical development was at one time used for ultra-fine-grain development: silver in solution was deposited on the development sites (and the inside of the tank, and the spiral...). The net result was very fine grain, but as the most popular formula (Dr Odell's) demanded very long development times and very careful temperature control, it never achieved widespread popularity and it pretty much disappeared in the years following World War II.

A fascinating variant on physical development is post-fixation development, where an over-exposed image is first fixed, then developed. Enough metallic silver remains at the development

BACKLIT BICYCLE
Roger has an inexplicable weakness for photographing bicycles. In order to hold detail in a shot this strongly backlit, you need a modern, contrasty, multi-coated camera lens: giving a bit of extra development to compensate for lens flare will not produce anything like the same tonality. Few if any zooms are suitable for this sort of shot.
ALPA 12 WA, 58/5.6 SUPER ANGULON, 6X8CM, ILFORD HP5 PLUS.

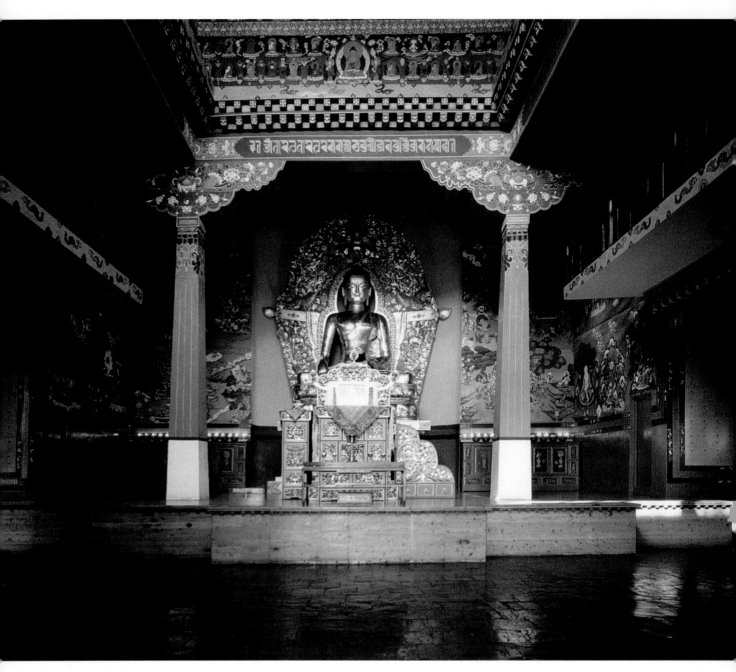

TEMPLE, NORBULINGKA
*Rather than colour,
Frances decided to use
monochrome, toned (in
sulphide) to create a
golden-bronze appearance
in the principal Buddha-
image. In polished metal,
grain is all too clear: she
chose to use 6x9cm on a
tripod-mounted Alpa 12
SWA with a 35/4.5
Apo-Grandagon, which
allowed the use of a
reasonably fast film. The
alternative would have
been 35mm with an ultra-
slow film and a fine-grain
developer.*

sites to allow physical development. It is, however,
a mere curiosity. We have never tried it, and we
have only met one person who has (a Kodak
researcher); but it is mentioned here purely
out of interest.

HIGH-ENERGY DEVELOPERS

High-energy developers give coarser grain than
D-76, but also higher true film speeds. True speed
gains of ½ stop are quite common; ⅔ stop is not
unusual; and gains of as much as a whole stop are
not unknown. Any greater speed gain than this is,

however, normally at the expense of shadow
detail, or involves a contrasty negative (which can
nevertheless be tamed to some extent with a soft-
er grade of paper). In other words, 'push' speeds
may be usable for many purposes, but they are not
true ISO film speeds.

Because this sort of 'pushing' works by
increasing the overall contrast, that is, by increas-
ing the slope of the characteristic curve, any gains
will always be more apparent in the mid-tones and
highlights than in the shadows, so the tonality of
the final image will not be the same as for a film
which has not been pushed.

The usual way to get more energy is to use more energetic developing agents, in a more alkaline solution. High-energy developers are not necessarily the same as high-contrast developers: it is possible to get high contrast, without high speed, by using a highly alkaline developer either with hydroquinone alone or with a much higher ratio of hydroquinone to metol than is normal, both developing agents being at a fairly high concentration. Most of these developers are quite strongly restrained: up to 6g/litre of bromide in M-Q developers, and as much as 20g/litre in plain hydroquinone developers.

STAINING DEVELOPERS

These are extremely interesting, in that they stain the film in direct proportion to the silver image: for obvious reasons, they are of limited interest for paper development. They give, to some extent, 'something for nothing' in the form of finer grain with excellent tonality.

Most staining developers are based on 'pyro' (pyrogallic acid or pyrogallol). This is fairly toxic and does not keep well in alkaline solutions, so pyro developers are normally made up in two-solution form, one containing everything except the alkali, and the other a straightforward sodium carbonate solution.

In the late 1990s, a formula known as PMK (Pyro-Metol-'Kodalk' – Kodalk is sodium metaborate) was very popular, and if you are prepared to put up with the toxicity, you can indeed get beautiful negatives; or more accurately, negatives which produce beautiful prints, though the negatives themselves look thin and strange.

POSITIVE DEVELOPERS

The big difference between films and papers is that papers are normally developed to finality: in other words, all the silver that can be developed, is developed. Films, on the other hand, are normally developed to a given contrast which is well short of finality. Lantern slides used to be processed in much the same way as papers, which is why this section is headed 'positive' developers instead of 'paper' developers.

The basic chemistry is much the same, except in two respects. One is that in order to speed development, the developers are normally more strongly alkaline, and the other is that because fog is even less welcome than it is in a negative developer, restrainers are widely used; the slight speed losses are irrelevant with paper. On the other hand, bromide must be kept to a minimum in order to get really deep blacks, so organic restrainers such as benzotriazole are popular, though higher bromide concentrations do allow warmer tones.

There are some so-called 'universal' developers which can be used at one dilution for paper, and another for film, but it should by now be clear why they are usually an undesirable compromise: they are unlikely to be active enough to give the best possible paper image, and they are likely to give quite large grain and poor speed with film. The only reason for using them is when convenience and economy take precedence over quality.

WHEELBARROW
The attraction of this picture was the silver-bright interior of the wheelbarrow against the many other textures in the scene. Unfortunately, Roger over-developed the film (Ilford Delta 100) grievously; in order to get a reasonable print, Frances had to expose MG Warmtone at grade 0 and develop it in Centrobrom.
HAND-HELD ALPA 12 SWA WITH 44X66MM BACK, 38/4.5 BIOGON.

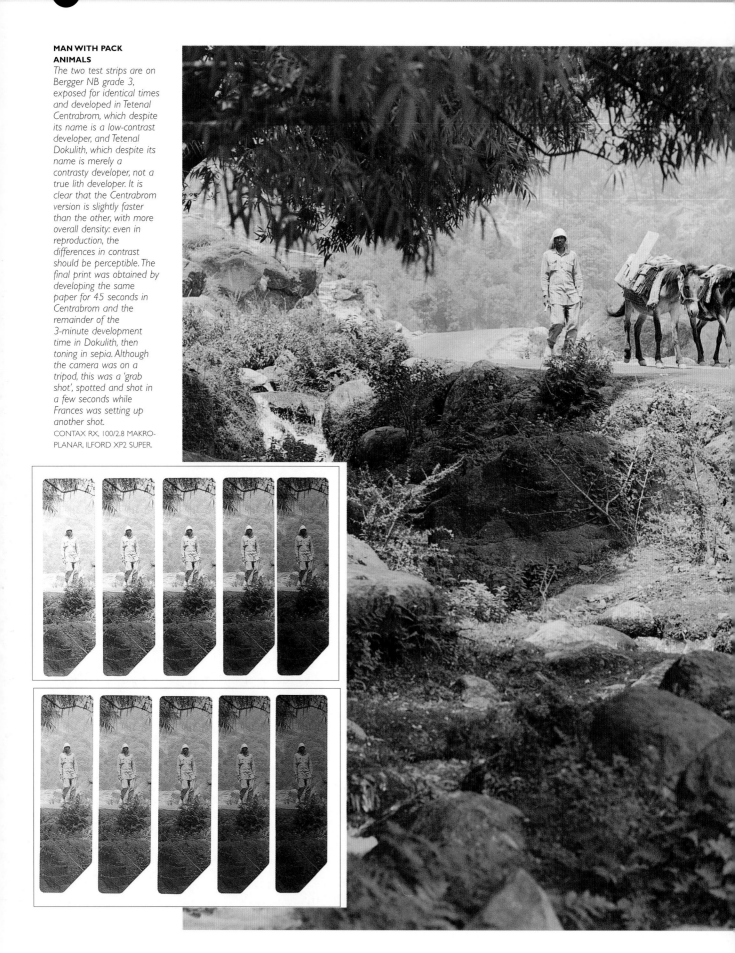

MAN WITH PACK ANIMALS

The two test strips are on Bergger NB grade 3, exposed for identical times and developed in Tetenal Centrabrom, which despite its name is a low-contrast developer, and Tetenal Dokulith, which despite its name is merely a contrasty developer, not a true lith developer. It is clear that the Centrabrom version is slightly faster than the other, with more overall density: even in reproduction, the differences in contrast should be perceptible. The final print was obtained by developing the same paper for 45 seconds in Centrabrom and the remainder of the 3-minute development time in Dokulith, then toning in sepia. Although the camera was on a tripod, this was a 'grab shot', spotted and shot in a few seconds while Frances was setting up another shot.
CONTAX RX, 100/2.8 MAKRO-PLANAR, ILFORD XP2 SUPER.

WARM-TONE DEVELOPERS

Image colour is largely a result of the size of the silver grains in the image: the smaller the grain, the warmer the tone. This in turn depends partly on the paper formulation and partly on the developer. The main difference between warm-tone and standard developers is normally that the warm-tone developers contain little or no metol (which gives blue-black tones), but instead use warm-tone developing agents, typically glycin or chlorquinol, though hydroquinone is also widely used. It is often possible to get warmer tones with an ordinary (non-warm-tone) developer, simply by using it at higher dilutions; but development times go up considerably, and the density of a maximum black is likely to decrease: we have found maximum densities of 1.8 to 2.0 instead of 2.0 to 2.2.

DEVELOPER LIFE AND CAPACITY

Exhaustion of developers is only very rarely the result of the actual developing agents being used up; as described on page 109, the amount of developer which is needed to develop a film or a sheet of paper is tiny. Rather, exhaustion is the result of oxidation of the developing agents, and of the build-up of both bromide from the emulsion (which acts as a restrainer) and developer by-products which may cause staining or loss of activity because they reduce alkalinity. With paper developers, there is no great problem in using the developer until it goes off – you can always remake a print or two – but this is not a desirable approach with film.

Where throughput is considerable, a replenished system arguably offers the greatest consistency, convenience and economy, albeit with reduced film speed (see page 123); but for small batch processing, or where speed is important, one-shot film developers are the best way to go.

VARIABLE-CONTRAST DEVELOPMENT

By varying the formulation of the paper developer, it is possible to effect a modest change in the contrast of the print, even with fixed-grade papers. You can gain maybe half a paper grade in contrast, or wipe off around a whole grade.

Although it is possible to formulate developers which can be mixed in varying proportions in order to give the required degree of contrast, a much more versatile approach is to use a two-

SWAMP, NEAR SELMA, ALABAMA
Agfa's Scala is a film which fascinates us. We have seen many excellent pictures shot on it – and yet we seem to be curiously out of sympathy with it, when it comes to actually getting good results ourselves. It is a clear illustration of the old saying that one man's meat is another man's poison.
NIKKORMAT FTN ON TRIPOD, 90/2.5 VIVITAR SERIES I MACRO. (FES)

COSTUME SHOP, TIPA
Medium-format colour negative allows remarkable quality, even with ISO 400 film: this is Kodak's excellent 400VC, exposed in a tripod-mounted Alpa 12 SWA with a 6x9cm back, using a 35/3.5 Apo-Grandagon. The extra speed of the ISO 400 film more than compensates for the slower lenses and reduced depth of field (necessitating smaller apertures) of MF as compared with 35mm. The pale picture shows what happens when the processing chemistry (Paterson Professional, used with Tetenal paper) suddenly 'dies': the previous print was entirely satisfactory.
(FES)

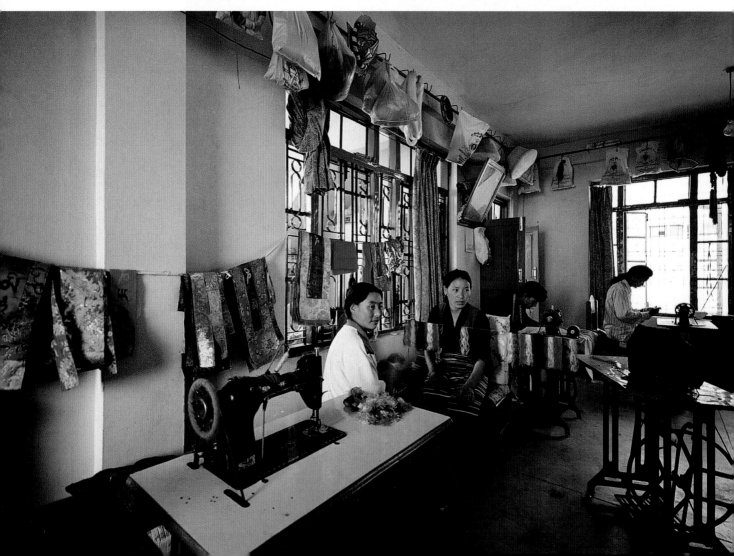

bath developer so that the paper can be given more time in one bath or the other. The big problems here are maintaining a constant image colour – which may not matter so much if the prints are to be toned – and cross-contamination, which inevitably leads to increasingly unpredictable behaviour, and also less differentiation between the baths.

For years, the only way to make up a variable-contrast, two-bath paper developer was to do it yourself, but now there are several on the market, including Tetenal's Centrabrom/Doculith. VC developers are less convenient than VC papers, but the effects are different enough to warrant investigation: VC developers affect mainly shoulder contrast, leaving toe contrast unchanged, while changing paper grade affects toe contrast.

TANNING DEVELOPERS

Tanning developers literally tan or harden the gelatine in direct proportion to the silver image, and were historically used in dye transfer and dye imbibition processes, among others. In the main surviving process which requires tanning, namely bromoil, the print is normally developed in a conventional print developer and then tanned by subsequent treatment.

REVERSAL DEVELOPERS

Conventional reversal processing involves, in effect, two developments in a row. The first processes the original (negative) image, leaving undeveloped silver halide in inverse proportion to the density of the negative. The original image is bleached out, leaving only unexposed halide, which is exposed to light, or treated chemically, to render it developable.

A second developer bath converts all (or almost all) of the remaining halide to the final, reversed image, though it is usual to give a final fix to dispose of any recalcitrant silver halide which may not have developed. Because the second development is to completion, it is rather less critical than the first, having far less effect on density.

There are relatively few monochrome reversal development kits on the market, though it is not difficult to make up a good, working process using formulae from old books. There are, however,

three significant drawbacks to reversal processing of most ordinary films.

The first, which applies to all formats, is that it is very time-consuming: the full sequence, with all necessary washes, normally takes about three-quarters of an hour, plus drying time.

The second is that maximum densities are rarely very impressive. Compared with slides made the traditional way, by printing from a negative on to positive film (or a lantern slide), the overall density range is likely to prove lean: as little as 100:1 (log range 2.0), as compared with up to 1000:1 (log range 3.0) for the printed slide.

The third applies principally to 35mm films, which are normally coated on a neutral grey base: this makes for a dull, flat-seeming transparency. If you pump enough light through it, and if it is not compared with purpose-made transparency films (such as colour slides or Agfa Scala, which are on a clear base), then this is no great drawback; but it is still visually unappetizing, for want of a better phrase.

COLOUR DEVELOPERS

The basic principles of colour development have already been covered on page 73: the incorporation of dye precursors into the film, which, during development, turn into the dye image. The developing agents which are needed to effect this transformation are different from those used for monochrome, and considerably more expensive.

For colour negative processes, the silver image and the unexposed halide are then dissolved out leaving only the dye image. For colour reversal processes, the first developer is, in effect, a slightly modified black and white negative developer and the second is the colour developer, working in the same way as a colour negative developer. Just as with conventional black and white materials, extra time in the first developer 'pushes' the film to higher usable speeds. Again, as with monochrome negative film, grain is made coarser by pushing, and after a certain point (which varies from film to film) the maximum black weakens rapidly and other colours are degraded.

Although it is possible for the 'gentleman amateur' to devise substitute formulae, the scope for disaster with colour is far wider than it is with monochrome, where almost any user error can

KHATAGS

These khatags or 'robes of the gods' are like flimsy scarves; Tibetans give them between friends on partings and arrivals, and as tokens of respect. These are laid upon a choerten built in memory of a Tibetan martyr, who immolated himself as a protest against Chinese behaviour in Tibet. With slide film, you would need to cut exposure slightly to hold detail in the white; with negative film, under-exposure might have led to loss of detail in the black tiles, so it is best to make any necessary adjustment at the printing stage.
ALPA 12SWA, 35/4.5 APO-GRANDAGON ON 6X9CM XP-2 SUPER. (FES)

generally be redeemed at the printing stage, so there is little incentive even to try.

As far as we have been able to find out, the main advantages of the full six-bath E-6 process over the so-called 'three-bath' version (actually four-bath, unless the stabilizer is omitted, which would be very foolish – see page 130) are that six-bath is easier to replenish and cheaper to run on a commercial scale; there seem to be no compelling quality or archival advantages in the extra baths.

CROSS PROCESSING

It is perfectly possible to process slide films in chemistry intended for negatives, and negative film in chemistry intended for slides. The former

is, however, a much more attractive option: the absence of an orange mask in a slide film is easily compensated for by adding filtration (in the form of a piece of unexposed, processed negative film, if need be), whereas the orange mask in the negative film somewhat detracts from its usefulness as a transparency.

In our view, although cross processing is a legitimate technique – pretty much anything is, in photography – it is also a technique which is grievously over-used. The distorted and generally highly saturated colours which it gives, together with more or less bizarre edge effects, may have an increasingly slight novelty value, but very few proponents of the process seem to have the artistic vision that is required to make anything worthwhile out of it.

CROSS PROCESSING
Cross processing intro-
duces colour shifts which
are often unpredictable
and almost always
unrealistic. Combine it
with infra-red film and
the possibilities are even
greater. Our own view is
that normally, the shock
value of cross processing
is considerably greater
than any aesthetic gain.
NIKON F ON TRIPOD, 35/2.8
PC-NIKKOR, KODAK E6 IR
PROCESSED IN C41. (RWH)

CHAPTER TEN

FILM PROCESSING

The previous chapter was heavily theoretical; this one is much more practical, and begins with the simple question of whether you will get better quality by doing your own film processing, or by leaving it to a commercial lab.

The answer depends on what sort of film you use, and what sort of lab. There are effectively four types of film, and for the sake of convenience, labs can be divided into amateur and professional, though it would be more realistic to think of them as a spectrum running from the finest professional labs to the worst amateur labs; in between, there will be amateur labs which work to professional standards, and allegedly professional labs to which no sane amateur would entrust his work.

THE FOUR TYPES OF FILM

Some films can only be processed in professional labs, either because of the complexity of the process (Kodachrome is the best known example) or because details of the process have not been released (as with Agfa Scala). Although both 'professional' and 'amateur' Kodachrome processing are offered, the only difference between them is that the former is faster.

Other colour slide films use a standardized process, generally known by its Kodak name of E-6, though other manufacturers have their own names. The process is mechanical, dull and time-consuming, and requires very accurate temperature control, the latter arguably at the limits of what most people can achieve. It is impossible for the small-scale home processor to get better results than a good lab; the best he can hope for are results which are as good. Unless there are compelling arguments to the contrary, it is generally best to leave it to the labs. The arguments to the contrary, and the best way of processing your own E-6, are given later in the chapter.

Colour negative films again use a standardized

KODACHROME
To this day, Kodachrome 25 is one of Roger's favourite films. The very low speed is something of an embarrassment, but you put up with it in return for the unique tonality and colour. Familiarity also means that Roger can guess the exposure for difficult grab shots like this one. Rather more of an embarrassment is having to wait several days to get the film processed.
HAND-HELD LEICA M4P, 35/1.4 SUMMILUX.

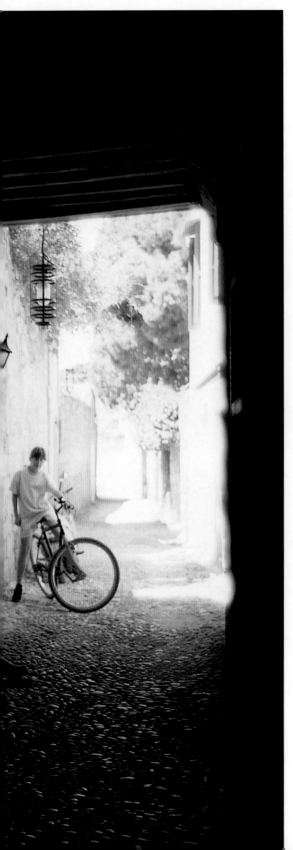

process, and again are generally known by a Kodak name, C-41. Although it is somewhat quicker and less demanding than E-6, it is still very demanding and the home processor can at best hope to equal the results of the commercial lab, so the same arguments apply as to colour slide. Chromogenic monochrome films such as Ilford's XP-2 and Kodak's T400CN are processed in C-41, and there is little point in processing them at home, either. Again, the question of processing your own C-41 is discussed later.

With conventional (non-chromogenic) mono- chrome negative films, the rules are changed utterly. There are a very few top professional labs which may give results which are as good as any reasonably careful amateur can get at home; the rest will, without question, give inferior results.

There are two reasons for this apparent anomaly. One is that unlike E-6 and C-41, there is no standardized monochrome process, and different films respond best to different developers and development times. The other is that most commercial labs use 'seasoned' or replenished developers, so that there is a slight (but noticeable) loss of film speed. Some labs trust their customers to over-expose to compensate, while others take matters into their own hands, and over-develop to compensate.

Where the home processor can experiment in order to find the best possible combination of film, developer and development time, the commercial lab frequently operates, at least to some extent, a policy of 'one size fits all'. The best labs do offer a choice of developers and development times, but the worst simply put all films through the same developer for the same time – generally a long time, so that the fast films are just about adequately developed, but the slow ones are inevitably severely over- developed. (There is more about processing monochrome later in the chapter.)

'PRO' AND 'AMATEUR' LABS

For slide films, the big differences between pro and amateur labs are speed and cost, and (in most of the world) slide mounting. Quality may or may not vary, and while lost films are rare with either, they are generally easier to trace in the pro lab because of the smaller volume and more personal service.

Where the amateur lab takes two or three days or even a week or more, the pro lab will take two or three hours. Pro labs typically charge twice as much as amateur labs, and will not honour process-paid films, which must go back to the

BARLEY
It may take a while to find a mini-lab which will process Ilford XP-2 cleanly, without crud and fingerprints, but when you do, the convenience and the quality are nigh-miraculous. This was processed at a supermarket, Tesco at Manston in Kent, about 10km (6 miles) from where we live. The quality is as high as you would get from any professional lab.
HAND-HELD LEICA M4-P, 35/1.4 SUMMILUX. (RWH)

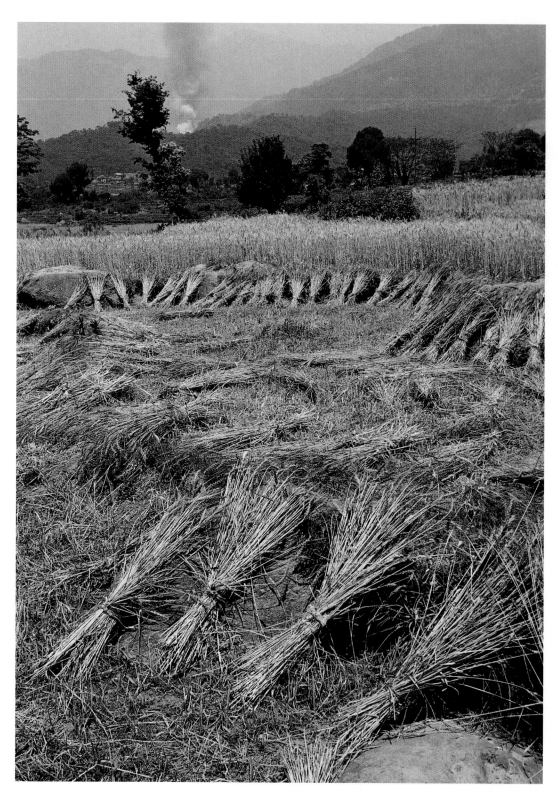

manufacturer's lab (or franchise). Many pro labs return slides uncut, in sleeves, rather than mounted.

The best amateur labs are as good as any pro lab, so the only real drawbacks are the time you have to wait to get your slides back, and the greater risk of their going astray. An old trick is to photograph your name and address on the first frame of any slide film, which will greatly increase its chances of coming back to you.

When it comes to negative films, amateur labs are a great deal cheaper: typically, you can get a

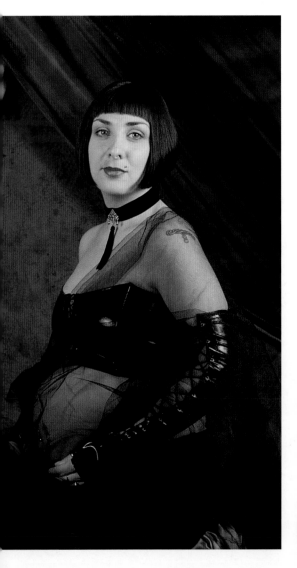

Mail-order houses are generally more consistent, but once again, you are into the problems of delays – several days, instead of same-day or even one-hour – and the risk of losing films. This is why we do not use them, even though the results are often astonishingly good: these are big operations, and they did not get big by being bad.

PRO LABS AND AMATEUR WORK

Many amateurs are worried that pro labs will not accept their work. This rarely happens: the labs are in business to process films, and they do not

◄ SARAH
Most of the E-6 in this book is processed at our neighbourhood pro lab, or at other pro labs in the UK and USA, but this picture by Marie Muscat-King was processed by an 'amateur' lab and is not one whit inferior in quality. The big difference is that Marie had to wait a week to get her pictures back, not two hours.
NIKKORMAT FTN, 85/1.8 NIKKOR, KODAK E100VS.

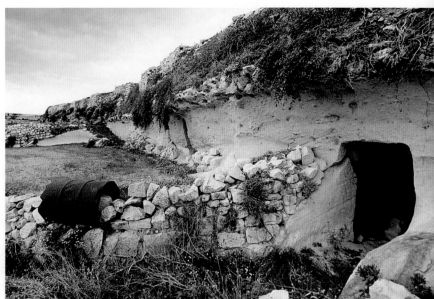

36-exposure film processed and printed at a good mini-lab for about 50 per cent more than process-only at a pro lab, and if you use one of the cheap mail-order houses, you can actually pay less for develop-and-print than the pro lab charges for develop-only. Develop-and-print packages at pro labs are normally horrifyingly expensive, two or three times as much as the mini-lab, or five times as much as the cheap mail-order house.

The big problem with mini-labs is that they are wildly inconsistent, often depending far too much on one skilled operator. Several times, we have found truly excellent mini-labs, and have used them for months; and then the skilled (or careful) operator leaves, and the negatives start coming back dirty and scratched, quite possibly with fingerprints on them, and the print colours go all over the place.

TROGLODYTE HOUSE
Different pictures, taken in the same place, appear as the Frontispiece and in Chapter 14. Frances used Ilford XP2 Super, probably her favourite film, in a tripod-mounted Contax RX with a 35/2.8 PC-Distagon. The film was processed at our nearest professional lab, Thomas Neile of Whitstable, about 25km (15 miles) away.

BRIDESMAID WITH CAMERA
A great advantage of having pictures developed and printed by a good local mini-lab – this was our faithful Tesco again – is that you can mark up the prints as proofs, for yourself, or to brief another printer, including 'shamateur' labs. You can also make printing notes on the back.
OLYMPUS ECRU, IMATION ISO 200 COLOUR PRINT FILM. (FES)

CHURCH, RABAT
The vignetting in the upper corners of this picture is the result of applying slightly more rising front than was wise. Any reasonably experienced photographer would realize this, but equally, this is the sort of thing that (some) amateurs blame pro labs for. In vain do the labs point out that they couldn't process just one frame wrong: there are some people who will argue anyway.
'BABY' LINHOF SUPER TECHNIKA IV ON TRIPOD, 6X7CM, 100/5.6 APO SYMMAR, FUJI ASTIA. (RWH)

care who exposed them. They may point out that they cost more than an amateur lab, just to make sure that the customer knows what he is going to have to pay, and they may point out that the slides are returned unmounted, for the same sort of reason; but these are merely precautions, so that the customer does not complain later. There is however one situation in which they may be reluctant to accept the work of someone who is clearly an amateur.

This is when they have recently (or repeatedly) dealt with an amateur or amateurs with totally unrealistic expectations. A professional can look at a film, and tell when he has made a mistake, and when the lab has made a mistake. A lot of amateurs can't, or won't. They will blame the lab for blatantly incorrect exposures, or accuse them of ruining a film which was in the camera when they opened the back. In general, pro labs don't make mistakes, and if they do, they are willing to admit it. They could not survive in business otherwise.

If you are unlucky, and hit a lab where they say, 'We don't take amateur work', first ask yourself if there is anywhere else you could conveniently go. If there isn't, explain that while you understand

that they may have had some bad experiences with amateurs, you are trying to work to the highest possible standards, and that as far as you are concerned, this means using the best labs – namely, them. You may even care to wave this book at them, and show them this passage. After that, it's a question of building up trust.

'SHAMATEUR' LABS

In the backs of the photo magazines, there are 'custom' labs which are clearly intended to appeal to serious amateurs rather than to professionals. They cost more than mini-labs or amateur labs, but less than pro labs. Often, they are operated by serious amateurs, especially by those that have retired early and have turned their hobby into a small business.

We have never used any of these, but we understand, from those who have, that the best of them are very good – well up to professional standards. They are of most interest, however, for custom printing rather than for film developing: some of them will make monochrome or colour prints to a very high standard, at half the price you would have to pay in a pro lab.

COLOUR FILM PROCESSING

The principal arguments in favour of doing your own colour film processing are speed and security. There may also be a direct cost saving, though this will depend on the sort of kit you use. If you use a typical 600ml kit to exhaustion, processing four films, it will cost about the same as a pro lab; moving up to a 1200ml kit, the cost should be about the same as an amateur lab. Bigger kits offer better savings: used one-shot in a CPE-2 processor (see below), Paterson's 15-litre kit will allow you to process up to 125 rolls of film, across a period of up to a year (because the chemicals are in 'wine boxes' and don't go bad in a hurry); maximum capacity, in a Nova hand line (below again), would be more like 200 films. The cost will be one-half to one-quarter that of an amateur lab, and one-quarter to one-seventh that of a pro lab – or better still for 5x4in.

As for indirect cost savings, we can process an E-6 film in about three-quarters of an hour, and have it dry and ready to mount in maybe an hour and a half. Processing C-41 is somewhat faster.

CERVEZA BUD
Quality is a double-edged sword. Roger visualized this shot as hard-edge, graphic, simple – but when he examined the transparency more closely, he realized that the dirt and cobwebs and debris said more than his original idea. Unless the quality is top-notch, such results can look more like a dirty transparency than a faithful record.
HAND-HELD LEICA M2, 90/2 SUMMICRON, FUJI RF ISO 50.

Our nearest pro lab is about 25 minutes (and 25km/15 miles) away by car or motorcycle. This means two 50-minute trips, with an hour and a half wait in between, for a total elapsed time of close on three hours, a total driving time of close on two hours, and a combined journey of some 60 miles (100km). Even costing our time at nothing, the fuel cost is significant as compared with the cost of processing, especially if we are having just a single roll processed.

Cost in our time as well, at our normal minimum of £25 ($40/40 euros) per hour in 1999, and the indirect costs in gasoline and time are well over £50. If we can process the film in an hour, including mixing chemicals and cleaning up afterwards, then the labour cost is £25 and there is no fuel cost. These are of course 1999/2000 values; make whatever adjustments you will, if you are reading this book in (say) 2005.

In order to control time and (most particularly) temperature with sufficient accuracy, it is not enough to rely on conventional small-tank processing, as described for monochrome film later in the chapter. Instead, you need either a thermostatically controlled hand line or a processing machine of some kind. There is also more about thermometers and timers in the next chapter.

HAND LINES

A hand line is nothing more or less than a row of open tanks in a thermostatically controlled water bath. Working in the dark, you load your spirals; place them on a rod; and carry out the initial processing stages (first development and wash, for E-6) in the dark. You can then turn the lights on for subsequent stages. Timing is most easily carried out with a tape recorder on which you have recorded a simple time-base: '... fifty seconds... one minute... one minute *ten*... one minute *twenty*...' You can also record actual processing instructions: 'Into first developer *now*... agitate, one, two, three, four, five...' although this creates problems if you mis-time one step, or if you want to vary the first development time in order to 'push' or 'pull' a film (see page 130). Subsequent (room light) processing steps may be timed conventionally.

The biggest single problem with a hand line, apart from working in the dark, is washes: you need to wash the film(s) in the dark, with water at around 38°C (100°F). The easiest approach, if you do not have a tempered water supply (an 'instant on' electric heater is good), is to mix up a bucket of water at about 40°C (104°F) and to work over a sink (or bathtub) where a few splashes do not

matter; you can then wash in (say) six changes of water in a suitable container, before transferring the film back to the hand line.

You also need to take great care to be consistent in your agitation, though this is a matter of self-discipline. We have had considerable success in processing both 4x5in and roll film E-6 in Nova hand lines.

PROCESSING MACHINES

Jobo's CPE-2, with lift, is one of the simplest and most popular processing machines. It consists of a processing drum which is partially immersed in a water bath, with automatic motor-driven agitation and (via the lift unit) rapid filling and emptying. The lift, which is sold separately, is all but essential for film processing, as otherwise, filling and emptying are rather slow. The whole assemblage is comparable in price with a modestly priced SLR with lens.

Many professionals use the CPE-2 for E-6, and the only point to note is temperature control. The chemistry is held in tempered bottles, but the temperature inside the processing tank itself will be lower than the temperature of the water-bath, and the chemistry cools as it runs in, so the water-bath generally needs to be set somewhat higher than the processing temperature; there is more about this below, under the heading 'Controlled Drift'. Also, ambient temperature makes quite a difference, so it is as well to heat (or air-condition) the darkroom to a reasonably constant temperature when you intend to process colour films.

There are several more sophisticated processing machines on the market, including more from Jobo, but one of the best is Durst's Filmetta. Fully auto processing (including washing) is available, at a price: you just load the film into the processor, press the 'START' button, and walk away. Such processors are expensive, comparable in price with a top-of-the-line 35mm SLR body, but the convenience is wonderful and the quality is comparable with any pro lab.

CONTROLLED DRIFT

Because of the near impossibility of maintaining an absolutely consistent 38°C (100°F), many people use a 'controlled drift' or 'fly-by' system, where the chemistry goes in slightly warm and comes out slightly cool. It is important to

NEW ORLEANS
To be cynical, shots like this — under seriously mixed lighting, with an added soupçon of reciprocity failure — are a great way to cut potential losses when experimenting with outdated film or with processing your own transparencies. Shoot a few conventional subjects (skin tones, neutral greys) on the same roll, to assess conventional quality: if it falls short, well, it won't show in this sort of picture.
NIKON F, 35/2.8 PC-NIKKOR, FUJI RF ISO 50. (RWH)

CAFÉ INTERIOR
When testing a new film/developer combina-tion, you can do a certain amount with grey cards and dull test subjects, but eventually, you have to get out and shoot some real pictures. There were no surprises in development here – this is C41 – but the film is Ilford XP2 Super, which was then new. It behaves just like its predecessor, only better: we routinely get better tonality, not least because the film is ⅓ stop faster and we were still metering as for the older material.
NIKKORMAT FTN, 35/2.8 PC-NIKKOR. (FES)

remember that the effect is most emphatically not linear, however, and that a warm start has a disproportionate effect. In other words, it is probably better to start at 38.5°C (101°F) and drift down to 37.0°C (98°F) than to start at 39.0°C (102°F) and drift down to the same 37.0°C (98°F). In practice, as with most photoprocessing, absolute temperatures are less important than consistency; you can always make slight adjustments to the time in order to compensate for a non-standard development temperature, if that temperature is consistent.

The best thing to do is to carry out a simple test, using the tank loaded with empty spirals; the thermal capacity of the film can safely be neglected. Set the water-bath at (say) 39°C (102°F). Temper a bottle of water to the same: use the same volume, of course, as you would use of developer. With the drum rotating, tip in the water. After 30 seconds, tip it out again and then measure the temperature. This is your effective initial working temperature. If it has fallen below 38°C (100°F), you will need to crank the thermo-

stat up some more. This test is, of course, good only for a single ambient temperature, though a variation of a couple of degrees either way in ambient temperature is unlikely to make a significant difference.

COLOUR CHEMISTRY

There are several makes of E-6 compatible chemistry, and most of them are pretty good. As noted on page 120, most are so-called 'three bath' (mono dev, colour dev, bleach/fix), but the fourth bath is a stabilizer which you omit at your peril: it acts as a fungicide, and mops up unwanted colour couplers, as well as hardening the film. Likewise, there are many good C-41 kits available. In both E6 and C41, we use mostly Paterson, and some Tetenal.

PUSHING AND PULLING

By varying the time in the first (mono) developer, it is possible to vary the effective speed of an E-6

SOPHIE
Marie Muscat-King, who took this picture, uses quite a lot of Paterson Phototec 100. This is one of the cheapest films on the market, and although the usable speed drops to about ISO 64 in a fine-grain developer such as Ilford Perceptol, it can handle 5x to 6x enlargements with a truly creamy tonality.
NIKKORMAT FTN, 85/1.8 NIKKOR.

film. The films themselves are constantly improving, and the penalties for pushing and pulling are falling all the time, but in general, pulling (speed reduction) will result in a decrease in contrast, and pushing (speed increase) in higher contrast and a weaker maximum black – the latter because more silver is used up at the initial (black and white) developing stage, leaving less for the colour development stage. The quality losses with most films should be negligible at up to ⅓ stop

pull and ½ stop push, and unimportant at ½ stop pull and 1 stop push; and with the right films, even greater pushes may still give excellent results.

Most amateurs regard pushing solely as a method of getting extra speed, but professionals use push and pull as a means of getting precisely the right density, as described on page 102. With roll or 35mm film, the first few frames (specially shot) may be clipped and developed normally, and the rest of the film pushed or pulled as appropriate.

Although push times for E-6 are defined in stops ('push 1' for 1 stop, and so forth), they don't always work like that. Long ago, we found that Fuji Provia 1600 needed to be rated at EI 2500 when processed for 3200, and in 1998/1999 several films appeared which admitted this sort of thing in their processing recommendations. Kodak's excellent E200, for example, went to 320 (not 400) at push 1, to 650 (not 800) at push 2, and to 1000 (not 1600) at push 3.

MONOCHROME PROCESSING

Monochrome processing illustrates two truths. One is that it is possible to get superb results by carefully personalizing your development technique. The other is that you can, at the printing stage, disguise dire shortcomings in development technique.

The ultimate expression of personalized development technique is Ansel Adams's Zone System. Via extensive testing, the photographer establishes first a 'normal' ('N') development time for 'normal' subjects, and then reduced ('N-') and increased ('N+') development times for subjects that have unusually long and unusually short brightness ranges.

While there is no doubt that the Zone System can be made to work superbly, there is equally little doubt that it can be carried to excess: many Zone *aficionados* waste a great deal of time in looking for a precision which simply isn't there. There is also no doubt that if you are using variable-contrast paper, this aspect of the Zone System is of even less use.

If you have a religious attachment to grade 2, and if you insist on using graded papers, then the best of luck to you; but from the point of view of quality, there are absolutely no advantages to using graded paper, unless you particularly want to use a variety of paper which is only available in graded form – usually, some of the more exotic surfaces. If you are in this league, then you need more information than can conveniently be incorporated here, though you may find it useful to read our book *Perfect Exposure* (David & Charles/Amphoto, 1999).

The most important single thing is to give enough exposure to get the shadow detail that you want, and this is dealt with in Chapter 6 and (once again) in *Perfect Exposure*. After this, development can vary within quite wide limits, and you will still get a negative which will print perfectly satisfactorily on variable-contrast paper.

We had an excellent example of this as we were working on this book. Ilford brought out a new developer, DD-X, and gave recommendations only for using it at a 1+4 dilution. After discussions with Ilford, we decided that for some films, there might be advantages in diluting it 1+9. The only problem was that we had to guess at the development times.

The first film we tried, Delta 100, we overshot by close on 30 per cent. The film was very contrasty, and needed to be printed on grade 0, with a pre-flash (see page 167). The results were still excellent: the sort of thing that most people would have been delighted to achieve. Remember that Delta 100 is, like all 'high-tech' films, more critical of development than older, cubic crystal films – and remember that 30 per cent is a long way out. With the next batch, we dropped the time from 15 minutes to 11½ (in a Jobo CPE-2, page 129), and the negatives were beautiful and printed perfectly on grade 2.

ITERATIVE TESTING

The test just described, of Delta 100 in DD-X, well illustrates the point that you need to be a very long way out before you get a negative which will not print well on variable-contrast paper; you will not write off your image, though you may not be able to print it easily or conveniently on graded paper.

If you are prepared to accept this, you can adopt a simple programme of iterative testing. Begin by developing the film in accordance with the film and developer manufacturers' recommendations, or if these are not available, at your best guess. If your first film doesn't print well on a

middling grade, change the development time for the second: if it required a very hard paper the first time, increase the development time; if it required a very soft paper, cut it.

If you are only a grade out, change the development time by half a minute or a minute – around 10 per cent. If you are a couple of grades out, change it by 20 or 30 per cent.

The manufacturers' recommendations are invariably the best starting point, despite the maunderings of many self-appointed experts. Purely personally, we have generally found that we prefer the results which we get with slightly more development than is recommended by most manufacturers, or (where they give a range of development times) where we use a time from the upper end of the range. Many others find the exact opposite. Neither is 'right', though once again, there are those who will tell you otherwise. It all comes down to the point which we have made repeatedly: it is important to consider the whole process, from shooting to the final print, and not just individual stages. And basically what works for you, works for you.

UNUSUAL SUBJECTS

A 'typical' subject is normally taken to have a brightness range of 128:1. If the brightness range is unusually long – either use a spot meter, or guess – then it is a good idea to cut development slightly, to reduce the contrast and to ensure that the subject will be realistically represented on the print: this is of course the 'N-' development of the Zone System.

Although the Zone System formalizes 'N-' according to the brightness range of the subject (N-1 for 256:1, N-2 for 512:1, N-3 for 1000:1, and even beyond), we have almost never seen successful examples of extreme N- development: the prints just look muddy. What makes it worse is that the people who make them are often so proud of them, and you can't help wondering why. From years of experience, we have found that cutting 15 per cent is an ideal compromise, and allows most subjects to be printed on grade 2 or grade 1.

The opposite of N- is of course N+, and once again, the Zone System formalizes this: N+1 for 64:1, N+2 for 32:1, N+3 for 16:1. Once again, we find this unnecessary. For really flat subjects, we normally give 50 per cent extra development, and leave it at that. We do not think that our prints (or those of other competent photographers who eschew the Zone System) are inferior to those produced by the vast majority of Zone System believers; and when you look at the finest prints by the finest printers, it doesn't seem to matter much whether they are Zone believers or not.

SHORT STOP, FIXING AND WASHING

For the most part, the manufacturers' instructions are all you need. Short stops are far from essential, but prolong the life of fixers slightly. Use non-hardening fixers, as these greatly shorten wash times. There are allegedly a very few places where the water is so soft, or so alkaline, that you need hardening fixers, but our suspicion (and that of industry experts) is that with modern films and anything resembling normal conditions, there is unlikely ever to be a need for hardening fixers.

To be sure that our films are adequately fixed, and that the fixer is not over-worked, there is a little trick we have used for years. Take a piece of undeveloped scrap film: a piece of 35mm leader is fine. Put a drop of fixer on it, and leave it for 20 or 30 seconds. Then drop the whole piece into the fixer, and time how long it takes for the spot to become invisible. This is your clearing time. Fix the film for at least twice the clearing time, and at most for three times. When the clearing time reaches twice that for fresh fixer, make up a new fixer bath. Washing is covered at the end of the chapter.

MONOCHROME PROCESSING EQUIPMENT AND TECHNIQUES

We have already mentioned hand lines and processing machines above, for colour processing, and they can equally well be used for monochrome. In fact, the majority of our 35mm and roll-film monochrome is now processed in a Jobo CPE-2: not only is it easier to control time and temperature, we can also process more films at a time than we can with small tanks, and the one-shot chemistry is very economical.

Although Jobo recommend a pre-soak, we prefer not to use one: the effects of pre-soaks range from irrelevant to unpredictable. Instead, we

cut development times by 10 per cent, rounding down to the nearest half minute, to compensate for the constant agitation. Ilford recommends no pre-soak and a 15 per cent cut, but generally, 15 per cent and rounding up will give much the same time as 10 per cent and rounding down. With a 12-minute development time, for example, we knock off 1.2 minutes and round 10.8 down to 10.5; Ilford's recommendations would subtract 1.8 minutes, leaving 10.2 which we would round up to 10.5 again. Besides, these are starting points; you can always go up or down half a minute, as necessary.

Small stainless steel or plastic tanks are perfectly adequate for processing monochrome 35mm and roll film, though we find it a good idea to take the temperature of the developer both when we pour it into the tank, and when we pour it out. This makes it easier to judge whether we are inadvertently using 'controlled drift' as described above. Most people develop monochrome at 20°C (68°F); or at least, that is the temperature when they put the developer in. If they checked the temperature when it came out, they might often find that it was a degree higher or lower, or even two degrees in a particularly warm or cool darkroom.

CUT FILM

Sheet film is rather more awkward than roll film, both because of the difficulty of keeping the temperature constant (using a large volume of developer helps) and because of the difficulty of ensuring evenness of processing. Tray processing is deservedly popular – it is cheap and simple – but it has to be done in the dark, and interleaving several sheets of film in the same tray has always struck us as a recipe for scratches, though many people seem to get away with it.

For 4x5in, you can use small tanks (including rotary processing machines), but some are slow to fill and empty. Hand lines are good for 4x5in, including Nova tanks designed for paper processing. BTZS film tubes are popular for all formats, while for 5x7in and 8x10in we use either Nova tanks or a Paterson Orbital tank, the latter now out of production though they can still be found used, and there may yet be a few new ones still lurking in some dealers' stocks.

The important thing with the Nova tanks is to

avoid over-agitation, which leads to excessive density around the edges. With 4x5in film in an 8x10in tank, there is no problem, but with 8x10in in the same size, agitation must be fairly stately. We use a variant on the old plate system: lift the film out with one top corner up, drain for a count of three, re-insert, move up and down by about 2cm (¾in), twice. Leave to the next half minute and repeat, but this time raising the other top corner.

The Orbital tank has been modified in that we have roughened the floor so that the film does not stick; we pitted it with a Dremel tool, though someone else who uses the same technique decided instead to cover the floor with countless tiny dots of adhesive. The great advantage of the Orbital is that it can process four sheets of 4x5in, two of 5x7in or one of 8x10in quickly and economically; the disadvantage is that temperature control is difficult, and relies on a darkroom which is at a constant temperature.

BTZS tubes suffer from the same drawback as an unmodified Orbital, in that backing layers fail to clear completely (they can be cleared in a sulphite bath or a second fixing bath) and there may be variations in texture on the backing, though these seem to have no effect on the image. The most alarming thing about BTZS tubes is that after

MERTOLA
Disaster! Roger tried to save time by processing Paterson Acupan 200 at 24°C (75°F) in a Nova hand line, using Paterson FX-39 1+9. The problem was that the development time of 3½ minutes was too short, so development was uneven. A much safer bet would have been to work at 20°C (68°F), and possibly to reduce the dilution as well, to 1+14: Acupan 200 is a very fast-developing film.
HAND-HELD NIKON F,
90–180/4.5 VIVITAR SERIES 1.

development they are opened, emptied, and filled with fixer by room light. Surprisingly, this is not a problem: the films are partially desensitized by the developer, and the induction period for development of the second exposure is longer than the time it takes to get the fixer in, so it doesn't matter at all.

EVENNESS OF DEVELOPMENT

The easiest way to ensure even development is with reasonably gentle agitation, as mentioned above, and reasonably long development times. In general, development times of much less than 5 minutes should be avoided: 4½ minutes should be all right, but 3½ minutes can definitely be too short, as we can attest from painful experience. If development times are uncomfortably short, try working at a lower temperature (for example, 20°C/68°F instead of 24°C/75°F), and if they are still too short, increase the dilution of the developer. Going from 1+4 to 1+9 will typically give around a 50 per cent increase in development time: despite the fact that the developer concentration is halved, the time doesn't double. Furthermore you do not need to increase the quantity of developer, no matter what you may read elsewhere.

J'AI TOUJOURS VÉCU
For grab shots in the city, latitude is the name of the game. Two of our favourite ways of achieving this are to use Ilford HP5 Plus rated at EI 250, with development at around the developer manufacturers' recommended minimum, or (as here) to use XP2 at a similar speed. Downrating means slightly decreased sharpness for both, and more grain with the HP5 Plus (though smaller grain with the chromogenic film), but these are small prices to pay for an easy stop either way of latitude while retaining excellent quality.
NIKKORMAT FTN, 90/2.5 VIVITAR SERIES 1. (FES)

CONSISTENCY

The importance of consistency cannot be over-emphasized: consistency is far more important than accuracy. If your thermometer over-reads by a degree, and you have found that in order to get the sort of negatives you like, you need to give two minutes' more development than the manufacturers recommend, this is absolutely no problem – as long as you stick to that thermometer, that indicated temperature, and that time. Switch thermometers, or change temperatures, and the results will be different.

Likewise, although you can get overly excited about consistency in agitation, you should be as consistent as you can. With small tanks, we give 5 seconds' agitation (six inversions for Roger, five for Frances) every 30 seconds. Results would be slightly different if we gave 10 seconds'

agitation every minute, though neither pattern is 'right' or 'wrong'. With short development times, it may be better to agitate every 30 seconds, but beyond six or seven minutes, it mostly doesn't matter which you use, as long as you always use the same one.

Agitation regimes which rely on long development times and minimal agitation are for the most part faddish and invite 'bromide streamers' in the negative. It is true that both compensating developers (see page 112) and acutance developers (see page 113) will have more effect with less agitation – but even then, agitation every minute is unlikely to do any harm.

GIRL ON MOTORCYCLE
Camera club 'studio nights' provide a wonderful opportunity to try out new films under (reasonably) real-world conditions. This was one of Roger's first experiments with the then-new Paterson Acupan 800, in a Leica M2 with a 90/2 Summicron. As is clear, there is scope for increasing development time to get more 'snap' in the negative.

FIXING AND WASHING

Fixing has already been covered – the only thing to note is that like the short stop, if you use one, the fixer temperature should be within a degree or so of the developer temperature – and Ilford's recommendation for archival washing is that you use water at the same temperature as the other processing baths, and fill the tank three times. The first time, invert it five times, and drain. The second time, invert ten times; the third time, twenty times. There is no need to wait five minutes between washes, or to wash in running water for luck.

On Ilford's tests, this gives archival longevity to ANSI IT9.1 or ISO 10602.1995: longer, that is, than triacetate film base will last. An extra wash or soak will not do any harm, and may even remove a little more fixer, but it is unclear whether this will make any difference to the overall life of the negative. Certainly, anything more than another five minutes is a waste of time and water.

Something that most people do not realize is that negative life is likely to be far shorter than print life: film base is the limiting factor. It is still possible to print from glass negatives that are well over a century old, but under normal storage conditions, modern triacetate film bases have a life which is measured in decades: few, except those that are stored under unusually cool conditions, will survive for as much as a century. Optimal storage conditions are a relative humidity of 20 to 30 per cent (go too low, and you risk distortion) at temperatures between 3° and 7°C (37° and 44°F): the higher the humidity, the lower the temperature should be.

Polyester film bases are much more stable: they are used for almost all cut films, except those which are perforated, such as Polaroid Type 55 P/N and Fuji's Quickload system. They will probably last for centuries, even at room temperature; accelerated ageing tests indicate a film base life in the 1000 to 2000 year range.

A SENSE OF PROPORTION

We own a densitometer, and as we were writing this, we decided to get a pH meter (see panel, page 112), but these are absolutely and utterly inessential for the normal pursuit of quality.

Indeed, they probably do more harm than good, in most cases, because they encourage people to run before they can walk. More than once, we have heard from readers who have invested large sums of money in equipment they don't need, don't understand, and can't use, when they would do better to follow the manufacturers' instructions on a bottle of developer. If you think we are exaggerating, one would-be densitometer user was getting odd readings because his films were not fully fixed: they still had that milky look of partially fixed emulsions. He just didn't know what dilution of fixer to use, or how long to use it for, or what a properly fixed film should look like.

Exotic tools also encourage people to waste time on pointless 'testing'. This time could far more usefully be spent in taking real pictures. We are involved in photography all the time, and shoot more film in a week than many enthusiasts do in a year, and we don't really need either a densitometer or a pH meter. The only reason we own the one, and decided to buy the other, is to add weight to some of our arguments: in photography, there are countless fads, myths, and what the estimable Ctein calls 'old shutterbug's tales'. Sometimes, the only way to counter these is with hard scientific evidence – and even then, some people cannot be convinced.

CONSIDER THE WHOLE PROCESS

As we have repeatedly said, no stage in the photographic process – including film development – can be considered in isolation. It is only part of a chain which begins with selecting the camera and lens and film; and then the subject; and then the exposure; and which, after development, also takes in the enlarger and its lens, the paper, the developer, and even the conditions under which the print is to be displayed.

What it does allow, though, is some compensation for other links in the chain. If your camera and lens suffer from flare, or for that matter, if the enlarger and its lens have the same problem, you can increase development somewhat to recover contrast – though the tonality will not be quite the same as the image from a high-contrast lens, developed for less time. As already noted, subjects with a long tonal range can stand slightly reduced development, while those with a

short tonal range will often benefit from rather longer development. Alternatively, you can compensate for any or all of these eventualities at the printing stage, by choosing a different grade of paper or a different paper developer.

Or again, your meter may read a little low, and your shutter may run a little slow, and the marked apertures on your lenses may indicate more speed than you actually have, especially the maximum aperture, which is often a marketing ploy rather than an accurate description. If you are lucky, all these factors may cancel out; if you are unlucky, they may all add up. There is absolutely nothing wrong with changing your processing slightly, even in colour, to get results that you like, though it took Roger years to accept this: he always feels that he should be able to do better at the published times.

Ultimately, there is only one arbiter of your work, and that is you. If you wish, you may pay due attention to the opinions of others. But the important point is to look at each stage of the quality chain, as dispassionately as you can, and to try to decide where you can make a meaningful improvement, and where you cannot; which is what this book is about.

STILL LIFE
This was taken with a superb camera and lens (Linhof 'baby' Super Technika IV, 100/5.6 Apo-Symmar on 6x7cm) using good fresh film (Ilford Delta 100) and printed on one of our favourite papers, Ilford Warmtone. It is still a failure. Why? Because it lacks passion – and composition.
(RWH)

CHAPTER ELEVEN

THE DARKROOM

UNIVERSITY OF KENT AT CANTERBURY
If a print is the final objective, negative film is vastly easier than slide film for a picture with a very long tonal range. Not only is the original exposure easier – you simply err on the side of over-exposure – but printing is vastly easier because you can dodge and burn as well as altering contrast by development.
HAND-HELD LEICA M2, 35/1.4 SUMMILUX, FUJI RF. (RWH)

It is perfectly possible to develop your own films without a darkroom. Use a changing bag to load the films into the tank, and everything else can be done in daylight. This is fine for slides. The only trouble is that if you process negatives, you need prints.

Admittedly you can live without a wet darkroom if you take the digital route. You can produce remarkably good prints from scanned-in negatives or (better still) transparencies, using an ink-jet printer. You will need a good, modern, high-resolution film scanner, and a state-of-the-art printer, though these are fairly modestly priced nowadays; the Epson Stylus Photo probably set the standard for high-quality, small-format ink-jet output, though it has its challengers.

The crunch comes, though, when you compare the quality of the best ink-jet prints with the best silver halide, especially in monochrome. Regardless of how many dots per inch (dpi) the printer delivers, it will never deliver the same quality as a continuous-tone silver image. This is not a question of waiting for better technology or improved ink-jets; it is the difference between a continuous tone image, and one made up of dots.

There are three other arguments in favour of the wet darkroom, too. One is that you can get better quality for less money, and the wet darkroom will depreciate far more slowly than any computer. The second – which surprises many people who come to photography via digital imaging – is that many common forms of image manipulation are actually easier in the wet darkroom than on the computer: dodging and burning come immediately to mind. The third is that many people find that it is more fun. After all, more and more people have to work with computers on a regular basis, connecting with a virtual world via a screen, a keyboard and a mouse. The wet darkroom is, for many, a welcome reminder of a real world in which things have weight and texture and smell and temperature. Even the opportunities for making mistakes are a useful reminder that in real life, you can't just press the 'UNDO' button or go back to the previous file version.

In theory, you can buy in your printing, using custom labs. Pro labs are hair-raisingly expensive, but the 'shamateur' labs mentioned on page 126 should deliver good quality at a reasonably affordable price. Doing it yourself allows ultimate control and keeps costs down; if you really care about quality, making your own prints is the only sensible option, and doing your own darkroom work is both easier and cheaper than most people imagine.

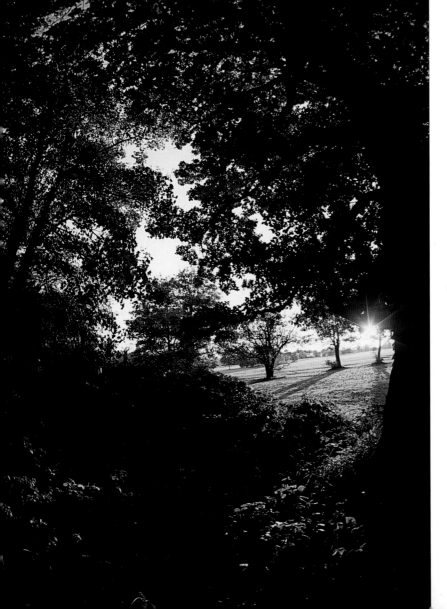

FINDING THE ROOM

The darkroom itself need not be large – though it will expand to fit the space available. Our present darkroom is approximately twelve feet square – making it twelve feet on each side. However the one we used for close on a decade before that was twelve square feet, about three feet six inches on each side.

The big darkroom is the converted dining room of our 1890s three-floor house: the small one was a Nova darkroom tent. If you have no room for a Nova tent, then you may well have an equivalent amount of space that you can colonize elsewhere: under the stairs, in the roof, a cloakroom, a corner of the garage.

A permanent darkroom makes it much easier to produce high-quality prints, and a semi-permanent darkroom – one that is taken down only when you have guests to stay, or whatever – is the next best thing. A great advantage of Nova tanks

(see panel overleaf) is that the chemistry can be left in them, and the heaters can either be left on all day, or switched on half an hour to an hour before you want to start printing. Set-up and clean-up times are thereby reduced to less than five minutes for the average printing session, which means that you can do a lot more printing. More printing means more practice, and this means better pictures: in printing, as in every other branch of photography, there is absolutely no substitute for practice.

The main requirements of a darkroom are that it should be dark, well ventilated (the smaller it gets, the more this matters), and capable of being maintained at a reasonable temperature for most of the year. Running water is a highly desirable luxury, but far from essential.

Although darkness may seem self-evident, many photographers' darkrooms do, in fact, have light leaks. With film, they will manifest themselves much faster than they do with paper – some

STILL LIFE
Marie Muscat-King, whose picture this is, often gets double mileage out of her food, once as the subject for a still life, and once as a meal: this was part of Christmas dinner. It is worth remembering, though, that food and photographic chemistry can be a dangerous combination, and great care should be taken to avoid cross-contamination if chemicals are mixed in the kitchen.
NIKKORMAT FTN ON TRIPOD, 85/1.8 NIKKOR, KODAK ELITE 200.

NOVA DARKROOM TENT ▶
In a tent similar to this, we did all our printing for all our books and magazine articles for close on a decade.
COURTESY NOVA

NOVA TANKS

In our Nova tent, we could (just) produce high-quality 12x16in colour or black and white prints, thanks to Nova tanks. These are deep-slot processors with integral temperature control. Processing RC prints is no problem at all, but fibre-base requires a bit of care if the clips which hold the print are not to tear through; a new design, introduced in 1999 along with a special fibre-base paper holder, should solve this problem.

There is no point in saying a great deal more about Nova tanks, the praises of which we have also sung in many other places including *The Black and White Handbook* (David & Charles, 1997), but if you are strapped for space, there is no finer solution.

NOVA TANK
This is the smallest of the heated Nova tanks, a two-slot 8x10in – entirely adequate for monochrome. We have three, four-slot (Quad) Novas, in 8x10in, 12x16in and 20x24in.
COURTESY NOVA

photographers will only handle film in their darkrooms at night, for this very reason – but even with paper, light leaks and unsafe safelighting will take the ultimate edge off a print, assuming they do not wreck it completely.

As well as exterior light leaks, you need to look for interior light sources and for light leaking from enlarger negative carriers, worn bellows and the like. We actually have a checklist in our darkroom, listing all possible sources of unwanted light (or at least, the ones we have found so far): the thermostat light on the Jobo CPE-2, the charging warning light on the cordless telephone, the telltales on the darkroom stereo (Frances, like all good darkroom techs, likes music while she works), the instrument panels (such as the Colorstar analyser) and indeed the safelights themselves, ever since Roger failed to notice a very deep red safelight for the first few minutes, and fogged half a box of 4x5in HP5 Plus. The same test as for unsafe safelights (see page 146) will also reveal other sources of unsafe lighting.

Ventilation is extremely important. Many photographers develop appalling, hacking coughs in their forties and fifties – like smokers' coughs, except that they have never smoked in their lives. We have a powerful fan blowing into the darkroom, and a chimney flue (with a gas fire) to vent air; in the winter, we always run the gas fire, which (surprisingly enough) seems safe for black and white, though not for colour, and which in conjunction with the positive pressure from the fan keeps the air very clean.

Temperature is not merely a matter of comfort: the chemistry must not be too cool or too warm, though heated deep tanks such as the Nova tanks described in the panel can make this easier.

In the tent, we had no running water. A large ice-chest was used as a dump tank for prints, which would periodically be taken out and washed in batches by normal room light.

ENLARGERS

You can easily spend the price of a reasonable second-hand car on a top-flight enlarger such as a De Vere, and if you can afford to do so, there is no reason not to. At the other extreme, people often give away astonishingly good enlargers, simply because they want the space: a friend of ours was given a Blumfield, one of the finest enlargers ever built. It was based on the Leitz Valoy, but without those compromises on materials and workmanship which, in the opinion of Mr Blumfield, Leitz had made. As long as an enlarger is reasonably solid; has a good, even light source; does not leak light;

and holds the film and the baseboard parallel, it does not need to do a lot more.

Admittedly, the Blumfield lacks a filter drawer, so you have to use below-lens filters. On the other hand, it has a three-filter holder below the lens, which allows tri-colour sequential printing (doing it the hard way, but possible) or easy Multigrade printing: you can either place the appropriate filter on the holder for half-grades, or use just two filters (grade 0 or even 00 and grade 5) and print through them sequentially to get any grade of which the paper is capable.

Historically, there were several different sorts of enlarger: point source, condenser/diffuser,

RIVER, CALIFORNIA
The strange colours here are nothing to do with the processing: they are the result of using a polarizer on the camera. The blue of a lake or river is the result of skylight reflected back from it; remove the reflections with a polarizer, and if you are lucky you will merely get emerald green. If you are unlucky, you will get mud.
TRIPOD-MOUNTED MAMIYA RB67, 150/4.5 SOFT FOCUS MAMIYA-SEKOR, KODAK EKTACHROME 64. (RWH)

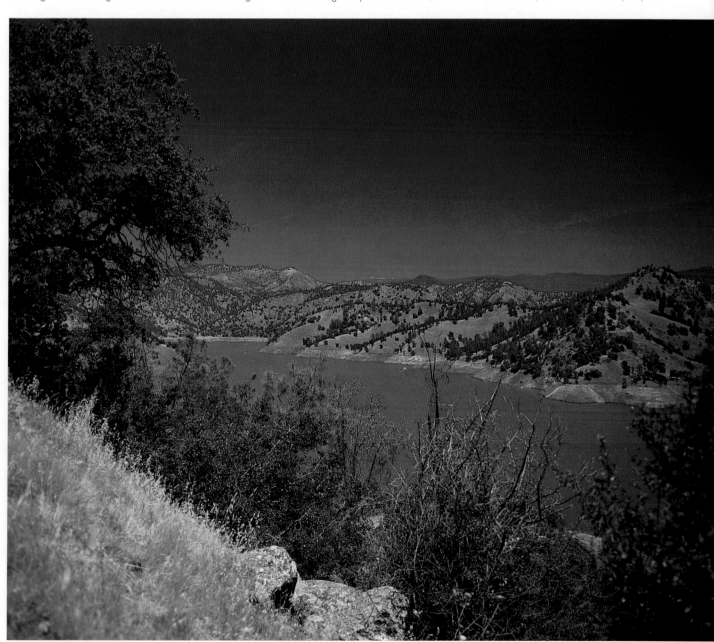

diffuser with mixing chamber, cold cathode. Nowadays, diffuser enlargers dominate the market, but it is worth taking a quick look at the alternatives.

Point source enlargers will give maximum sharpness, but they also show up every scratch and mote of dust, so they are only for masochists: preferably, for masochists who don't mind oil-immersion printing, with the negative sandwiched between glass in a silicone oil which has to be cleaned off before the negative can be put away.

Condenser/diffuser enlargers are the ones that are normally given away, and they can be used for both colour and VC printing with discrete filters, either in a drawer or under the lens.

Diffuser enlargers with dial-in filtration (for colour or for variable contrast) are the standard today – they are what we use – but quite honestly, they make no real difference to image

quality: they are merely more convenient than condenser/diffuser enlargers.

Cold cathode enlargers, which use a variety of fluorescent lamp as a light source, have a sort of mystical aura to them which is not, in our experience, particularly justified. Because the light is very diffuse, they are alleged to produce the closest effect to that of a contact print, but equally, if a diffuser enlarger has the final diffuser plate close enough to the negative, the difference is very slight. We have both cold cathode and diffuser heads for our 5x7in enlarger, and we almost never use the cold cathode head, not least because it does not filter very well for VC paper. Cold cathode heads also need to warm up: the initial composition and intensity of the light is not the same as it is when the head has been on for a while.

FEEDING BIRDS, ZUERICH
In the caption on page 32 we have sung the praises of the 6x8cm format; but it is worth remembering that many enlargers stop short at 6x7cm, and that even if your enlarger will handle 6x8cm, there is very unlikely to be a carrier for that format, so you will need to use built-in masking bars (where available) or to cut a black paper mask, if you want the ultimate in quality.
HAND-HELD ALPA 12WA, 58/5.6 SUPER ANGULON, KODAK EKTACHROME EPN. (RWH)

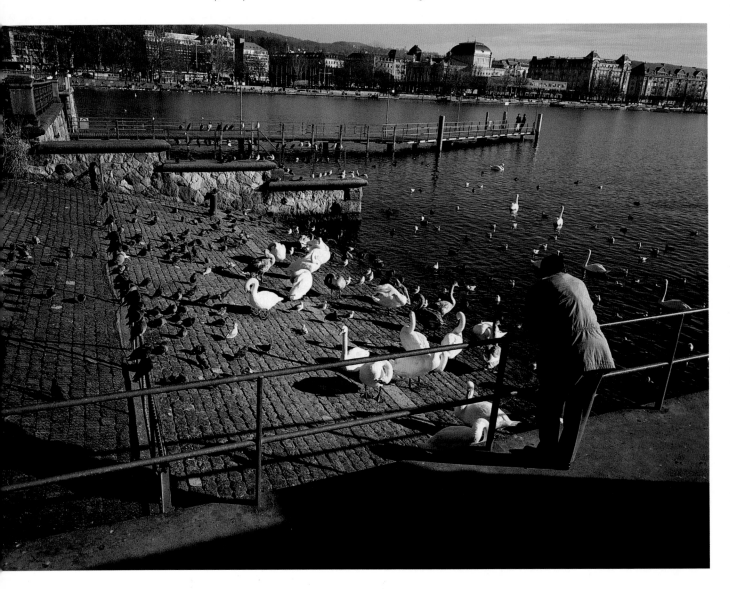

NEW YORK
A reviewer of one of Roger's books, many years ago, complained about the 'contrasty, over-polarized images'. He thereby revealed first, that he had not actually read the book – Roger complained in the text that polarizers were too hard to use on M-series Leicas – and second, that he was unfamiliar with the kind of contrast and saturation that Leica M-series lenses can deliver.
HAND-HELD LEICA M4-P,
35/1.4 SUMMILUX, FUJI RFP.
(RWH)

LIGHT SOURCES AND THE CALLIER EFFECT

The grain in a negative does not merely block the light: it also scatters it, thereby effectively introducing extra contrast in proportion to the density of the image. The Callier effect is (predictably) most obvious in a point source enlarger, where the beam is most highly collimated, and least apparent in a cold cathode enlarger. Variations in the Callier effect are one reason why different photographers need different degrees of contrast in their negatives: formerly, film and developer manufacturers often used to recommend one development time for condenser enlargers, and another, longer development time for diffuser enlargers.

Because chromogenic films such as Ilford XP2 and Kodak T400CN have only a dye image, with no silver, they do not exhibit the Callier effect and will normally print at pretty much the same contrast in any enlarger.

NEGATIVE CARRIERS

At least as important as the light source is the construction of the negative carrier. A perfect negative carrier would hold the negative dead flat without glass. A few do this, but it seems to be a matter of luck, even among the best enlargers. The next option is a single-glass carrier, where the film is against glass on one side but open on the other; and the third and final option is a double-glass carrier.

The disadvantages of any glass carrier are that there are two or four extra surfaces to gather (or seemingly, attract) dust, and that with some films and some glass carriers you will get Newton's rings, those infuriating oil-in-a-puddle rainbow rings which are caused when two very smooth transparent surfaces are in contact.

The disadvantages of glassless carriers are equally clear. They do not hold the film as flat, and worse still, some of them allow the negative to 'pop' as it warms up in the film gate. This is particularly vexing when you have focused your image carefully, only to see it pop out of focus just before you turn the enlarger off to put the paper in (or worse still, during the exposure).

Either type of carrier is a compromise, and some enlargers allow you to use either, depending on your mood and most recent bad experiences. Regardless of which type you have – and we have both – it is very useful to have sliding masks in the enlarger or carrier so that you can mask off any unwanted bright areas. This can greatly reduce flare (see below, under 'Lenses'). If you do not have sliding masks, then seriously consider cutting small black paper masks to size if you need to block off any large light areas.

UPDATING OLD ENLARGERS

Earlier, we said that it is often possible to update old enlargers, and if you have a sound chassis with a good negative carrier, this may be the best option. New lenses are the most obvious investment, and often the best, but it may also be possible to 'bodge on' a new enlarger head. Our ancient 5x7in MPP Micromatic now sports a De Vere 507 dichroic colour head, one of the finest ever made, and it would be possible with many smaller-format enlargers to lash up a Meopta colour or VC head, which can be bought separately.

It is also worth knowing that some old enlargers are much better supported than others. De Vere can supply most parts for all but their very oldest enlargers, while in the United States, there are still plenty of parts even for very elderly Omegas, and old Beselers can often be updated.

ENLARGER LENSES

One of the most important investments you can make is in a good enlarging lens – but 'good' bears a lot of close investigation. First, there is the question of flare. Enlarger lenses seem peculiarly susceptible to pitting and grime with the passage of the years, perhaps because of the humid and sometimes chemical-laden environment in which they work. A good enlarger lens has a life of decades, but it will not last forever, and a lens which was state-of-the-art when it was new, thirty years ago, may well have lost its 'edge'. Old lenses (especially old, uncoated lenses) are normally a lot less contrasty than new ones, and flare also affects colour balance, adding a blue/cyan tinge in colour negative printing.

Second, there is the question of enlargement size. The bigger the enlargement, the better the

PARIS
*Today, we would not
bother to make a
conventional reversal print
of a subject such as this,
because we could get
excellent results by
scanning in the trans-
parency and printing it
with an Epson Stylus
Photo. But for pictures
with large areas of subtle
highlight tone, or where
shadow detail is
important, silver still
maintains the lead.*
TRIPOD-MOUNTED
NIKKORMAT FTN, 35/2.8
PC-NIKKOR, KODACHROME 64.
(FES)

lens has to be. If you look at enlarger lenses from top manufacturers, you will see that they commonly offer at least two ranges. Look closely at the specification of the cheaper range, and you will find that lenses for 35mm are typically optimized for an enlargement size of around 5x or 6x, and those for roll film at around 4x. This equates to around 5x7in (13x18cm) or 6x9in (15x22cm) off 35mm, or around 10x12in (24x30cm) off 6x7cm. The more expensive range will be optimized for 8x or 10x off 35mm (8x12in to 10x15in, or 20x30cm to 25x40cm) and for maybe 7x off roll film (16x20in/40x50cm off 6x7cm).

At the smaller enlargement sizes, the cheaper lens may be just as good as the more expensive one. It may even be contrastier: we have a 105mm Meopta Anaret (three-glass) and a 95mm Computar (six-glass), and at up to about 4x, the Anaret is sometimes more pleasing. At 12x16 (30x40cm), the Computar is clearly pulling ahead, but if you do not print at such sizes, do you need to spend the money?

Third, there is the question of distortion. A more expensive lens will almost invariably render straight lines more accurately at the edge of the image, without bowing outwards (barrel distortion) or inwards (pincushion distortion). This is, however, likely to be visible only with certain subjects such as architecture: with portraits or landscapes, the effect is likely to be imperceptible.

Fourth, there is the question of evenness of illumination. A general rule here is that the longer the lens, the more evenly it will project an image from a given size of negative. This is, however, only a general rule: a high-quality 90mm lens, with six glasses and relatively large front and rear elements, may well equal or surpass the coverage of a 105mm of three-glass construction. A lot depends on the enlarger light source, too.

With any lens, there is likely to be an optimum aperture, as canvassed for camera lenses on page 52. Enlarger lenses are not particularly hard to design, so there is no reason why this should not be a couple of stops, or even one stop, down from maximum aperture. Certainly, stopping down unnecessarily will reduce definition, and many people reckon that their favourite enlarger lens has a very clear 'sweet spot' where it gives better definition than even ½ stop either side. It is well

worth experimenting with a grainy negative to see if your lens has such a 'sweet spot.'

To sum up, in 35mm, only the best lenses are likely to be good enough – but the best can last a very long time, as evidence our 30-year-old 50mm f/4.5 Leitz Focotar, which still bears comparison with new top-of-the-line lenses (we are loaned them for review, of course). Move up to roll film, and even a very modest lens can give excellent quality, provided you do not want to make very big enlargements. By the time you get to 4x5in and 5x7in, resolution has ceased to matter; distortion is unlikely to be a problem, except with the very worst lenses; and as long as you have adequate contrast, you are likely to have all you need.

SAFELIGHTS

After an enlarger and some means of processing the prints, the only other thing you cannot easily live without is a safelight.

The colour you need depends on what sort of processing you want to do, and unsafe safelights are one of the greatest unsuspected thieves of quality, at least after other sources of stray light.

For monochrome, we use red safelights which are safe with just about all materials including ortho film (at a reasonable distance), but some people apparently do not like working by red light; they prefer brown or amber. This is fine, but not all brown and amber safelights are safe for all materials, especially VC paper. With any safelight, a proper test, as described below, is a good idea – and it is not a bad idea to repeat the test occasionally, as safelights can and do fade.

In colour, gas discharge and light-emitting diode (LED) safelights can be made monochromatic at a wavelength to which (most) colour negative papers are partially or completely insensitive. This allows remarkably bright safelighting – reputedly, enough to read a newspaper by, if you use some of the big sodium vapour lamps – but the disadvantage is the price. LED safelights are cheaper than gas discharge: we use the Nova Five Star, which as its name suggests consists of five LEDs in a star, and which is not too expensive.

Note that colour safelights are not necessarily safe for all VC materials, although they should be safe for graded papers. Nothing is safe for the reversal papers which are used for making prints from transparencies.

SAFELIGHT TESTING

The classic test of safelighting is the 'coin test'. A couple of coins are placed on an unexposed sheet of sensitized material, which is left out for at least as long as it would normally be left uncovered in normal darkroom work, and preferably for a good deal longer. The material is then processed. If there is any shadow of the coins, the light in the darkroom is not safe.

It is however possible to enhance the sensitivity of the test by pre-flashing the sensitized material. Determine, by experiment, the shortest exposure (under the enlarger, with no negative in the carrier) that is required to give a barely detectable tone. You can do this by winding the enlarger up to the top of the column, stopping the lens well down, and giving a sequence of brief exposures: maybe ½ second, 1 second, 2 seconds and 4 seconds.

Whatever exposure gives a density, expose another sheet for one-half of that exposure. This will overcome the inertia of the material – the minimum exposure required to make any detectable difference to the material – and make it even more sensitive to fogging. Do the same coin test on the pre-flashed material. It is quite possible that lighting which looks safe with a plain coin test will now turn out to have the very slightest fogging effect; and this tiny amount of extra sensitivity is all that you need to take the ultimate edge off your exhibition prints. We know a number of photographers who have received nasty surprises when they tried this.

THERMOMETERS

There are four available options here. The most usual choice is a spirit thermometer. The usual alternatives are then digital thermometers and dial thermometers; mercury thermometers, the fourth and best choice, are increasingly hard to find, though Kodak still offered a superb one at the time of writing.

You need at least two thermometers: one reference thermometer, against which all others are calibrated, and one working. Whenever you have to replace the working thermometer, you should calibrate it against your reference thermometer. At the very least, this should be a

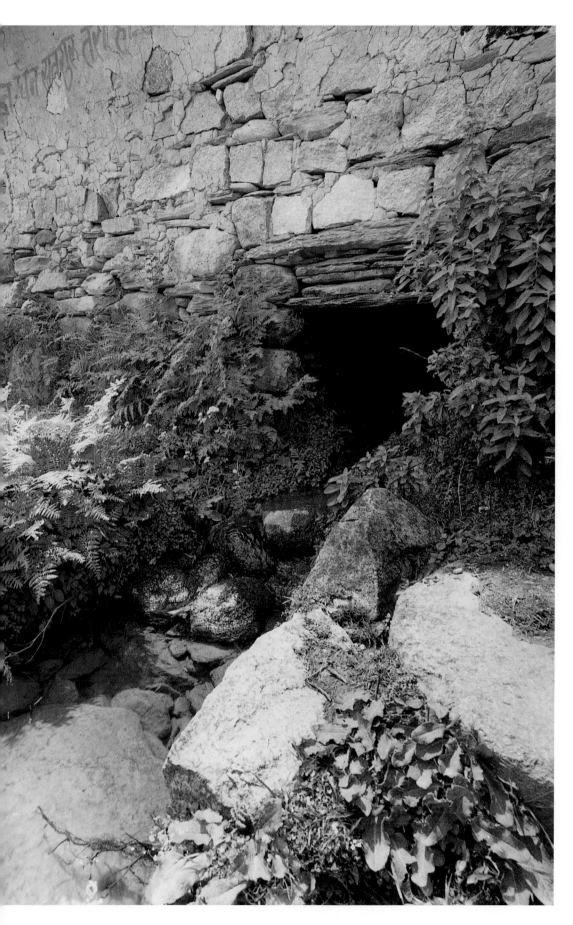

MILL STREAM
*Like the picture of the
wheelbarrow on page 115,
this was printed from a
grossly overdeveloped
Delta 100 negative. The
overall density range was
about 1.75 (almost 6
stops) on the baseboard,
as measured with a
Colorstar, so Frances knew
she was going to have to
work hard to tame the
contrast. She adopted the
same approach as
described for the wheel-
barrow picture.*
TRIPOD-MOUNTED ALPA 12
WA 38/4.5 BIOGON 44X66MM.
(RWH)

high-quality spirit thermometer; preferably, it should be a high-quality mercury thermometer. Best of all would be a calibrated mercury thermometer, no more than one or two generations from a National Physical Laboratory or other national standard.

Calibration, both of your own working thermometers and of calibrated thermometers, is nothing more or less than comparison of the reading on the thermometer to be calibrated with the reading on a reference thermometer.

For reference, we use two old Brannan mercury-in-glass thermometers, which agree perfectly at 20°C (68°F) and are within 0.1 degree of one another at 40°C (104°F). For a long time, our principal working thermometer has been an old, non-calibrated Paterson, which relative to the Brannans reads 0.3 degrees low at 20°C (68°F) (19.7°C is in fact 20°C by our standard), and runs out of scale at around 30°C (86°F). At the time of writing, we had just added an RH Designs digital thermometer, which reads 0.1 degrees low at 20°C (68°F) (19.9 °C is a standard 20°C) and 0.3 degrees low at 40°C (104°F).

Note that our Brannans are not necessarily accurate, but they are extremely consistent. It may well be that at a true 20°C (68°F), the RH is spot-on, the Paterson is 0.2 degree low and the Brannans are 0.1 degree high. This doesn't matter. We have standardized on the Brannans.

We check both working thermometers frequently – indeed, we check the RH against a Brannan whenever we run E6 colour at 38°C (100°F). This is no reflection on the RH: it is just that we have never encountered such a good digital thermometer before. Digital thermometers do not fail safe, and many are notoriously deficient both in accuracy and in consistency.

The great advantage of the RH is that the digital display is very easy to read, especially as compared with the 0.1 degree scale on one of the Brannans (the other has 0.2 degree divisions). It is also admirably quick to respond, nearly as fast as a mercury-in-glass thermometer, while the Paterson (like any spirit thermometer) takes 10 or 15 seconds to come to equilibrium.

A significant advantage of mercury over spirit is that the mercury column almost never separates; and as long as it doesn't separate, the accuracy of the thermometer is unlikely to drift. Spirit columns can separate, and the only reliable method to re-unite them is to immerse them in sufficiently hot water that the spirit goes up into the bulb at the top. As soon as it does this, remove the thermometer from the bath and let it shrink back. With mercury, you can either use this approach, or simply shake the column down. Until we explained about column separation, one of our friends was using a spirit thermometer with a column which was so badly fragmented that it was reading about two degrees high. Heating thermometers in this way requires fine judgement: overdo it, and they can burst.

While dial thermometers are usually easy to read, they are exceptionally prone to mechanical derangement, usually by being dropped, and this does nothing for either accuracy or consistency. Like digital thermometers, they should be checked frequently against a known reference.

Another point about thermometers, one that is little appreciated by most people, is that they are necessarily designed for a specific immersion. A typical figure is 10cm (4in). In practice, it will not matter if you immerse three inches or five; but if you immerse only the bulb, you may well find that the temperature under-reads.

Finally, remember that a thermometer is not a stirring rod; at least, not a mercury or spirit thermometer. Everyone does it, and to a certain extent you have to, in order to make sure that the liquid is evenly mixed and at a consistent temperature; but if you must do it, be gentle, especially if you are rash enough to use a mercury thermometer. This is another advantage of the RH:

PRINT DRYER (PATERSON)
Although we now use a Nova hot-air dryer, we used a Paterson dryer like this for many years. Not all useful darkroom tools are particularly complicated or expensive.
COURTESY PATERSON.

its stainless steel probe is much more robust than glass, and with the clip-on plastic shield (perforated to allow water in and out), it is even less likely to be damaged, though the shield does need to be washed out carefully after use.

TIMERS

There are four and a half options. The first, and easily the least convenient, is a conventional wall clock or watch; we shall ignore this one. The second is an electronic, digital timer. The third is a quartz analogue timer. The fourth is a mechanical timer. And the half-option is a tape recorder.

Any timer, digital or analogue, is likely to be more than accurate enough for all photographic purposes. Many are better than 99.999 per cent accurate (1 second in 16 minutes), and even 99 per cent accuracy would be more than good enough. Any clock error is likely to be less significant than variations in human reaction time.

Whether you prefer digital or analogue timers is a matter of personal preference, but we have always found it easier to work with an analogue timer: we can then start a particular operation, such as emptying a tank, when the second hand is at a particular point, such as 'quarter to' or 'quarter past'.

Another reason we prefer analogue timers is that we like mechanical clocks. When a digital clock stops, invariably at the least convenient moment, then even if you have a spare battery taped to it, you cannot get the clock going again in less than 20 or 30 seconds, and it may take a lot longer, especially if you do not have a battery handy. With a mechanical clock, checking the spring tension at the beginning of a session is something which you can usually remember to do; and even if you cannot, it takes only a few seconds to turn the winding key a couple of times and get it running again. Our principal timer for a quarter of a century was a Smith's stop-clock, one of the old cream models. When it died, its quartz replacement was so nerve-wracking that we hunted out another mechanical timer at a camera fair. Today, we use Paterson's excellent, all-mechanical 'Acu-tick'.

The half option, a tape recorder, is particularly handy when you have to work in the dark; it has already been described on page 128.

PRINT WASHERS AND DRYERS

Washing prints in the bath is reasonably effective if you do not have too many prints in there together, but if they clump together, washing can be very inefficient indeed. A good print washer – we use both Paterson and Nova – can make for much faster, more efficient print washing, and takes up relatively little room. In the short term, better washing makes no difference to the quality of your prints; in the long term, it averts stains.

RUE DES FRANCS BOURGEOIS
Image manipulation without a computer is entirely possible, and can give results which could only be duplicated on a computer with some difficulty. This was produced easily enough by sandwiching a Paterson texture screen with a 35mm negative, and printing the sandwich. TRIPOD-MOUNTED NIKKORMAT FTN, 35/2.8 PC-NIKKOR, ILFORD XP2. (FES)

BURBLING WATER
This is a surprisingly difficult subject to print, and even now, we are not sure whether it is a success. Sometimes, in the darkroom, you just have to accept that there are some things which are better remembered than represented in photographs.
CONTAX RX, 100/2.8 MAKRO-PLANAR, ILFORD XP2 SUPER. (RWH)

Many people over-wash their prints, on the time-honoured basis that if some is good, more is better. In practice, if you follow the manufacturers' washing recommendations (with the use of a wash aid if necessary, for fibre-base prints) then they will be archivally permanent.

After washing, a purpose-made print dryer can greatly speed drying and will reduce the risk of the prints picking up dust and hairs. For RC papers, a warm-air dryer like our Nova is ideal; for fibre-base papers, a blotter plus air drying, or air drying on its own, is better. We use a clothes-horse in the bath for drying even 16x20in (40x50cm) prints; an ordinary clothes-peg is used to hang them from one corner.

ENLARGER TIMERS

Although you can switch an enlarger on and off while watching a clock (a foot switch makes it easier), it is unquestionably more convenient to have a proper, dedicated enlarger timer that turns the enlarger on and off. With the exception of mechanical timers at settings of less than 5 seconds, most enlarger timers are reasonably good and reasonably consistent.

MECHANICAL TIMERS

Mechanical timers normally consist of a dial scaled up to 60 seconds. At very short times, setting errors can be significant, and the timer may not always engage very consistently, so times may sometimes be absurdly shorter than set (0.5 seconds or 1 second when 5 seconds is set). At longer times, consistency is normally good, but accuracy is not always very high: timers may run 5 or 10 per cent fast or (more usually, with old timers) up to 20 per cent slow. You can of course compensate for this if this is the only timer you use. In general, though, the only reason to use any but the best mechanical timers is because you do not have anything better.

With most enlargers, times of less than 5 seconds should be avoided anyway, as a significant part of the total exposure time is occupied by the lamp warming up and cooling off. This is a disaster in colour, as it introduces a colour cast which will disappear at longer times, and it may affect contrast with VC papers, though the effect is likely to be slight.

ELECTRONIC TIMERS

With electronic timers, the choice is between digital and analogue settings. A typical analogue timer has three 'decade' settings of 0–90 seconds in 10-second rests; 0–9 seconds in 1-second rests; and 0–0.9 seconds in 0.1-second rests. It is therefore possible to set anything from 0.1 to 99.9 seconds. Digital timers normally use 'up' and 'down' keys. Digital timers should be fractionally more reliable, as there are fewer electro-mechanical interfaces (which is where things go wrong, normally) but there is not much in it. All are likely to be both very accurate, and very consistent: errors are going to be negligible.

ADDITIONAL FEATURES

Both digital and analogue timers may offer an 'auto-off' for safelights, so that when the enlarger is on, the safelight is off. This is particularly handy if you use any kind of enlarger exposure meter or

analyser, which can give false readings if the safelight is on.

'F/stop' timing, where the exposure increments can be set in fractions of a stop instead of seconds, is something which some find invaluable and others find incomprehensible. Those who find it invaluable will point out that you normally look at a test strip and say, 'Hmm, needs ⅓ stop more' (or whatever) while those who find them incomprehensible are those who set 10 seconds, knock off ⅓ stop, and are then confronted with what looks like a random (and impossible to remember) number. Frances is in the former camp, Roger in the latter. We both agree that f/stop timing is by no means essential.

Another refinement in timers, usually found in conjunction with f/stop timing, is a dry-down timer. This makes automatic allowance for dry-down, the inevitable loss of contrast and (more importantly) increase in density which you get when a monochrome print dries. We have to admit to having no experience of these; but we cannot help feeling that once you are experienced enough to allow for dry-down, you are experienced enough to make the necessary adjustments to exposure and contrast without help. In any case, dry-down varies dramatically from paper to paper, so this feature is only of any use if you stick to a single paper.

ENLARGING EXPOSURE METERS

Enlarging exposure meters are best treated as an adjunct to experience, rather than a replacement for it. As with camera exposure meters, you often need to interpret the readings, and until you have the necessary experience to do so, a meter reading can mislead you as often as it helps you.

Also, in order to calibrate any enlarging exposure meter (or analyser), you need a 'perfect' print, that is, one which is correctly exposed and has a full tonal range. The meter manufacturer's instructions will tell you how to work backwards from this – but unless you can make a perfect print to begin with, the meter may not do you much good. At best, they can transform a lucky fluke into a set of guidelines; at worst, they can leave you flailing around without any very convincing direction.

The simplest enlarging exposure meters take either integrated readings (via a diffuser in front of the lens) or spot readings. Integrated readings suffer from the same problem as broad-area reflected light readings for negative exposures: they assume an 'average' subject and can only give a broad idea of the exposure.

Spot readings can be more use if they are used to take a reading from a particular, 'typical' tone. In portraiture, a good example would be a skin highlight, on the cheek or the forehead; in landscapes, grass or similar foliage might be a good starting point.

For really informative spot readings in monochrome, you can read the thinnest area of the negative in which you want tone to appear in the print, and the densest. The required exposure can be determined from the reading for the densest area, using the manufacturers' instructions, and you can also choose a grade of paper which will correspond to the difference between this and the thinnest area where you want to hold texture. If the meter gives a read-out in densities, you can choose the paper grade directly, as described below in 'Monochrome Analysers'. Otherwise, you can work on the following rough guide:

1½ stops difference	grade 5
2 stops difference	grade 4
3 stops difference	grade 3
3½ stops difference	grade 2
4½ stops difference	grade 1

Any meter should be used with the safelight off, as safelighting can give misleading exposure readings, and also (still more) misleading contrast readings, though some meters are affected more than others.

MONOCHROME ANALYSERS

A monochrome analyser basically mechanizes the process described above. You take one reading in the densest area where you want texture (the highlights in the final print); press a button; take a second reading in the lightest area where you want texture (the shadows in the final print); press another button; and you are rewarded with a recommended exposure and contrast grade.

The analyser works on the known exposure range of the paper, the ISO(R) range. This is the log exposure range required to give the appropriate density range on the paper, rounded

to two significant figures, with the decimal point knocked out. They are not fully standardized, but good working ranges are:

	
Grade 5	40
Grade 4	60
Grade 3	90
Grade 2	110
Grade 1	130
Grade 0	150

The best mono analysers will greatly increase your chances of getting a good exposure and approximately the right paper grade, straight off, thereby saving a few test strips, but they still require some experience before you can interpret their recommendations. They are by no means essential: it is much more important to know what a good print looks like, as described on page 11.

FRANCES AND YETTI
When Frances tried to print this picture, in England, she was convinced that her analyser (a Colorstar) was giving her the wrong answers, because Yetti kept turning out slightly pink. The next time we saw Yetti in the United States, we realized why: she was slightly pink! The reference point for the analyser was a forehead highlight.
PENTAX 928 COMPACT CAMERA, AGFA ISO 400 PRINT FILM. (RWH)

COLOUR ANALYSERS

A colour analyser does more or less the same as a mono analyser, with recommendations for colour filtration instead of contrast grade. The process of setting up an analyser can be somewhat tedious, but the best of them, such as the Lici Colorstar, tell you how to make a neutral grey test-strip of the right density as a precursor to setting up other channels for specific applications such as portraits or landscapes. Once again, they are far from essential in your search for quality, but they are arguably the most useful of all meters and analysers as many of them can be used both for mono and for colour; once you have even a modicum of experience, they should greatly increase your working speed.

The traditional view of colour analysers is that before you can use one, you should already know how to make a good colour print without one. This is simply not true. Frances taught herself colour printing, from square one, using one of the best colour analysers on the market (the ColorStar). You must, however, do two things if you want to take this path. One is to follow the instructions implicitly: getting a good neutral grey is an essential precursor to making a good print. The other is to apply a certain amount of intellectual effort, especially with colour negative printing. Thinking 'backwards' in colour is quite demanding, as in adding yellow to get rid of a yellow cast, or subtracting cyan in order to get rid of a red cast. Our experience is that a good colour analyser can greatly speed the making of the first good work print, after which it is a matter of artistic interpretation to make the final print that you want.

The biggest single drawback to most colour analysers is that the instructions are at best lengthy, and at worst opaque: an analyser without an instruction book is not worth having, and even an analyser with its instruction book may be of limited use until you have managed to get at least a few good prints by trial and error.

PRINTING EASELS

At first sight, a printing easel is a fairly 'low tech' item which does not deserve much discussion; but we have several, each with its own particular advantages.

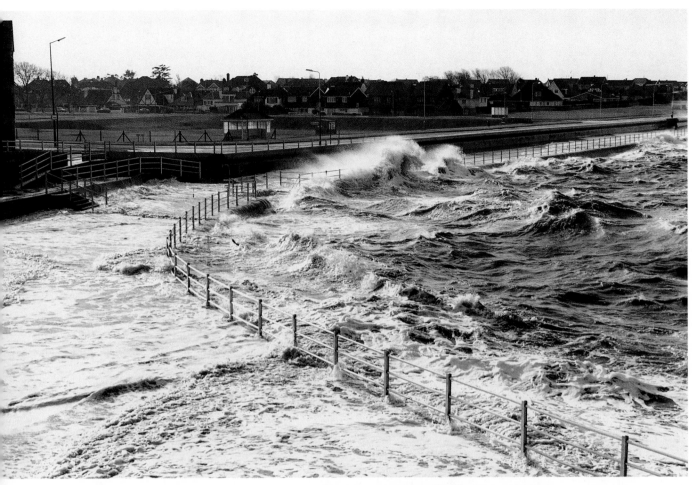

For maximum speed, we use Saunders fixed-size easels: one for 8x10in with a ³⁄₁₆in (5mm) border, and one for full-frame 35mm (or 6x9cm or 44x66mm) on 8x10in. These are ideal for straight-forward pictures for publication, or for making numbers of identical prints, as the paper is inserted and removed very quickly and located very positively. The disadvantages are that there is no way to crop the picture, or to vary the image size.

For maximum versatility, we use a 16x20in (40x50cm) four-blade Beard easel, which allows borders of any width, symmetrical or asymmetrical, on any size of paper, and makes it (relatively) easy to print pin-lines around the edge of the paper. The disadvantages are comparatively the long set-up times when you change paper sizes or crops.

For quick and easy pin-lines, albeit at a limited number of fixed sizes, we use a Quadro, and for a general compromise on speed of operation plus versatility we still keep an old Kayfro 12x16in (30x40cm) easel.

▲ ROUGH SEA
◀ HOLLY
These two pictures, of very different subjects, reveal how much difference a pin-line around a print can make. The picture of Holly Lewis would 'fall apart' without the pin-line, and the picture of the rough seas at Minnis Bay, near our house, would be greatly improved if one were added.
HOLLY: 1960S SV PENTAX, 85/1.8 SUPER-TAKUMAR. (RWH)
THE SEA: 1990S Z-1 PENTAX, 28-80/3.5 ZOOM. (RWH)

CHAPTER TWELVE

SILVER GELATINE PRINTING

Myth, prejudice and incomplete understanding are as common in discussions of printing materials and techniques as anywhere else in photography. Misconceptions are more common in monochrome, for the simple reason that with colour, you either follow the instructions or you get undeniably bad prints, while with monochrome, it is harder to make a complete mess of the picture as a result of following some guru's bad advice.

For this reason, it is easiest to begin with colour, and the first and simplest piece of advice is to use fresh paper and chemistry. Outdated materials may, depending on how the materials were stored, give anything from first-class results to a total disaster, with poor saturation, funny colours and crossed curves.

'Crossed curves' mean that you cannot correct a colour cast in both the highlights and the shadows. If you have neutral dark tones, and a magenta cast in the light tones, the price of getting rid of the magenta cast in the light tones is a green cast in the shadows. If both your film and your paper are suspect, you may be unable to distinguish which is causing the problem. If you cannot get a good print on fresh paper, it is the film; if you can get a good print on other paper, but not on the paper you are using, then it is clearly the paper.

COLOUR REVERSAL PRINTING

Printing from slides has several advantages, not least that you have the original slide as a reference. It also gives you the option of using Ilfochrome, still commonly known by its old name of Cibachrome, with its stunning quality and excellent archival keeping. Alternatively, you can use a conventional reversal paper, most commonly known as R-types. The status of the third reversal printing process, dye transfer, was unclear at the time of writing: it had been discontinued by Kodak, but there was some prospect of its being reintroduced by another manufacturer. If it comes back, it is arguably the most beautiful and permanent of all reversal processes, but it is time-consuming and expensive.

PRAGUE
This is a reversal print, without any unsharp masking. The original print is pretty good, but the whole idea of photo-mechanical reproduction from a reversal print is rather dubious: you are now looking at a third generation (slide–print–book) instead of merely second generation (slide–book), so it is questionable whether you can ever learn very much from such an illustration. Once again, looking at original prints is essential.
LEICA M, 90/2 SUMMICRON, FILM STOCK FORGOTTEN. (RWH)

Most colour materials are coated on a similar sort of RC base to monochrome papers, though a few are coated on a very glossy, very dimensionally stable, and very expensive polyester base. There are no mass-market fibre-base papers in colour.

Because you are dealing with a reversal process, colour adjustment is pretty much intuitive. If you have a blue cast, you dial in some yellow in order to get rid of it; if you have a magenta cast, you take out some magenta. For a lighter picture, you give more light, and for a darker picture, less. The only problem comes when you are already used to neg/pos printing, and start trying to make corrections 'backwards'.

Colour reversal printing is almost certainly the best option for the photographer who wants to farm out the actual printing, because there is not much scope for dispute on colour balance: either it matches the slide, or it doesn't.

Today, it is possible to buy two or even three versions of some reversal printing materials, in 'high contrast,' 'normal contrast' and 'low contrast'. For many purposes, these suffice, and indeed, 'normal contrast' is easily the best seller; but for the ultimate in contrast control (and, therefore, for the ultimate in quality) you need to try unsharp masking.

UNSHARP MASKING

An unsharp mask is made by placing the transparency on one side of a sheet of glass; the masking film on the other; and making a thin, weak, slightly out-of-focus negative. This is then placed in the negative carrier in register with the transparency, and the sandwich is printed. The highlights of the negative (the darker areas) are in register with the highlights of the transparency (the lighter areas), while the shadows of the negative are in register with the shadows of the transparency. The contrast range is thereby magically compressed.

The whole process is less difficult than it sounds, but this is not the same as saying that it is easy. The biggest single problem is dust, and meticulous cleaning with anti-static brushes is essential. A less immediately obvious problem is image colour in the unsharp mask. Normally, a thin, weak negative will be brownish in tone, and the colour may also vary from the highlights to

CHOERTEN
Until 1999, it was difficult (though not impossible) to vary the contrast of colour materials in development. But then Paterson devised a split-developer system which allowed substantially independent control of density and contrast, by varying the times in the two baths. Some of the control available to Zone System users was suddenly available to colour print workers.
HAND-HELD ALPA 12 SWA, 35/4.5 APO GRANDAGON, 6X9CM, KODAK PORTRA 400VC. (FES)

MELON AND CAPE GOOSEBERRIES
Almost all our 'fine' monochrome pictures are toned. This is lightly bleached, then toned in a 5 per cent sodium sulphide bath, out of doors: a stink, but a beautiful tone on Ilford Multigrade IV.
LINHOF TECHNIKARDAN, 210/5.6 APO-SIRONAR-N, ILFORD FP4 PLUS. (RWH)

the shadows. You therefore need an appropriate developer to give a neutral image tone.

Fairly obviously, you need a panchromatic film: anything else would lead to differential masking of the various colours. To be honest, this is not an area which we have explored, and it is also an area where devoted – one might almost say, obsessive – technicians are constantly making small but worthwhile improvements both to technique and to convenience. If you want to go down this path, we would recommend Ctein's book, *Post Exposure* (Focal Press, 1998). There is also considerable scope for correspondence with other practitioners and for on-line investigation of their work.

ILFOCHROME

Ilfochrome actually uses a different colour process from most colour materials, namely, dye-destruction. In other words, instead of using dye precursors which are converted into dyes, the dyes are already present and are destroyed in proportion to the silver image. This is how it can be so permanent – and it is also why it cannot be processed in normal reversal-process chemistry. Despite the superlative quality of Ilfochrome, there are three factors which militate against it.

One is the cost: it is considerably more expensive than conventional materials, partly because of the polyester base (though a cheaper version is available on RC paper) and partly because of the unique and inherently expensive nature of the process. Being made in Switzerland doesn't help, either.

The second is the speed: it is a lot slower than conventional materials, so you need long exposure times, even with powerful light sources.

The third is that the beautiful shiny surface is easily marred, though this is pretty much a case of exercising reasonable care in processing.

If you can afford it; if you can already turn out excellent transparencies; if you are willing to try unsharp masking; and if you do not mind the long exposure times (which are rather less of a problem with larger formats, where you can pour more light through the transparency): if you can meet all these conditions, then Ilfochrome probably offers one of the quickest and best off-the-shelf solutions to the search for quality that there is.

OTHER CONVENTIONAL REVERSAL MATERIALS

Much the same observations apply to other reversal materials as to Ilfochrome. On the plus side, they cost less and are faster; but on the minus side, they are less permanent and (for the most part) less attractive. Our own view is that if you want high-quality reversal prints for exhibition, it probably makes the most sense to use Ilfochrome, with unsharp masking.

DYE TRANSFER

Dye transfers begin with a set of three separation negatives, made from the original transparency. Each of these is then contact printed or enlarged on to special matrix film which is developed in a tanning developer (see page 119). The untanned emulsion is next washed away with hot water, leaving an image in which the thickness of the gelatine is in direct proportion to the intensity of the image.

The three matrices are then 'dyed up' in cyan, magenta and yellow dyes respectively, and rinsed in acetic acid to remove the surplus dye. At this stage, contrast in the middle and shadow tones can be adjusted by treating the matrices with sodium acetate; highlights can be brightened with Calgon; and overall contrast can be controlled by varying the strength of the acid rinse.

The matrices are brought in turn (and in register) into contact with the sheet of dye transfer paper, which absorbs the dye out of the matrices. As may be guessed, the process offers as much scope for error as it does for control, which is one reason it was never widely popular. The densities of the separation negs must be precisely matched; the matrices likewise; the matrices must be washed at the same temperature, or they will expand differentially and there will be colour fringing; the dyes must be checked, and their intensities adjusted (if necessary) by adding acetic acid; the matrix controls must be in step; and the images must be transferred in register.

On the other hand, both colour and contrast can be controlled within very wide limits, and the matrices may be used to produce multiple copies – perhaps as many as 150 – and both permanence and quality can be superb. If you have the patience and the time, and if the materials are available, this is a superb process – but it is also one which lends itself to a preoccupation with the process rather than with the results, if the photographer is that way inclined.

COLOUR NEGATIVE PRINTING

Surprisingly little needs to be said here. The materials are getting better all the time, and all are good. Contrast can be controlled in a number of ways. Some control is possible at the negative developing stage (more development means more contrast, though you will have to do your own C-41 as few commercial labs will do 'push' and 'pull'); some print materials are available in different contrast grades; and the Paterson three-bath chemistry, described in the caption on page 155, allows still further contrast control.

To a very large extent, colour negative printing is a question of following the manufacturers' instructions, and taking considerable pains at each stage.

BOATS, MARSAXLOKK, MALTA
To many people, infra-red means the soft, grainy look of Kodak materials, usually printed on FB paper. Frances chose glossy RC (MG IV) to give a 'hard edge' look for this picture shot in Marsaxlokk on Ilford SFX with an IR (T$_{50}$ = 715nm) filter. There is a colour picture of her taking the shot on page 55.
CONTAX RX ON TRIPOD, 35/2.8 PC-DISTAGON.

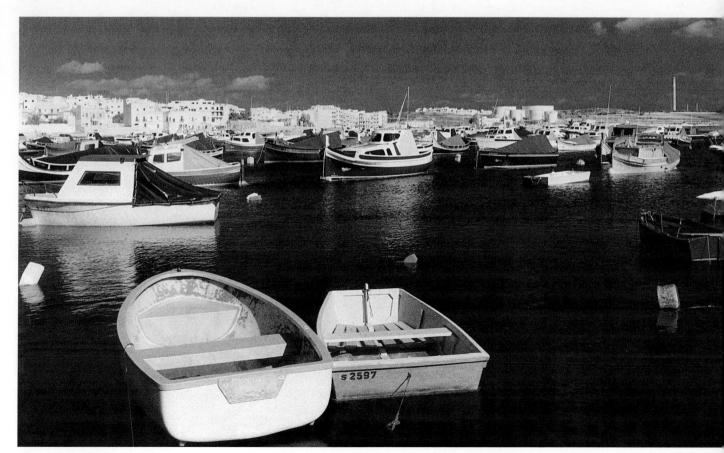

NOWROJEE'S (ESTD 1860)
Nowrojee's in Dharamsala is the longest-established shop on the northern sub-continent: a wonderful combination of museum and working shop. The advantage of shooting on colour negative – this is Kodak Portra 400 VC – is that filtration for colour balance can be done in the darkroom, rather than having to be done at the time as it would with slide film: here, there is daylight, tungsten and fluorescent, hopelessly mixed.
ALPA 12 SWA TRIPOD-MOUNTED, 35/4.5 APO GRANDAGON ON 6X9CM BACK. (FES)

MONOCHROME PAPERS

There is absolutely no doubt that some monochrome papers are better than others, with a higher maximum density and a more pleasing texture. There is equally little doubt that even where it is impossible to describe one paper as 'better' than another, there are very significant differences. For example, we find that Ilford Multigrade IV Warmtone differentiates dark mid-tones better than Ilford Multigrade IV – but Multigrade IV may be a better choice in some pictures where highlight detail is important. Nor can one deny that choice of developer can make an immense difference to image tone and even to the tonal range. The most surprising (but equally incontestable) truth is that none of this seems to matter very much: a paper which one photographer finds completely unusable may well, in the hands of another, produce indisputably superb prints.

This leaves all photographers on the horns of an uncomfortable dilemma. It is flatly impossible to try every combination of paper and developer on the market – but hitting upon the perfect combination is very much a matter of luck. All one can do is to make it one's business to learn as much as possible, in order to be able to evaluate what people say and write, and in order to understand what is happening.

THE 'SILVER RICH' MYTH

An enduring myth among camera-club 'experts' is that the best papers are 'silver rich', that is, they have more silver halide per square centimetre, also known as a higher coating weight. This is completely and utterly untrue. A great deal more depends on how the emulsion is designed and used, than on the amount of silver halide in the emulsion.

There is of course a minimum amount of silver which is required to give a good maximum black, but once you have that minimum, you will not see any benefit from more. The important thing is covering power, which depends principally on crystal size but is also influenced by the binder/halide ratio. Put crudely, smaller crystals pack closer together and give a higher covering power, and the less binder you use, the closer the crystals can pack. Most modern papers use a combination of gelatine and synthetic latexes as a binder, though a few still use only gelatine.

Actual coating weights vary from around 0.5g per square metre (gsm) to over 2.0gsm; at the time of writing, most variable-contrast papers from major manufacturers were coated at about 1.6gsm, with graded papers in the 1.0 to 1.4 range. Maximum densities of untoned prints typically ran at around 2.15 to 2.30, with no particular correlation between density and coating weight; choosing an example from some years ago, a contact paper with a coating weight of 0.5gsm gave a maximum density about ½ stop (D=0.15) greater than a bromide paper with a coating weight of over 2.0gsm.

Although it is obviously in the interest of paper manufacturers to reduce silver content in order to save money, the cost of silver is a very minor part of the cost of the whole manufacturing process, and at least one manufacturer cheerfully admits to using more silver than is actually needed, purely as a marketing tool: if people want to believe that 'silver rich' papers are essential, it does not cost a fortune to pander to them – especially if you can charge a premium for doing so.

It is also worth making the point that while the eye can spot tiny variations in density in the highlights, as little as D=0.005 (which is better than most densitometers can measure), it is much less sensitive to any variations in shadow density. Even under glaring light, variations of 0.10 are the least that are detectable, and in normal terms, 0.15 (½ stop) is what is needed to make a significant difference. Most maximum density variations are less than this.

BROMIDE AND CHLORIDE PAPERS

As with 'silver rich' papers, there is a great deal of mythology surrounding chloride, bromide and chlorobromide papers. Today, it is possible to grow chloride, bromide and chlorobromide crystals to much the same size, and as it is crystal size (and hence silver grain size) which principally influences image tone, it is possible to make warm-tone bromide papers and cool-tone chlorobromides. In practice, a number of other factors influence the choice to use the different halides. Sensitivity is an obvious one, but as chlorobromides can be dye-sensitized to more than adequate speeds, it is not really all that important. Another factor is the interaction of the halide crystals with other chemicals in the emulsion; for example, with the rhodium salts which are used to govern paper grade in graded paper (more rhodium means more contrast).

TONING

Toning is widely used to improve maximum density, and it is quite possible with a little gold or selenium toning to get another ½ stop or more of maximum density, lifting the D_{max} of a paper in the 2.15 to 2.20 range to 2.30 or better. As usual, there is a law of diminishing returns: if the D_{max} is 2.30 to begin with, you will be lucky to see 2.40 after toning.

DEVELOPERS AND IMAGE TONE

Development has a great influence on image tone, and the interaction of a given emulsion with a given developer is by no means predictable. We use quite a lot of Ilford Multigrade Warmtone, developed in Agfa Neutol WA to get a really warm image; in some other developers, the difference between Warmtone and the (rather cheaper) plain-vanilla Multigrade is not worth worrying about, though the cream base of the Warmtone still creates a somewhat different impression. A good deal depends, too, on the light under which the print will eventually be seen: in

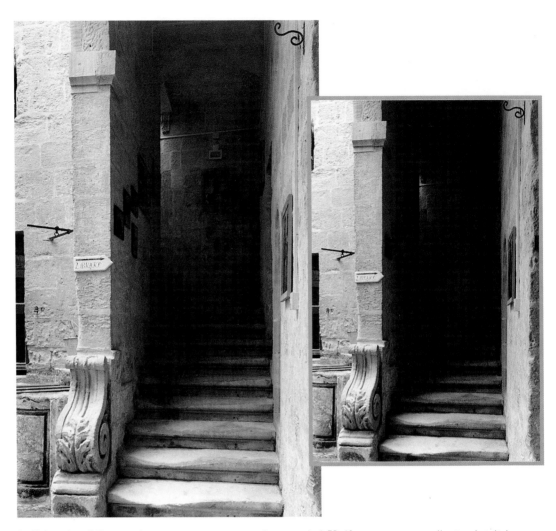

AUBERGE D'ANGLETERRE, BIRGU
Matching film to paper can make an immense difference. One of these prints is on MG IV, and the other is on MG Warmtone. Both are burned on the upper left, to hold detail in the wall, but otherwise they are 'straight': there is no dodging in the stairway. The Warmtone is actually exposed a quarter of a grade harder than the plain Multigrade, but as well as having vastly more shadow detail, it still holds a greater dynamic range, from the texture in the bottom step to the sign in the window (which probably will not show in reproduction). It might be possible to get a slightly better print on plain MG IV, by making tiny changes to exposure and contrast, but why bother, when it is so much easier to get a good print on Warmtone?
TRIPOD-MOUNTED CONTAX RX, 35/2.8 PC-DISTAGON, ILFORD XP2 SUPER. (FES)

KITCHEN, MISION LA PURISIMA, CALIFORNIA
Heavily textured papers are a matter of personal taste and of course fashion. Kentmere in the UK (sold as Luminos in the United States) offers one of the widest ranges of surface. Here, the image was bleached back to create an antique effect; the bleach-back process also makes the texture of the paper more obvious.
ALL DETAILS FORGOTTEN AND NOT VERY RELEVANT ANYWAY. (RWH)

daylight, the difference between warm-tone and cool-tone papers is generally much clearer than it is under tungsten.

It is possible to warm the tone of almost any paper by using a dilute developer and developing to less than finality, but the penalty will always be a reduced maximum density. Purpose-made warm-tone papers, on the other hand, can give warm tones with a respectable D_{max}.

GRADED/VC AND RC/FB PAPERS

Yet another myth is that variable-contrast (VC) papers cannot equal graded papers for quality. This is, at best, a matter of how you define 'quality'. There is no doubt that a fibre-base paper has a superior tactile quality to resin-coated (RC), and because fibre-base (FB) is often associated with graded papers, many people assume that graded papers are 'better' than VC. A similar argument arises because so many first-class printers, out of habit or sheer prejudice, use

graded FB: if you see an excellent print, it is more likely to be on graded FB than on VC RC, which leads people to imagine that graded papers (and indeed graded FB papers) are inherently superior to VC RC.

In logical terms, though, this is a classic omitted middle: 'Because these graded FB prints are excellent, the only excellent prints are graded FB.'

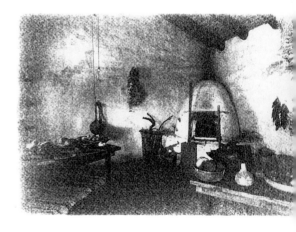

If the print is behind glass, it can be impossible to tell fibre from RC, and any manufacturer can demonstrate that their VC papers are indistinguishable in density range from graded, especially if you tone them after printing. It is also a sad truth that here, as in so many other areas of photography, people try to run before they can walk: they spend a great deal of time and money on graded FB before they can make a decent print, ever, on anything. If they started out with a faster and more forgiving medium, namely RC VC, they would learn a great deal more about printing than they ever do by flailing around (slowly) with graded FB.

This is not to say that FB – even graded FB – should not be used for fine prints. To this day, a well-processed FB print has better archival keeping qualities than RC, at least on display (in dark storage, there seems to be little to choose between them), and the tactile advantages have already been mentioned. Also, there are some particularly attractive papers that are available only in graded form, either for technical reasons (for instance, it is difficult to coat VC emulsions on heavily textured papers) or simply because that is what the market demands.

PAPER SURFACES

Paper surfaces are partly a matter of fashion; partly a matter of practicality; and partly a matter of economics. As recently as the 1970s, even the major companies offered a wild profusion of textures and colours: glossy, silk, crystal, matt, semi-matt, lustre, suede and more, in white, cream and ivory. Today, even the specialist companies offer comparatively few surfaces, normally in only one colour (white).

To the modern eye, some of these losses are no loss at all: the surfaces are downright ugly. But this is a matter of fashion, and they may yet return, if one of the ever-decreasing number of manufacturers of photographic paper base consents to make them; as we were writing this book, Glory Mill, the only British-based manufacturer, was closed down after having been acquired by Felix Schoeller.

Purely practically, glossy papers are best for reproduction, and they are also suitable for small exhibition prints. 'Glossy unglazed' (available only with FB, because glossy RC prints are always

MOSS AND STREAM
Pictures of plants often look more convincing on warm-tone paper; cold-tone is too clinical and distancing. At least, that is how we feel today; but there is no doubt that fashion plays a part in paper selection.
HAND-HELD CONTAX RX, 100/2.8 MAKRO-PLANAR, ILFORD XP2 SUPER. (RWH)

glossier than an air-dried FB print) is arguably more useful for most exhibition prints because it does not reflect lights as boldly as either a glazed glossy FB print or an RC glossy, while big exhibition prints often look best on some form of semi-matt or 'pearl' surface, simply because exhibition lighting can glare back off anything else, creating hot-spots.

Our own general feeling is that it is possible to become overly excited about paper surfaces, and that as soon as the medium (the paper) becomes more important than the message (the image), the photographer has begun to lose his or her way. Once again, this is not to deny the excellence of some surfaces and colours, or their appropriateness to some photographers' vision; but we firmly believe that before you start to experiment with exotic surfaces and colours, you need to master conventional printing. All too many people do not.

LITH PAPERS AND PROCESSING

Lith papers deliver very high contrast and were originally designed for graphic arts use, where the intention was to create a pure black against a pure white, with no half-tones. Lith developers use 'infectious development', where density builds

RED SQUARE
As a straight bromide, this is reasonably successful, but switching to lith processing allows a much clearer differentiation between the figures in the foreground and the misty shape of Sankt Basilius in the background.
HAND-HELD NIKKORMAT FTN, 90/2.5 VIVITAR SERIES 1, ILFORD XP2. (FES)

exponentially. In other words, the darker an area is, the faster it develops, and the darker it gets, so the faster it develops...

It is possible to use lith papers in lith developer; or lith papers in normal developer; or (some) normal papers in lith developers. In all

BROKEN TREASURES
Frances roughly coated a sheet of heavy water-colour paper with Maco liquid emulsion, so that the texture of the coating would blend into the dark area of the photograph. There is always an element of chance in this sort of picture: you may have to coat (and expose) half a dozen sheets in order to get the effect you want.
GANDOLFI VARIANT 5X4IN ON TRIPOD, 210/5.6 SYMMAR, ILFORD FP4 PLUS. (RWH)

cases, the key is incomplete development: the effects are similar, but not identical.

The basic technique is gross over-exposure, followed by development in dilute developer (to slow development), and 'snatching' the print as soon as the important blacks are at the desired degree of intensity. The dark areas are then very black and contrasty, while the light areas are only partially developed. Because they are only partially developed, there is excellent highlight differentiation (remember, the highlights are heavily over-exposed) and there is also a considerable degree of colour in the light tones: the partially developed crystals have created very small silver grains, which give the colour effects.

The undisputed expert on the process is Dr Tim Rudman, whose compendiously named *The Master Photographer's Lith Printing Course* (Argentum, 1998) is the definitive work on the subject. He makes the point, which is fairly obvious once you have heard it, that exposure controls highlight density, while development controls shadow density. In other words, if the highlights are too thin when the blacks achieve the required density, then over-expose some more (anything up to 3 stops more than you would give a normal print). If the highlights are too dense, cut the exposure.

The lith process is without question capable of giving wonderful effects, but it has two major

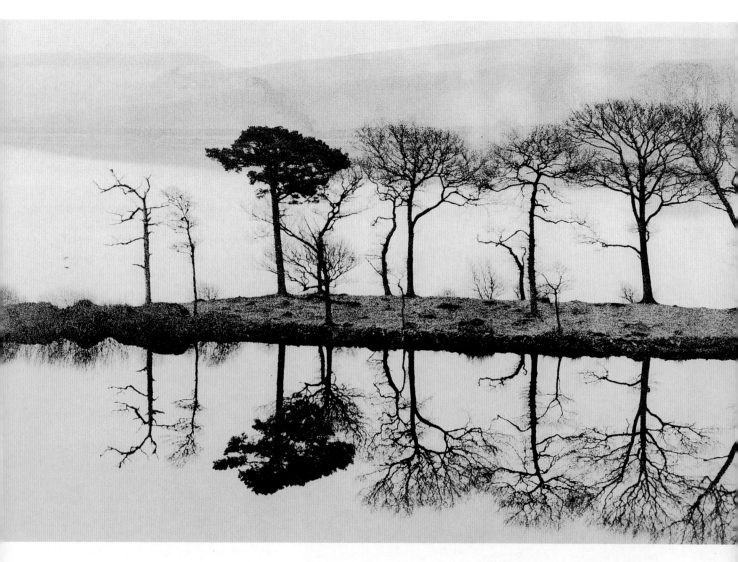

disadvantages. One is that development times are very long, typically 15 to 20 minutes, so this is not a process for the easily bored. The other is that the effects themselves depend, essentially, on partially exhausted developer which is loaded with development by-products: the best prints are therefore made in the 'window' between fresh developer (which does not give the best effects) and exhausted developer (which doesn't work either). Using very large quantities of developer – typically four litres, in a huge tray – and priming new developer with used (saved from a previous session) will extend the window of opportunity, but there is always the risk that the developer will suddenly die in the middle of making a print.

LIQUID EMULSIONS

Liquid emulsions are exactly what their name suggests: similar emulsions to those which are coated on normal photographic paper, for coating on to whatever you wish: not just papers, but stone, ceramics and metals.

Getting the coating even can be a problem (though of course you can always make a feature of unevenness) and variations in coating thickness from one sheet to the next will mean that density and apparent contrast can vary quite widely: this is why there is no real point in VC liquid emulsions, quite apart from the likelihood of dye migrations which will reduce the whole pot to a single contrast grade anyway.

Despite these theoretical objections, we have enjoyed some success with liquid emulsions, especially with Maco which is part of a complete system with a gelatine subbing solution and hardener. This makes it much easier to get the gelatine to stick to all supports, but especially non-porous ones: during washing, otherwise, the emulsion has a distressing tendency to float off its

TREES AND LAKE
We were at a talk given by Dr Tim Rudman, whose lith prints are quite miraculous. As he described his techniques, and showed examples of his pictures, Frances realized that this picture (which she also likes very much in 'straight' form) would work very well in lith; and so it did.
HAND-HELD NIKKORMAT FTN, 90/2.5 VIVITAR SERIES 1, ILFORD XP2 SUPER.

support. Keep the emulsion in the refrigerator when you are not using it; warm it well (and pre-warm the paper or other substrate) to avoid lumpiness in coating; and dry carefully, or you may get marks from the drying rack.

Of course, if you only want to coat high-quality watercolour paper, it is easier (though alarmingly expensive) to buy ready-coated Bergger papers, which are machine-coated on to a special Arches paper and give wonderful effects.

PRINTING-OUT PAPERS

Printing-out paper (POP) is not developed: it is sandwiched in contact with the negative (preferably with a very thin sheet of Mylar or similar film between, to remove the risk of excess silver in the paper contaminating the film) and 'printed out' under a strong light source until the image is rather darker than is desired in the final print. The paper is then washed, toned, fixed, and washed again.

Like any contact print, POP retains the maximum possible detail from the negative, but it also has the advantage that it is self-masking. As shadow density builds up, the image itself forms a

PRINTING-OUT EQUIPMENT
As well as large printing-out frames for 5x7in, 8x10in and even 11x14in paper, we also have quite a collection of smaller ones, from quarter plate (3¼ x 4¼in/83x108mm) to 6x4.5cm. The way in which split-back frames work should be clear from this picture. (FES)

barrier to further and deeper darkening. The contrast range of the negative is thereby magically compressed on to the paper, which itself has a long inherent tonal range: a density range of 2.40 (250:1), with excellent tonal differentiation, is entirely feasible in the toned print.

The main things you need for POP are the paper itself (manufactured by Kentmere for the splendidly named Chicago Albumen Company of Housatonic, Massachusetts); a split-back printing-out frame (so you can inspect the progress of the printing out); a negative of unusually high contrast with a long tonal range (a gamma of 1.0 and a density range of 2.0 and greater are desirable – see page 25); either gold or – in our view, better still – platinum toner; and also plain hypo, for fixing. You can use sunlight for printing out, but we use a Philips UV tanning lamp because it is more predictable and because we can simply set the timer and forget it.

Processing begins with a wash or sequence of washes, until the milkiness caused by the excess silver nitrate washing out of the emulsion disappears; then toning, until the desired image

colour is reached, which is a matter of experience because the tone will change in fixing; fixing, in two baths of 10 per cent plain hypo (anything more aggressive will bleach the highlights); and then washing, as for any other fibre-base paper.

ARCHIVAL PRINT PROCESSING

Archival print processing is, like a number of other topics covered in this chapter, something which over-excites some people. The first question to ask yourself is why photographers in general want their work to last forever. In some media, such as stone sculpture, the process is inherently durable. In others, artists just refuse to worry about it: the fact that some of Jackson Pollock's more impressive paintings are actually falling apart because of the sheer thickness of paint, is not regarded with much alarm by anyone except museum conservators.

The second question is why you personally want your prints to last forever. Put harshly, when most photographers die, their pictures are thrown away. It was ever thus. There may be little point in making pictures that will last longer than you will.

The answers to both questions are, however, the same: photographers want their pictures to last, because they can be made to last.

This gives rise to the third question, which is how difficult it is to make an archival print. The answer is that it is not very difficult at all: it just takes a bit longer than making one that is non-archival.

For a start, you should use FB paper, at least if you plan to display the print. No one is entirely sure why FB prints last longer than RC, but the favourite view is that the fibre absorbs atmospheric pollutants which cannot sink into the RC base. Develop as you wish, and fix adequately, using any reasonably fresh *non-hardening* fixer (hardening fixers greatly extend wash times). Follow the manufacturers' instructions: there is no need to fix for longer, or to change fixer more often.

Finally, you should wash fully, using a wash aid. Once again, you will get fully archival prints if you follow the manufacturer's instructions, using any good washer (we use Nova and Paterson). Excess washing is unlikely to do any harm, at least until the emulsion dissolves off the paper (which can take days), but it will not do any good either.

Typically, a five-minute wash in running water, followed by five minutes in wash aid, followed by fifteen to thirty minutes in running water (the longer time for double weight, the shorter for single weight), will give you archival permanence.

There is absolutely no point in using wash aid with RC prints, which wash in a few minutes anyway (typically well under five minutes in running water), and for dark storage, an RC print can be archivally processed very quickly. Indeed, over-fixing and over-washing may well reduce the life of RC prints: Ilford recommend that total wet time should not exceed ten minutes, from going into the developer to coming out of the washer.

TERMITE-EATEN WOOD
'Gaslight' paper is one of the less likely survivals from the past. It can safely be handled by tungsten light (or of course gaslight) and is designed to be exposed by daylight or (more usually) with a UV light box. The blue tone is inherent, and is delivered by any normal developer. The material (Roomlight Contact Paper from Kentmere) is very slow and is suitable only for contact printing.
CAMBO CADET 5X4IN ON TRIPOD, 203/7.7 KODAK EKTAR, POLAROID TYPE 55 P/N. (RWH)

CHAPTER THIRTEEN

ADVANCED PRINTING – AND BEYOND

GUEST HOUSE, NORBULINGKA
All printing is a matter of interpretation – and sometimes, you have to try different interpretations, to see which one works best. Which of these two (fairly subtly) different interpretations do you prefer: the one with the extra detail in the skylights, or the 'straight' print?
ALPA 12 SWA ON TRIPOD, 35/4.5 APO-GRANDAGON ON 6X9CM KODAK PORTRA 400VC. (FES)

With conventional silver halide printing, there are relatively few hints and tips which matter much. Some are almost painfully obvious: others are less so. Perhaps the most important is print size.

As already mentioned in Chapter 2, we increasingly believe that the key to making really good black and white enlargements is to choose your enlargement ratios carefully. They must either be small enough that there is no evidence of the half-tone effect, or large enough that the grain is a clear part of the image. In between, there is an unhappy no-man's-land where sharpness may be entirely adequate, but tonality suffers.

In practice, this means that we will normally print at 5x or below, or 10x or above. These are by no means absolutes, and they vary from film to film, but as a general rule, we find that we get the best pictures this way. With 35mm, in particular, we find that we can achieve a result which is reminiscent of a contact print from 5x7in (13x18cm) by using Ilford Delta 100 or XP2 Super, and enlarging just 5x (cropping the long dimension slightly, of course). We also find that making a deliberately small print has more visual impact than making an all-too-familiar 8x10in.

With 44x66mm negatives from Roger's preferred Alpa configuration, the same enlargement ratio corresponds to about 8x12in (20x30cm) (typically on 12x16in/30x40cm paper), while Frances can go to around 24x36cm (11x14in), because she favours the 6x9cm format (actually 56x84mm). With 4x5in film, a 16x20in (40x50cm) enlargement is little more than a 4x enlargement, and you can get wonderful tonality even from Ilford HP5 Plus at ISO 400.

In colour, we find the half-tone effect less obvious, and actual, perceptible grain is what really matters; but once grain arrives, we find it significantly less palatable than we do with 35mm. This means that enlargements as big as 10x are entirely feasible from the best current colour films, typically ISO 100 or less – and at this point, image sharpness is as important a point as tonality, so only the finest lenses will do. Given that we use Leitz, Zeiss and Nikon, this is hardly a major problem, but we try to follow all our own advice as given in Chapter 4 in order to get the maximum possible sharpness.

For colour enlargements over about 10x12in (25x30cm), we prefer whenever possible to use medium format, principally on the grounds of sharpness: ISO 400 film gives perfectly adequate grain up to about 5x (12x16in/30x40cm off 6x7cm or bigger), while ISO 160 or slower is preferable for still bigger enlargements.

STREET, BIRGU, MALTA
The smaller print is the work print, on grade 2½. The upper right is burned out, and differentiation of the building on the right and the moulding over the door is much poorer than in the final print, where pre-flashing at grade 1 and local burning in the upper right have allowed better tonal differentiation at grade 2 and the retention of much more detail.
CONTAX RX ON TRIPOD, 35/2.8 PC-DISTAGON, ILFORD XP2. (FES)

WORK PRINTS

A major difference between skilled printers and beginners is that skilled printers normally begin with a 'work print', instead of trying to get a perfect picture, first time.

The vast majority of pictures are likely to need at least some burning and dodging; some may need pre-flashing; and there is always the possibility of selective bleaching afterwards. It is easiest to work out precisely what they will need if you first make a reasonably 'straight' print, let it dry, and use that as a basis for deciding on what more is needed.

BURNING, DODGING AND PRE-FLASHING

There is little point in saying much about burning and dodging, as easily the best approach is simply to illustrate the techniques with pairs of prints. Likewise, there is not very much to say about pre-flashing. The technique of pre-flashing to overcome inertia has already been discussed on page 146.

The big advantage of pre-flashing is when you want to hold highlight detail which is on the negative, but seemingly just out of reach on the print. Pre-flashing will quite magically allow you to hold that detail without dropping to a softer grade of paper and without increasing exposure,

EAGLE FOUNTAIN
The monochrome print is the original work print, all-in off a 35mm Ilford SFX negative, using a 100/2.8 Makro-Planar on a Contax Aria. The toned print is cropped; heavily burned on the upper right, to retain texture in the stone; dodged in the wings to retain detail (look at the cross on the right wing, camera left); and toned in selenium for the image colour. (FES)

YOUDON AT THE TARAGARH PALACE
There is little point in showing 'before' and 'after' pictures of this shot, because the differences would be very hard to spot in reproduction; but in the pre-flashed picture, as reproduced here, there is much more detail in the window at the top of the picture, and some texture (which is otherwise entirely lacking) in the topmost of the three lampshades.
ALPA 12 SWA ON TRIPOD, 35/4.5 APO-GRANDAGON ON 6X9CM, ILFORD HP5 PLUS. (FES)

both of which may result in a 'muddy' print and the latter of which will also block up shadow detail. The softer the initial grade, the more successful pre-flashing is; with 00, 0 and 1, it is

really useful, but by grade 5, the effect is unlikely even to be perceptible. It can also be used in colour, though from our experience, it is more successful in mono.

SELECTIVE BLEACHING

The name 'liquid sunshine' is sometimes given to Farmer's reducer, a mixture of potassium ferricyanide ('pot ferri') and sodium thiosulphate ('hypo'). The name comes from the magical way it can add 'sunny' highlights to monochrome prints.

It is normally made up as two stock solutions, the first consisting of 10 per cent pot ferri (50g in 500ml of water) and the second of 20 per cent hypo (200g in 1 litre of water); for use, one part of A and 5 parts of B are added to 30 or more parts of water (for example, 5ml of A, 25ml of B, and 150ml of water). The mixed reducer has a life of about a quarter of an hour, and must always be mixed fresh.

Local bleaching is normally done with a brush (which should not be used for anything else) or with a cotton swab, usually on a wet print. The action of the reducer is arrested by washing, so bleaching should always be stopped slightly before the aim-point is reached. Some papers display

excessive colour shifts when bleached locally; this can only be discovered by trial and error, preferably on an unimportant print. After local bleaching, the paper must be washed in the same way it is after fixing, or staining will result.

TONING

In the 1960s and even 1970s, it looked as if toning might die out completely. Today, depending on whom you believe, 60 per cent or more of prize-winning prints (whether commercial or salon) are toned to a greater or lesser degree.

Some are toned merely to improve the maximum density, as noted on page 159; either gold or selenium toners, following the manufacturers' instructions, are all that is needed.

Others are toned for improved archival permanence. Again, gold or selenium will do this with negligible or modest colour shifts, while sepia toning will give a much more noticeable shift. Then there is toning just for colour, with sepia or with other toners which may or may not improve the archival quality of the image; most don't.

Generally, using toners is a matter of following the manufacturer's instructions, but three points need to be made. The first is that an almost infinite variety of effects may be achieved by partial toning, or by dual-toning in first one toner, and then another. Some of these results are quite unexpected, such as the peachy-red colour which you get by gold toning after sepia. The second is that some toners are much easier to use than others. In particular, blue toners are incredibly sensitive to the slightest splash of anything alkaline, especially developer, which will remove the blue tone completely; with some waters, you may even need to add a little acetic acid to the working solution in order to get a decent blue. The third is that not all sepia toners are created equal, and that unfortunately, the attractiveness of the results seems to be in inverse proportion to the unpleasantness and inconvenience of the process.

Although we have never tried it ourselves, some of the finest sepia tones we have ever seen have come from the hot hypo-alum process, where the prints are toned for 10 or 15 minutes in a hot (50–55°C/120–130°F), stinking, poisonous solution of hypo and potassium aluminium sulphate (potash alum).

Our best sepias have been with potassium

VILLAGE ASTROLOGER, USA
This photograph shows why, for years, we did not use HP5 Plus; we had not found the right developer. Here, the tonality is gritty, 'mean streets', and this is not an effect we often want. But with Paterson FX39 or Ilford DD-X 1+9, and slightly more generous exposure (as a result of spot metering), we get a tonality which we really like. To get the right print, you have to start with the right negative.
HAND-HELD NIKKORMAT FTN, 35/2.8 PC-NIKKOR. (FES)

SELECTIVE BLEACHING
This picture also appears on page 93, in two forms – all-in and cropped – but here, Frances burned the sky very strongly (which led to rather a flat, muddy-looking shot) and then used pot ferri to brighten up the clouds. A somewhat similar effect might have been attainable with filtration, but pot ferri allowed a dramatic picture to be extracted from a fairly indifferent negative.
TECHNICAL INFORMATION ON PAGE 93. (RWH)

sulphide, again a very malodorous and poisonous solution which needs to be used in a very well-ventilated room (or preferably out of doors). The prints are first bleached in a halogenizing bleach which re-converts the image to a silver halide, then 'developed' in the toner.

Odourless thiourea (thiocarbamide) may be substituted for sulphide, but the tones are rarely as pleasing – though they can be altered by varying the alkalinity of the solution, by adding more and more sodium hydroxide.

BLEACH-BACK AND RELATED TECHNIQUES

Interesting effects can be obtained by grossly over-exposing conventional papers, then bleaching them back in a variety of solutions. There is more about this in our *Black and White Handbook* (David & Charles, 1997), but it is disputable whether this is much to do with quality in any conventional sense, the more so as blacks are often degraded to an unacceptable extent by this process.

FINISHING (SPOTTING)

Even a mediocre print is greatly improved by spotting, and even a great print can be ruined by failing to remove the dust marks which are, to some extent, all but inevitable. A few simple tools, and a couple of even simpler rules, make spotting very much easier.

The most basic tool is a fine brush, of the highest quality you can afford: an 00 or an 000 suits most people best, though there is much to be said for using a larger brush which will hold more medium and can, if it is of high enough quality, be persuaded to take as fine a point. In mono, you can use this to apply dyes (which sink into the paper invisibly, but are hard to remove) or pigments (which are easier to remove, but show up as an area of different texture on the print). In colour, dyes are more usual.

If you have to bleach out dark spots, you can use a local bleach (as described on page 168), but remember to wash the print afterwards. When it is washed and dried, you can retouch the white spot, which is much easier than painting over a dark one.

We actually use SpotPens for both colour and mono. These are pre-loaded with dyes in a slightly syrupy medium so that they do not sink in immediately and can be wiped off; if they are left, however, they sink in, just like other dyes. If you are used to conventional dyes or pigments, they can take a little time to master, but once you are used to them, there is nothing better. Their only real disadvantage is the price: they come in (quite expensive) sets of ten, in warm-tone mono, cool-tone mono, and (at the time of writing) four sets of colours. Once you have them, though, they last half-way to forever: our original set was at least five years old at the time of writing, and showed no sign of flagging. As well as the dye pens, there is a bleach pen and bleach neutralizer.

As for rules, the first rule is that it is generally much more important to match tone than to match colour. A spot of the right density will be very hard to see, even if you have used a warm-tone spotting medium on a cold-tone paper, or vice versa, and much the same is true in colour.

The second rule is that large flaws should be broken up with a sequence of small marks, breaking up the outline of the flaw (typically a hair), rather than trying to paint it out.

HAND COLOURING

Arguably, the importance of hand colouring to quality in photography is peripheral, and so we propose to treat it only in passing. The main thing

POSTES
This was done on hand-coated watercolour paper, hand coloured with Marshall's Oils. Sometimes, you plan an image like this at the taking stage. At other times, you look at a negative (or contact sheet) and say, 'This would work if I did this.'
TOHO FC45A, 120/6.8 ANGULON, POLAROID TYPE 55 P/N. (FES)

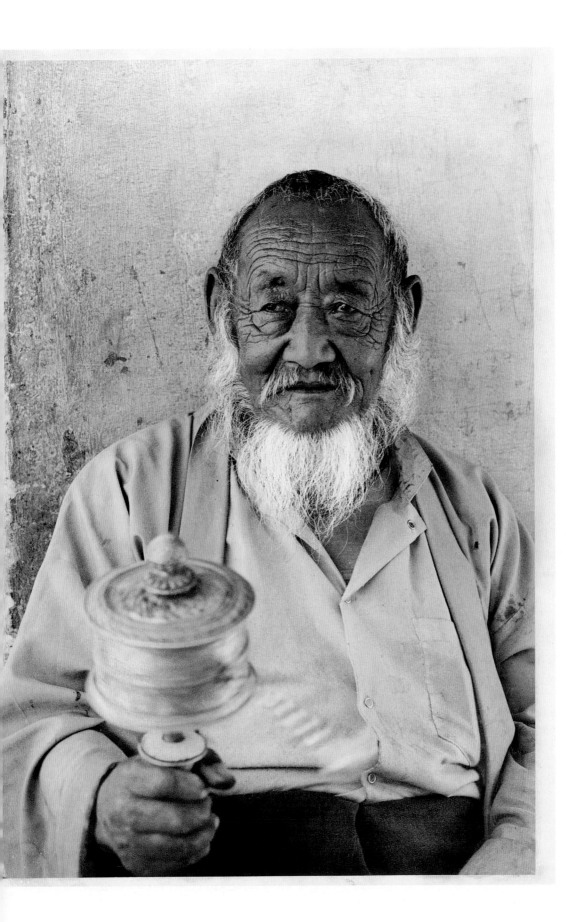

TIBETAN MONK, BIR
Another view of this reverend gentleman is on page 16, for which the technical details are identical, but here, Frances used Marshall's Oils to hand colour the image. Sepia toning of a light print not only helped to get a natural-looking skin tone; it also warmed up the rendered wall behind him, which looks rather cold and bleak otherwise. At a trade show where Frances was demonstrating Marshall's Oils, one bystander kept coming back until he plucked up the courage to ask if he could have a copy, to frame and put on his wall.

that we want to say is that it is far easier than it looks. If you have even the slightest natural talent – and you don't need to be able to draw or paint conventionally, though it may help if you can – then you can get surprisingly good results, surprisingly quickly.

Apart from this, there are a few tricks which make it easier still. First, it is generally best to have a light print, rather than a dark one, provided you do not sacrifice highlight detail: applying colour to light tones is easier than applying colour to dark tones. Extending this approach to include high key and reduced contrast can make life easier still, again provided that the image is suitable: a great deal depends on the picture, and on what you want to do with it.

Second, sepia toning often provides a happier background than do neutral blacks or even warm-tone. This is particularly true for skin tones, though it seems also to be the case for most other subjects.

Third, filtration at the taking stage can be extremely valuable. Use a red filter to lighten a red rose, or a green filter to lighten foliage; and remember the possibilities of infra-red film, which often yields images particularly suitable for hand colouring.

ALTERNATIVE PROCESSES

Many of the techniques outlined above are applicable to so-called 'alternative' processes, and it is as well to mention them briefly here. In an earlier book – *The Black and White Handbook* – we discussed these at slightly greater length, and it would not be fair to readers who already have the other book to repeat the information here, but they do need to be mentioned. This may sound like a thinly veiled invitation to buy the earlier book, but in any case, we harbour serious doubts about the place of almost all of these 'alternative' processes in a book such as this.

To begin with, many of them deliberately throw away much of what is normally regarded as photographic quality: resolution, detail, photographic tonality. This is often seen as an advantage: they are not 'mere photography' but are somehow 'more artistic' or even 'painterly'. Everyone has their own limits as to where 'straight' (or 'mere') photography ends, and 'artistic' derivatives take off. Those limits may not

even be particularly consistent: why should hand colouring be more 'photographic' than bromoil, for example? But this is a book about 'mere photography', and about how to get the best out of it; and besides, it is our book, and we are happier with hand colouring than with alternative processes.

More importantly, most of these processes are hard to master. There are whole books dedicated to individual processes, and there is simply no room here to go into them in the depth which would be needed to guarantee quality even by their own lights. Once you have mastered conventional photographic quality, you may decide to diversify into these processes, but it is an acutely personal choice, and besides, we can guarantee two things. The first is that even if you love the results, there are going to be plenty who hate them, and the second is that many alternative processes seem to breed in-fighting in the same way as the average communist party: there will be factions, and sub-factions, and vicious denunciations, and cliques and individuals who refuse to speak to one another. We know. We have been on the receiving end of it.

In any case, as noted elsewhere, prints from alternative processes rarely reproduce well: they look like inferior bromide prints. You really need to see originals to appreciate why anyone goes for these processes, which (once again) means that a brief description in a book like this is of limited value.

DIGITAL IMAGING

Something which surprises many people who have come to photography via digital imaging is how much easier conventional photography can be than digital: burning in a sky, for example, or dodging a face, or (as already mentioned) hand colouring. To be sure, there are certain things which are much easier on a computer than they are on a wet print, such as cutting out backgrounds or spotting, but the most important thing is that at the time of writing, we could not see why anyone who is interested in the maximum possible technical quality in a decent-sized print would even consider digital imaging. However, it is important to distinguish between image capture, image manipulation, and image output, and there is no denying that digital imaging has its place.

BROMOIL
To make a bromoil, you make a conventional print; bleach out the image with a tanning bleach, which hardens the gelatine in proportion to the density of the original image; then dab on a greasy ink, which adheres in proportion to the tanning. By using more or less ink, considerable control is possible. Bromoil is particularly effective for emphasizing compositional shapes and masses of tone. This same picture appears 'straight', with technical information, on page 53.
BROMOIL BY FES.

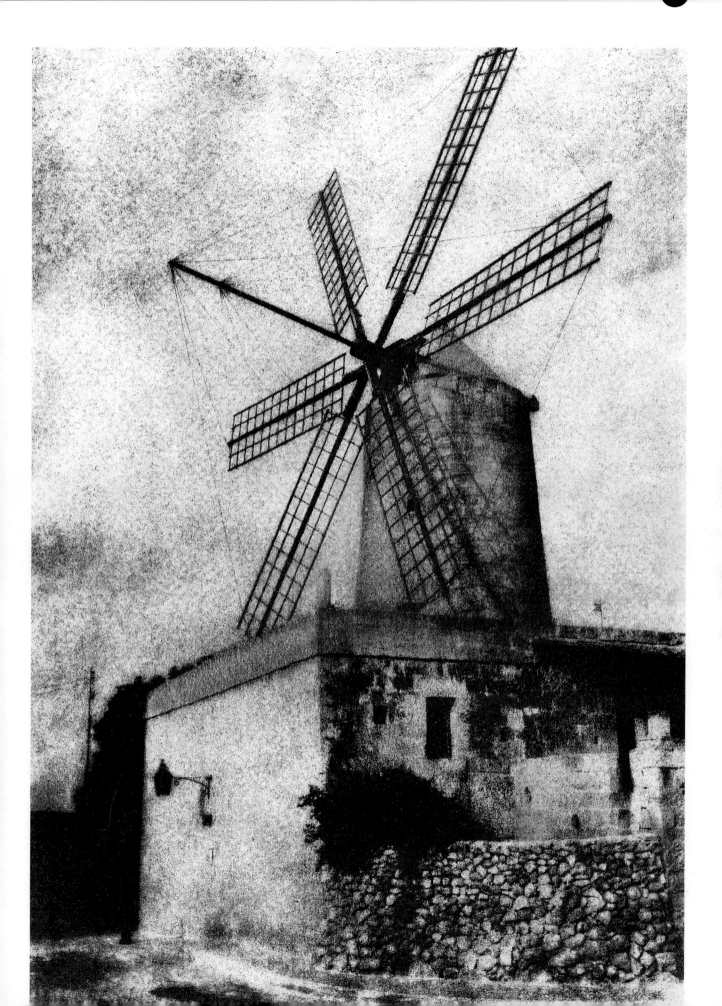

IMAGE CAPTURE

We have already touched upon digital cameras in Chapter 3, and there is little more to say here, except that an image from a 6-megapixel chip contains about one-third as much information as a 35mm Kodachrome (estimated at around 20 megapixels); a 1.3 megapixel chip therefore contains about one-fifteenth as much. It is conceivable (though by no means certain) that instant-capture digital image chips will one day equal 35mm; but given the tiny market of photographers who want quality even that good, let alone better, it seems to us profoundly unlikely that there will ever be chips which can equal the quality of even 645, let alone 6x7cm. Scanning digital backs are another matter, and already equal film quality; but they can only be used with stationary subjects.

It may be worth adding that as we were working on this book, two of the magazines for which we write issued instructions saying that they did not want any more digital image submissions, from anyone, wherever possible; the quality they were getting, after two or three years of experimenting with accepting digital submissions, was simply not adequate.

They were talking about the results from film scanners which cost at least as much as a good, mid-range SLR, hooked up to computers which cost several times as much again; and still they were not happy with the quality. They wanted to scan the images themselves, on drum scanners which cost as much as a good motor-car, and to manipulate the resulting seriously large (50 to 100 megabyte) files in their own powerful computers.

In other words, although electronic 'processing' is now the norm in publishing, the difference between professional equipment and amateur equipment is like the difference between a Formula One racing car and a family runabout – and even at that, the best photomechanical reproduction cannot match a good silver gelatine print.

FUTURE IMPROVEMENTS

We had originally intended to go into such technical matters as scan depth and scan resolution, both true (optical) and interpolated; but then we realized that from the point of view

ROGER WITH LEICA
One of the things that digital manipulation can teach you is how little information you actually need to convey a familiar image. Here, Roger's beard and Leica are clearly recognizable. This sort of understanding can also be carried over into conventional imaging.
NIKKORMAT FTN, 90/2.5 VIVITAR SERIES 1 MACRO, PATERSON ACUPAN 200; MANIPULATION IN ADOBE PHOTOSHOP WITH A PATERSON DIGITAL LAB. (FES)

GIRL AT THE TUDOR HOUSE, MARGATE
We find our computer more use for rectifying mistakes than for creating quality in the first place. This film was dried in a recently acquired second-hand drying cabinet, and was appallingly speckled with dust. It was cleaned up in Adobe Photoshop with the Clone tool. Roger lost count of the number of 'hits' after 250 or so...
LEICA M2, 35/1.7 VOIGTLANDER, KODAK E200 PUSH 1 AT EI 320.

of this book, there was absolutely no point in doing so. Yes, we have seen truly spectacular quality; but the original images were captured either with scanning-back cameras, or on silver halide which was then scanned with a high-end scanner, and the final prints were made with a 'paper writer' which prints directly on to silver halide paper, using lasers or LEDs. Either way, you are looking at the price of at least one new Rolls Royce, and possibly at the price of two.

Even if prices fall like a stone, it will still be several years before digital imaging can seriously challenge silver halide when it comes to maximum quality at a realistic price. At the time of writing, silver not only delivered better quality than digital: it delivered better quality at between one-tenth and one-hundredth of the price. And we are sure that it will be quite a while before the balance is tipped the other way.

THE USES OF ELECTRONIC IMAGING

Despite the lamentation above, we believe that digital imaging does have a place alongside conventional photography, for four reasons.

The first is that a digital camera allows cheap, easy practice in taking pictures and making work prints – and practice is the single most important factor in becoming a better photographer. The

only drawback is the risk of shooting a wonderful picture, and then being unable to make a decent print any bigger than postcard size.

The second is that there are no absolutes in photography of any kind. A sufficiently great picture – whether it be well observed, well composed, or well assembled from disparate elements in the computer – can transcend its technical imperfections, or even transmute them into desirable qualities, just as grain or high contrast or blur or any other 'fault' can be used creatively with silver halide.

The third is that there are things which can be done with a computer which simply cannot be achieved by other means, or at least, which cannot realistically be achieved by other means.

The fourth is that there are always pictures where conventional quality just does not matter: snapshots, pictures for transmission over the Internet, catalogue shots... The list goes on.

This last point is why we mention digital imaging again – and not so disparagingly – in the next chapter. We are more than happy, however, to let time be our judge on the relative advantages of silver halide and digital imaging. At the very least, we believe that there are qualities in silver halide which cannot be equalled with digital imaging, and that these advantages may well endure without limit. After all, painting was not killed off by photography, nor radio by television.

NOVA HAND LINE
This hand processing line for 4x5in film, described on page 128, was for some inscrutable reason photographed on a red grid. 'Cutting out' in Adobe Photoshop took about 20 minutes, which is much better than would have been possible using masking film and an airbrush or any other conventional approach. The product shot has since been re-taken on a more conventional background!
COURTESY NOVA.

SOPHIE MUSCAT-KING
Without the digital manipulation, this is a fairly ordinary 'dressing up' shot. To achieve a similar effect with conventional chemistry would be expensive and time-consuming. The great advantage of digital imaging is that it allows you to play around with an idea, without spending anything on materials, until you get an effect that you like – at which point you can either print it out electronically, or take the traditional silver route. HAND-HELD CONTAX G2, 90/2.8 SONNAR, PATERSON ACUPAN 200 MANIPULATED IN ADOBE PHOTOSHOP USING A PATERSON DIGITAL LAB. (RWH)

CHAPTER FOURTEEN

SELECTION AND PRESENTATION

It is always tempting, when you are asked which is your best picture, to say, 'I don't know – I haven't taken it yet.' There are also two conflicting tendencies when it comes to looking at your own recent work. One is to think it is your best ever, because the enthusiasm is still fresh in you. The other is to be convinced that you are losing your touch, because you are too close to it, and you have not yet managed to separate your feelings about the subject from your feelings about the picture, as described on page 14.

To make matters still worse, photographers are not always the best judges of their own work: more than once, we have been surprised when an editor has made a lead picture of an image which we regarded as little more than a makeweight – but which we have to admit was an excellent choice on the page.

You have to fight with all of this when it comes to showing your work. As the old saying goes, you are not judged by the pictures you take: you are judged by the pictures you show. Showing failures, and showing too many images, are the greatest errors that most people make when they first begin to show off their photographs. So how do you select your pictures?

INITIAL SELECTION

The first round of selection is easy enough: you simply winnow out all the technical failures. Even here, though, you have to be careful. How do you judge a 'failure'? There are pictures which are not as sharp as they might be, or where colours are a bit funny, but where sheer impact makes up for the deficiencies. But equally, you can try and kid yourself that a picture which is not really good enough is saved by its composition, or whatever, when in your heart of hearts, you know that it isn't. If you really aren't sure, give yourself the benefit of the doubt.

The second round is only a little more difficult. Where you have several identical or near-identical pictures, select just one of them. Remember, too,

TROGLODYTE HOUSE, GOZO
There is a difference between a batch of similar pictures of the same subject, and a set of pictures which show different aspects of the same subject. The former, no one wants to see; the latter may well be more interesting than a portfolio made up of substantially unrelated pictures. This is the basis of the 'picture essay'. Other pictures of the same place appear in this book as the Frontispiece and on page 125; the technical information is identical.
(FES)

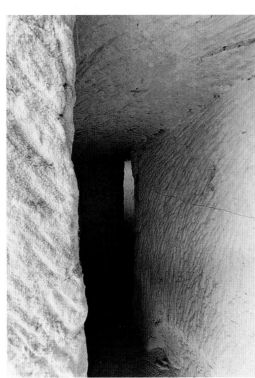

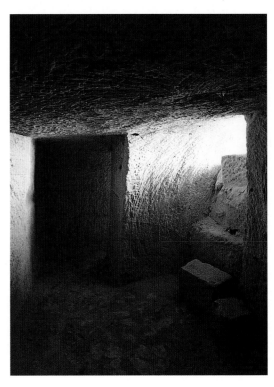

that pictures which are significantly different for you may be substantially identical for someone else: if they are (for example) of the same people in the same setting, the fact that there are slightly different poses may be of limited interest.

The third round is more artificial. Count the number of pictures you have – and reduce it by an arbitrary percentage, at least 10, and maybe as high as 50. Initially, we very strongly recommend that you select no more than ten pictures in all, or a dozen at the outside, as this greatly reduces the risk of boring the person to whom you show your pictures.

The value of this third round is that it forces you to ask some slightly harder questions than you needed to ask in the first two. What were you trying to say? Were you successful in saying it? Why should this picture be included, rather than that one?

REVELATIONS

Now is the time to show your pictures – but not to everyone. Show them to someone whose opinion you respect; who will, you hope, be reasonably honest; but who should not, with any luck, be too hard on you. They should be an experienced photographer: if they are not, they may hardly notice technical shortcomings which are, in the context of this book, very significant. Ask them to separate their criticism, as far as they can, into an aesthetic strand and a technical strand.

We recommended a maximum of ten or twelve pictures because, if the pictures are really good, then they will want to see more – but not necessarily immediately. Even the finest pictures can rapidly become cloying; one's senses are soon overloaded. If the pictures are less than stellar, or if you have chosen the wrong person, then ten will be plenty for your critic to venture useful opinions on how they might be improved; any more will induce a rapid sinking of the heart, in one party or the other or both.

Pay due attention to what they say, but remember that everyone has his or her own hang-ups. We might well criticize a picture for being over-enlarged, where someone else might say that it would look better if it were bigger. Then there are the die-hards for whom grain is anathema, or who refuse to take 35mm seriously. Others will

take the opportunity to hop on to their hobby horse and tell you what you should be doing, whether it is using their favourite film or developer, or buying a new camera or lens.

Try to separate the constructive criticism from the chaff. Some problems can easily be remedied, either next time you shoot, or by remaking a print: sloping horizons, for example, or inadequate or excessive contrast. Other criticisms may be fair enough, but you may not be able to do anything about them, whether for financial or other reasons: switching to another format, perhaps, or travelling more – or standing in the middle of a

SWEEP
Subject to the limitations imposed by sharpness, this picture works pretty well at almost any size, from a postcard (or smaller) to an exhibition print. Why? It is hard to say – except that it partakes of both record photography and portraiture.
HAND-HELD LEICA M2, 90/2 SUMMICRON, KODAK PJ 400. (RWH)

▲ PLOUGH
ARGYROTYPE
As a conventional picture, this is rather dull; but presented as an Argyrotype, it has a timeless quality, like a glimpse of the past. While it is true that all too often, 'alternative' processes are used in an attempt to save inadequate pictures, it is also true that the right subject, shot with the appropriate process in mind, can be very effective.
MPP MK. VII, 150/4.5 APO LANTHAR, ILFORD FP4 PLUS. (RWH)

there are the things that are simply irrelevant, either for all time, or for now.

There is a great deal of overlap between the categories, of course, and your views may change over time; but the important part is to think about each criticism (including favourable comments) carefully, giving them due weight, but no more.

Up to this point, you have not had to worry too much about presentation; you can show your transparencies on a light box, or use reference prints from the local mini-lab, or whatever, because you are trying to get feedback from a fellow photographer.

As soon as you start showing your pictures to a larger and more critical audience, however, you need to start thinking about how your photographs are presented. A great deal will depend on what medium you are using (slides, prints or electronic) and on whom you want to look at the pictures.

SLIDES

The classic slide presentation is the slide show, and there are a number of simple rules which will make the presentation smoother and more attractive. The ten most important are given in the panel, and similar considerations can be applied to video displays, insofar as they can be (in effect) slide shows on a screen. If you are making up

canal, or shooting at dawn in a location which opens at ten in the morning.

Then there will be the points about which you have mixed feelings. For instance, a separate, hand-held meter is not particularly expensive, but do you want one? Do you actually understand their criticism? On this point, remember that you may come to understand more as you improve. Could you actually work in the way suggested? For example, some people will tell you that you should note every exposure, with details of camera and lens and aperture and shutter speed. Maybe it works for them, but will it for you? Such a method certainly wouldn't work for us. And then

a slide show which you expect to show many times, seriously consider glass mounts to help protect the slides from damage.

To present slides for publication, the multi-pocket slide sheet is probably the best idea, ideally with black frame surrounds. Unless the demands of sequencing override the need for design, try to avoid putting bright slides next to dark ones. We make a conscious effort to have the lightest slide in one corner, and the darkest in the corner diagonally opposite, with a gradation in between. Never use glass-mounted slides for publication or competition entries: the risk of breakage and subsequent damage is just too great.

CART TRACKS, MALTA
A picture of this type can hardly stand on its own; it is an illustration, not a pictorial image. What is interesting about it is that these 'cart tracks' were made thousands of years ago, before the invention of the wheel, by stone-tipped wooden travois. Centuries of dragging loads along the same routes dug these tracks, which have since weathered to the point where they need some explication merely to be recognizable.
LEICA M2, 35/1.4 SUMMILUX, FUJI ASTIA. (RWH)

TEN RULES FOR SLIDE SHOWS

1. KEEP IT BRIEF Ten minutes is a good length; 15 is a sensible maximum; and 20 is an absolute maximum. Even the best slides in the world start to pall after a while.

2. STRUCTURE IT You need a beginning, a middle, and an end. The approach can be chronological or thematic or even based on shapes and colours, but there has to be some sort of structure.

3. HAVE THE COMMENTARY AT YOUR FINGERTIPS 'Ums' and 'ers' do nothing to enhance a presentation; you need a prepared patter. Use notes if you have to.

4. DON'T LEAVE SLIDES UP FOR TOO LONG Only if you are talking about a specific picture, such as how it was lit or exposed or composed or whatever, should it be on the screen for longer than 8 or 10 seconds. Unless there is a good reason, it should not be up for much over 5 seconds.

5. DON'T TRY TO GET TOO MUCH IN If at all possible, illustrate ten points with ten slides, not with one slide which stays on the screen forever.

6. DON'T SWAP ORIENTATIONS Try to keep all slides either landscape format or portrait. If you have to switch, try for a sequence of one format, then a sequence of the other, rather than dotting back and forth.

7. AVOID SUDDEN BRIGHTNESS CHANGES Unless you are doing it for a particular effect (which is unlikely to be successful), don't suddenly go from dark to light, as it will dazzle the audience, and don't suddenly go from light to dark, as they won't be able to see what is going on. Use a 'filler' slide as transition, if need be.

8. DON'T CHANGE FILM STOCKS UNNECESSARILY Not changing them at all is a counsel of perfection, but switching from one stock to the next can be all too obvious if, for example, you switch from Kodachrome 25 to Imation 640T and then to Fuji Astia.

9. CHECK BEFORE YOU SHOW Make sure there are no upside-down, or backwards, or out-of-sequence slides. We carry our shows in a Kodak Carousel, which we test before we set out.

10. BLACK OUT THE ROOM WELL It will vastly increase the impact of your slides.

◄ **BOAT ON LAKE, AUSTRIAN ALPS**
This picture has everything — except composition. Because the boat is almost dead in the middle, there is a curious lack of dynamism. On their own, exposure, sharpness and colour are not enough.
LINHOF TECHNIKA 70, 105/4.5 APO LANTHAR, KODAK EKTACHROME 64. (RWH)

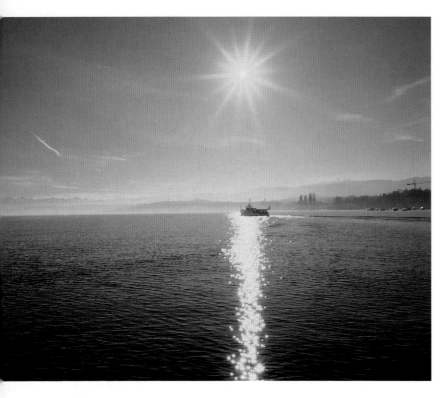

ZUERCHER ZEE
It is sad, but true, that if you bracket shots of a changing subject, you will all too often find that the best exposure and the best composition are not on the same shot. Another exposure in this sequence has more saturation, which looks better, but (of course) the ferry is in a different place.
The exposure, on 6x8cm Kodak Ektachrome EPN, was guessed.
HAND-HELD ALPA 12 WA, 58/5.6 SUPER ANGULON. (RWH)

MNAJDRA ▶
*Even with-
out any explanation, this picture has a certain fascination: it is pictorially (reasonably) attractive, even if we do not know that these ruins are around 50 centuries old, though the explanation adds to its merit. To hang on the wall, however, Roger (who took this picture) suspects that it would be more successful in monochrome.*
LINHOF 'BABY' SUPER TECHNIKA IV ON TRIPOD, 105/5.6 APO SYMMAR, 6X7CM, FUJI ASTIA.

scanner operators are fairly lazy, so the print may lose some information near the edges; and stick a label on the print, with the necessary information. We use LabelBase, as already described for slides. Anything other than glossy paper may not reproduce well: scanners cannot necessarily handle matt or textured surfaces. Consider making transparency copies of prints where this could be a problem.

For individual slides, black paper masks with appropriately sized cut-outs are generally best; protect the slide with an acetate sleeve over the whole thing.

Label all slides, whether for publication, competition or a slide show, with your name, address and copyright claim, and (if necessary) with a caption or identifying mark. We use LabelBase, a computer program which allows us to put up to four lines of text on to a label which will fit easily on to a slide mount.

When it comes to prints, the way in which you present them will depend on whether you are setting up an exhibition, showing off your portfolio, or submitting pictures for publication or for a competition. It is easiest to deal with these in reverse order, as the elaborateness (and expense) of presentation goes up at each stage.

PRINTS FOR PUBLICATION

For publication, all you need is 8x10in unmounted glossy pictures. Almost all the prints in this book were reproduced from 'ten-eight glossies'. You can go to 8½x11in, but anything bigger will not win you any friends: the prints are simply too big to handle in bulk. Likewise, mounting will preclude scanning on a drum scanner. Leave a small border for handling and dog-ears; remember that many

Prints for magazine and similar competitions are normally required in the same format as for publication; prints for competitions based around exhibitions may need to be mounted, as described below. With any competition, do not assume that you will improve your chances by doing something more elaborate than the rules call for. Often, you will simply row yourself out of the competition; at best, your efforts will be ignored.

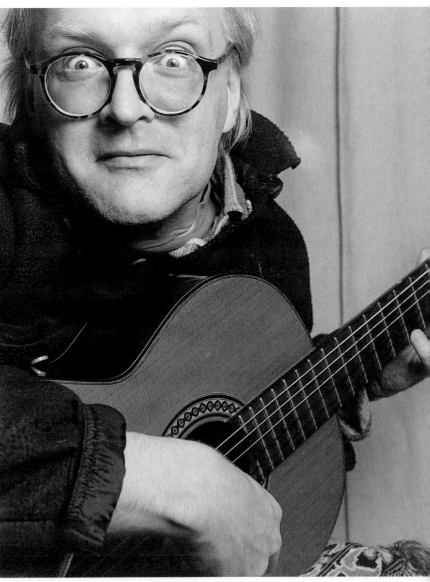

PORTFOLIOS

For a portfolio, arguably the best approach is lamination, as this helps protect your pictures against inconsiderate handling. On the down side, it can also detract from their impact, especially if you are into fine monochrome printing, and it means that the picture has to be reprinted if it is wanted for any other purpose. Also, laminating is not cheap. You may therefore decide to go to window-mounts or dry-mounted images, as described below.

Choose a standard card size: 10x12in (25x30cm) is as small as you could decently go, while anything larger than 12x16in (30x40cm) is likely to be inconveniently large. Get a good, solid portfolio case, and show your 'book' as loose sheets. You

PAUL AND GUITAR
It is hard to look at this picture without smiling: we have all had the experience of someone suddenly making a face like this, when we least expect it. The composition breaks every 'rule' in the book – which all goes to show that 'rules' are not everything. Technical quality (sharpness, grain, etc) is almost irrelevant: as long as it is above the 'quality plateau', as it clearly is here, composition and content carry the picture.
NIKKORMAT FTN, 85/1.8 NIKKOR, PATERSON ACUPAN 200. (MARIE MUSCAT-KING)

need enough good pictures to get people's attention, but not so many that they get bored: a minimum of ten or a dozen, a maximum of about twenty. The sheets should be single sided; no one wants to have to keep turning images over to see the other side.

The size of the prints themselves will depend on your personality, the style of your photography, and the size the print 'wants' to be – a subject which is covered below, where we now talk about exhibitions.

EXHIBITIONS AND DISPLAY PRINTS

Whether you are planning an exhibition of many prints, or preparing a single print for display (as you might with a portrait), most ground rules are constant.

The first question is print size. We have already made our views clear on this: too many people make prints that are the wrong size, being neither intimate with creamy tonality, nor big and dramatic with clear grain. A great deal, too, depends on the

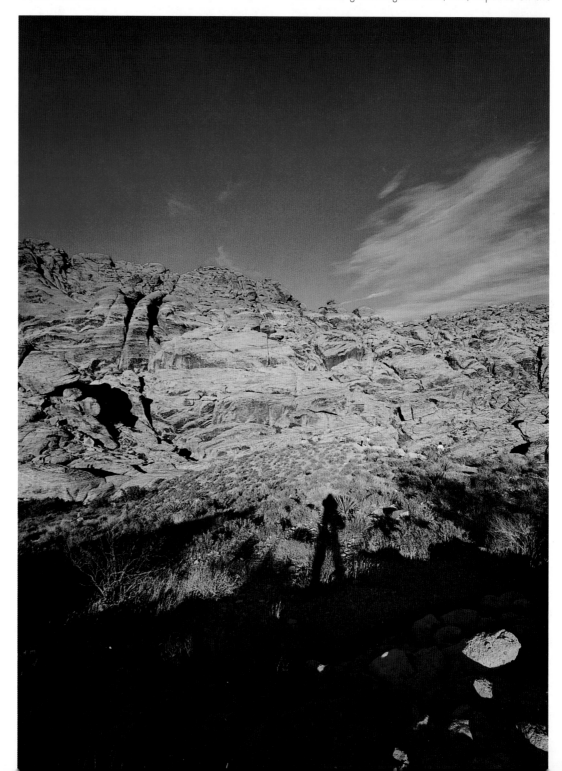

RED ROCKS
It is not just the monumentality of the rocks, and the scale of the scene, that makes this picture 'want' to be big: it is also the inclusion of the photographer's shadow, like a colossus. There is a certain humour in making, for example, a 12x16in (30x40cm) print; at postcard size, it is merely a snapshot with the photographer's shadow in.
ALPA 12 SWA ON TRIPOD, 35/4.5 APO GRANDAGON ON 6X9CM KODAK PORTRA 400 VC. (FES)

DAYTONA BEACH
In the rear-view mirror of the Ducati in the foreground, there is an American flag. With slight sepia toning (for a 'vintage' look) and the flag hand coloured, this picture works very well at 12x16in (30x40cm).
NIKKORMAT FTN, 35/2.8
PC-NIKKOR, ILFORD XP2. (FES)

TANKARD AND CHARGER
*This is from one of Roger's
favourite series of photo-
graphs, shot on 4x5in and
contact printed on to
Centennial POP, toned
with platinum. It seems to
'want' to be small; if it is
enlarged (as was done
with another negative,
processed for enlarging),
the areas of plain pewter
are too large and the
interrelationship of the
shapes seems to
break down.*
GANDOLFI VARIANT, 210/5.6
SYMMAR, ILFORD FP4 PLUS.

venue; the subject matter; the photographer's personal vision; and finally the size that the print 'wants' to be.

In a big exhibition space, where people can be expected to look at the prints from some considerable distance, big pictures generally have a clear advantage. In a more intimate setting, or in a casual setting such as a small foyer or corridor gallery, smaller prints may well work better: a big print, seen from too close up, is often hard to appreciate. Subject matter and personal vision are not really something that can be discussed, but the size that a picture 'wants' to be warrants a heading to itself.

THE SIZE A PRINT 'WANTS' TO BE

This is a difficult concept to convey in a book, where even the largest prints are pretty small, and the smallest ones are little more than postage-stamp sized. A thought-experiment makes it easier to imagine, though.

Think of a series of nude studies. Depending on the photographer's style, some might work best as 'cabinet' pictures, as small as 5x7in, while others might demand to be very big, as much as 4x6ft (120x180cm), for a dramatic, graphic style. The former would be more like engravings, Boucher paintings, silverpoints, watercolours; the latter more like big, bold Dutch Old Master paintings or 1960s posters.

There are many stages in between these extremes – in particular, there are 'normal' exhibition pictures at up to 12x16in (30x40cm), and large exhibition prints at 16x20in (40x50cm) and even 20x24in (50x60cm). Very occasionally, too, it is possible to make tiny exhibition prints, as small as postcard size, but there is a danger of looking pretentious if you do. But when you start to look at your own pictures, and at those of other people, you begin to appreciate which ones 'want' to be big, and which ones are big merely because the photographer imagines that bigger is invariably better.

MOUNTING

The three main varieties of mounts are borderless, flush and matted. Borderless mounts can be dry-mounted on card (see panel) or

glue-mounted on card or foam-core board: there are even self-adhesive foam-core boards for this very purpose. The trouble with adhesives, including spray adhesives, is that they tend to go where they are not wanted, and their influence on the archival keeping qualities of a print is suspect. The old standby of 'Cow Gum' or other rubber solutions is not recommended, because of the sulphur in the rubber, and besides, they are increasingly hard to find; and the (even older) starch-based pastes are an invitation to insects to eat the print.

Borderless mounts go in and out of fashion, but regardless of the technique used, the edges are difficult to finish (they always seem to lift, somewhere) and although the corners cannot logically be much more vulnerable than the corners of a flush or window mount, any damage is made more obvious by the fact that it is in the image area, and by the way in which the photograph and the mount often separate when a corner is damaged.

Flush mounting consists simply of mounting the photograph on a larger piece of cardboard, again using adhesive (spray adhesive is popular) or a

DRY-MOUNTING

Dry-mounting tissue is a sort of fusible glue, sold in sheets or rolls. It is tacked to the back of the print, using a special tacking iron or a soldering iron (which is what we use) or even a domestic iron, and then cut to size. The print-plus-tissue is then placed on the mount, with a sheet of silicone release paper over the top (so that the print will not stick to the platen) and the whole sandwich is squeezed in a dry-mounting press which melts the glue and welds it all (except the release paper) together. The dry-mount resin forms a barrier between the paper and the board, and reputedly does not impair archival keeping – though if archival keeping is paramount, most museums prefer unmounted prints, stored between acid-free tissue paper in archival boxes.

Dry-mounting presses are very expensive new, but they sometimes come up remarkably cheaply at going-out-of-business sales, or government surplus auctions, or the like. Anything less than 12x16in (30x40cm) is likely to prove inconveniently small, while anything larger than 20x24in (50x60cm) takes up too much space. It is possible to dry-mount pictures using a domestic iron, but it is a job for masochists: the danger of grit and bubbles (the besetting problems of dry-mounting) are much greater, and there is a high risk of marring the surface of the print.

dry-mounting press. It has the advantage that prints of different sizes can be accommodated on a standard size of board.

Window mounts are most easily and neatly made with a purpose-built mount cutter such as the Olfa (page 188), which is used in conjunction with a straight-edge to give a neat cut with a 45-degree sloping face. Again, prints of different sizes can be mounted in a standard size mount.

We generally dry-mount the photographs that we intend to window-mount, taping the backing board (which is rather bigger than the photograph) to the window mount with old-fashioned brown paper 'lick and stick' tape (though a sponge in a saucer is easier than actually licking), as we have found that this is much more durable than any form of self-adhesive tape, and does not exude nasty, sticky residues.

FRAMING

Framing can make a print look great, but it can also cost a fortune. Framing individual prints is not too disastrous, and indeed we are often pleasantly surprised at how little it costs to have just one print professionally framed; but framing an exhibition of 20 or 30 prints is another matter – and if the prints don't sell, you are left with a bulky storage problem. Plain card mounts may be preferable.

The sort of frame a print 'wants' is a question akin to the size it 'wants' to be, and the only way to decide is to look at as many framed prints as possible, and as many frames as possible. We have a weakness for quite small colour prints in gilded frames; mono prints generally seem to 'want' plain metal or black frames, unless they are heavily sepia or gold/sepia toned.

Glazed frames protect the print from fingerprints and light, though it is disputable whether they protect it from atmospheric pollution; they may even trap pollution and make matters worse. Undeniably, they place a barrier between the picture and the person who is looking at it. They can also reflect light far worse than a bare print surface. You may therefore want to think twice about whether your prints should be behind glass or not.

LIGHTING PRINTS

In an ideal world, a print would be made to suit the environment in which it is to be displayed. There are a few prints – a very few – which look good in almost any light, but generally, a print which is optimized for display in a gloomy corridor will not be at its best under an exhibition spotlight, and vice versa. This is worth remembering in the darkroom, where too powerful an examination light can prove a snare and a delusion. We use just a 60W bulb in a broad, matt reflector, with a blue glass filter to bring it closer to daylight.

If you do have the luxury of choosing the lighting under which your prints will be seen, you can afford to go for a much 'richer' print (read: darker) in bright light than is suitable for display under weaker lighting. Remember, too, that people are of different heights: a layout which may be admirably glare-free for someone of average height is all too often a complete disaster for short people.

ALBUMS

The rules for laying out a photographic album are really much the same as those given earlier for planning a slide show, *mutatis mutandis*. The only additional points worth making are that acid-free pages will greatly prolong the life of your pictures, and that the old-fashioned corner-type mounts will also do less harm than adhesive mounting or (worse still) 'cling film' mounting where the pictures are stored under an acetate shield. With the latter, the photographs stick to the acetate, and the surface texture of the print is also unpleasantly obscured.

FRAMING
Cheap frames are available in many places; with the aid of some cardboard and a mount cutter such as the Olfa shown, a suitable picture can be transformed into quite a handsome gift — or a means of raising money for a favourite cause, including one's own bank account.

ELECTRONIC PRESENTATION

As intimated earlier in the book, the relevance of electronic presentation to high-quality photography is in reality extremely limited, simply because the resolution and sharpness of even the highest quality monitors is very low when compared with the resolution and sharpness of a photographic print.

There is also the point that for on-screen display, you need the smallest possible digital files, in order to minimize the time it takes for the image to come up on the screen. Read and download speeds are improving at the same rate as everything else electronic, but no matter how fast a computer gets, it can never be fast enough: the impatience threshold simply rises in exact step with successive improvements in speed.

There are however good reasons for using electronic presentation in some circumstances. We have already mentioned the possibility of transferring a slide show to the screen, pretty much in its original form, but there are rather stronger arguments for using electronic presentation when you want to show your 'book' (portfolio) to people, or you want to construct yourself a website.

PORTFOLIOS

The easiest approach is probably just to make small files that are written on to a CD-ROM (you really need your own CD-ROM writer), and then opened in Adobe Photoshop or a similar image program. No format has any very great advantage: we do not bother to compress the files (as JPEG or something similar) because even with uncompressed TIFF files we can get 50 or 60 screen-filling images on to a single CD-ROM. This is equivalent to scanning a 35mm transparency at 600 pixels per inch: around a one megabyte file. Purely empirically, this looks good on a high-quality 17in monitor, and acceptable on a 19in.

If you are more energetic (and more computer literate), a better idea may be to use HTML (hyper-text mark-up language) and create your 'book' in much the same way as you create a website, mixing information about yourself with pictures, using hypertext to cross-link whatever you may consider to be of interest. You can even provide links to technical aspects of your work, such as the equipment you use and the darkroom side of things; there is always the possibility that someone will be interested, and if they are not, they don't have to read it. This is one of the great advantages of an electronic portfolio: it can be all things to all people, without (if it is well done) boring any of them. Another advantage is that it is easy to make multiple copies, and leave them with different people. In this case, compressed files may have marked advantages, as you may want to get a great deal on to a single CD-ROM.

WEBSITES

We have to confess that at the time of writing, we were still just dabbling with the idea of setting up our own website, though by the time you read this, we may yet have one up and running. If we do, it will be hot-linked to the website of David & Charles, UK publishers of this book: www.davidandcharles.co.uk.

From perusal of friends' websites, it looks as if the construction of your own website is as personal as taking pictures or writing books, but a few observations might with advantage be entered. One is that you should not assume that people want to know all about you. A second point, closely related to the first, is that simplicity and brevity are almost invariably preferable to complexity and prolixity. A third is that whimsy should be used with restraint: dancing hippos and the like may amuse you, but will they amuse the person who has to wait forever for them to download? Our own feeling is that the fewer embedded graphics there are within a personal website, the better: any pictures should be a part of the story, not mere ornament. Fourth and finally, a website is a complex mixture of exhibition, magazine article, portfolio and ego trip, and blending these disparate components successfully is not always particularly easy.

PUTTING YOUR HEAD ABOVE THE PARAPET

If you are honest, you have to admit that whenever you show someone your pictures, you are, on some level, seeking approval or even praise. The classic cliché of the amateur photographer, 'I like it, and that's all that matters,' is *ipso facto* a lie. If your personal opinion were really all that mattered, you would not bother to show your pictures to other people. But they can enjoy your pictures, and you can learn from one another, even if you are a long way from the greatest photographer in the world. You cannot ask for much more than this.

What you choose to photograph, and how you choose to photograph it, and to whom you present those photographs, is an intensely personal matter. Only you can decide what works for you. This may sound like the exact opposite of what we said a moment ago, but it isn't. It is perfectly legitimate to say, 'I am showing you this picture for no better reason than that I like it,' and indeed we do it all the time; but when we show it, we know we are putting ourselves on the line, and inviting the brickbats along with the bouquets. We get both.

Of course we hope you will have liked this book, and that you will think well of us and our work. But, as we have said elsewhere in print, we hope still more strongly that you may have picked up enough tips and ideas to look at our pictures and say, 'I could do better than that' – and then go out and do it. If you do, we shall have succeeded.

Envoi - A Sense of Vision

We hope that after reading this book, you will have a better idea of both how to analyse quality, and how to achieve it. As already mentioned, we hope, too, that you will have said, at least once, 'I could do better than that!' – and that you will proceed to do so.

It is, after all, a mistake to try to dazzle the reader with the authors' cleverness and talent. No matter how good an author may be, or how much he or she may know, there will always be readers who know more, and who can achieve more. In a book of this kind, an author can hope for no more than this: that the book should be remembered with affection, and perhaps with some respect, as something which helped the reader to become a better photographer. We, like you, are learning all the time. Where we have learned more than some, it is because we have spent more time on the subject than most; we hope that the fruits of our researches may be useful to you. At the end of it all, though, there is one last point that we would like to reiterate. It is this:

There is a great difference between a technically excellent picture, and one which is a work of art. A work of art transcends technical limitations; it may well incorporate them, or even make a feature of them.

This is a very long way from saying that technique does not matter. There are plenty of self-proclaimed artists whose modest talents would look a great deal better if they paid more attention to technique, and less to originality (or to mere shock value) at any cost. But equally, there are plenty of technicians whose work is flawless, but who rarely, if ever, stray into the realms of art.

This is, in effect, the difference between quality in illustration, and quality in art. Given reasonable access to equipment and materials, the former depends solely on technique, which can be learned. The latter depends only partly on quality, and the better the artist's eye, the more original the artist's vision, the more passion in the artist's soul, the less important the technique becomes. The sole relevance of technique to a great artist is that it may unlock the door to his or her art: it is the realization that 'Hey, I can do this!'

There are, we know, plenty of pictures in this book – and not just the equipment illustrations – that fall short of what we would like. Partly, this is because of the way we earn a living: we have to illustrate various technical points, and we cannot always do so with pictures of the quality we might wish. Partly, too, it is because we are not the artists we would like to be.

There are, however, at least a few pictures in here that remind us of why we take photographs, and give us hope that we may take other good pictures in the future. Look back among your own pictures, and dwell upon your favourites. Ask yourself if there are not others which might have been favourites, if only they had been technically better. If there are: well, get out there, and start shooting!

SUNSET OVER SEA
Cropped to a panorama, this is dramatic and moody. All in, it is dominated by an overly dark foreground. Instead of a Leica with a 35mm lens (f/1.4 Summilux), Roger might have done better to use a 6x17cm camera with a 300mm lens, but this is something we rarely carry with us. Cropping is a compromise, but it may be the only sensible compromise.
FUJI ASTIA.

Index